IMAGES OF AMERICA

CHELSEA

LYNN

MALDEN

William Boardman Jr. William Boardman

Cheever

Thomas Douglas Berry.
Long Pond

Newburyport Turnpike 1804

Earliest Road to Salem

Salem Turnpike 1803

Breeden

Robert Waite

Pines River

Point of Pines

Chelsea Beach

1. JOHN BRINTNALL.
2. BENJAMIN BRINTNALL.
3. THE TAVERN.
4. SAMUEL WATTS.
5. EUSTIS, TENANT OF THOMPSON.
6. STEPHEN KENT, TENANT OF THOMA...
7. THE MILL.
8. DANIEL WATTS.
9. THOMAS PRATT
10. SAMUEL PRATT.
11. NATHAN CHEEVER.
12. REV. THOMAS CHEEVER.
13. ISAAC LEWIS.
14. ELISHA TUTTLE.
15. JOHN TUTTLE.
16. HEIRS OF ASA HASEY.
17. THE GRIST MILLS.
18. THE YEAMANS HOUSE.
19. JACOB HASEY.
20. WILLIAM HASEY.
21. JOHN HASEY.
22. WILLIAM HASEY'S LANDING PLACE.
23. SAMUEL TUTTLE.
24. THE JONATHAN TUTTLE FARM, OWN...
25. THE MEETING HOUSE.
26. THE GRAVE YARD.
27. EDWARD TUTTLE.
28. DANIEL TUTTLE.
29. JOHN FLOYD.
30. OAK ISLAND.
31. SAMUEL FLOYD.
32. THE DAMMED MARSH.
33. THE NATHANIEL TUTTLE FARM, OW...
 INGRAHAM.
34. THE FARM OF BENJAMIN FLOYD.
35. HUGH FLOYD.
36. THE DUDLEY FARM HOUSE.
37. CAPT. NATHANAEL OLIVER
38. JOHN LATHE.
39. THE HEIRS OF ELISHA BENNETT, ...
 TENANT?
40. JOHN SALE.
41. JOHN GROVER.
42. DEACON JOHN CHAMBERLAIN.
43. BENJAMIN WHITTEMORE?
44. JOHN TEWKSBURY?
45. CHARLES BILL.
46. JONATHAN BILL.
47. SITE OF OLD INDIAN FORT

Hog Island

tic River

HARLES-
TOWN

les River

Winnisimmet Ferry

Mill

Noddles Island

BOSTON

Pullen Point

Fisher's Creek

Joseph Belcher

Snake Id.

BOSTON
HARBOR

Governor's Id.

Deer Id.

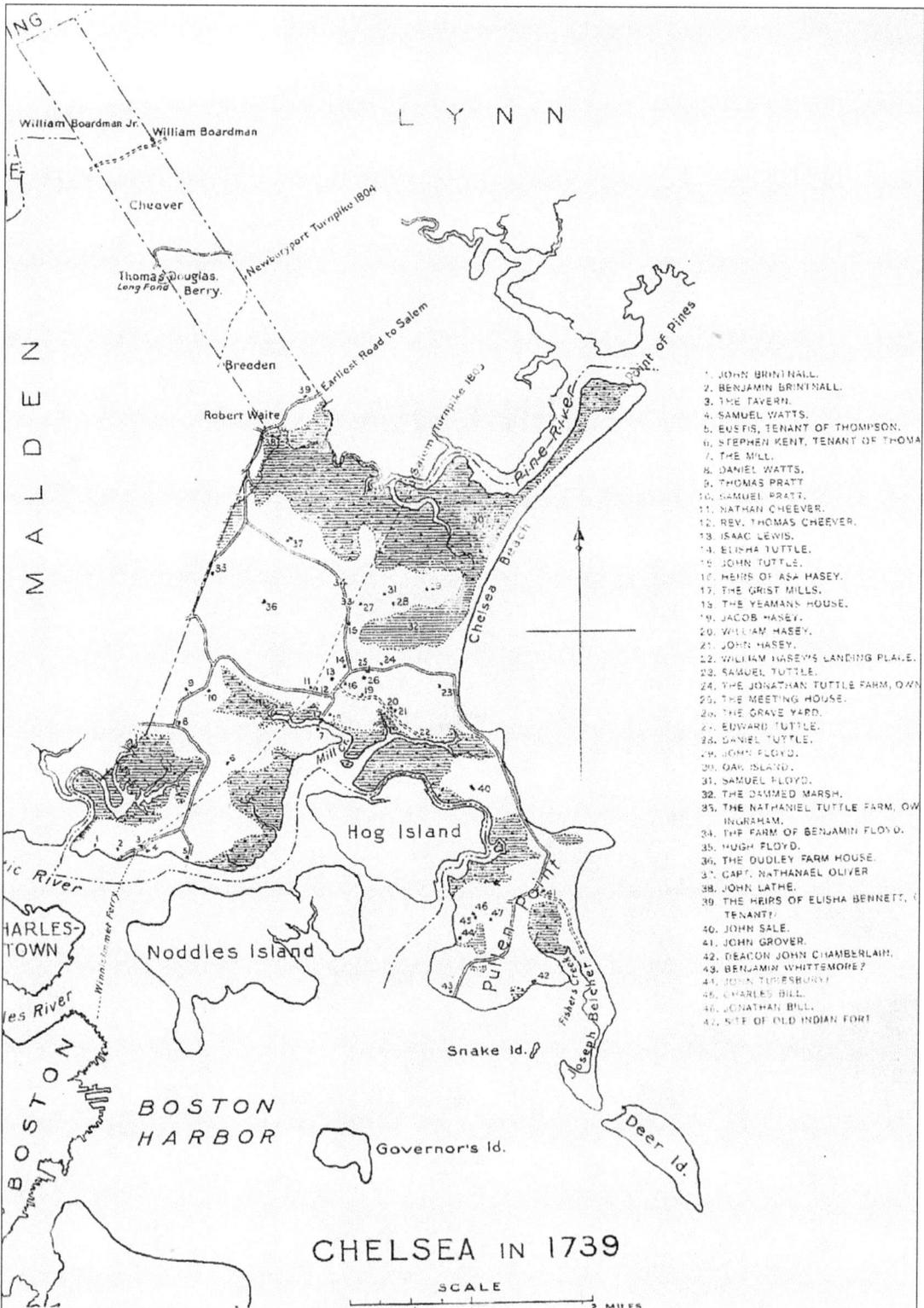

CHELSEA IN 1739

SCALE

MILES

IMAGES OF AMERICA

CHELSEA

MARGARET HARRIMAN CLARKE

ARCADIA
PUBLISHING

Dedicated with affection to Aunt Mary B.
I thank her for her intelligence, her courage, and her wit.

Frontispiece: This detailed map of Chelsea in 1739 shows not only the extent of the original settlement, it also identifies its inhabitants. The early Winnisimmet Ferry route ran from Hanover Street in Boston to the foot of Winnisimmet Street. The dotted line continues along what was later Broadway, the route of the turnpike to Salem. The double line indicates roads that existed in 1739 that connected the local farms. The shaded areas were marshland that, until dammed or filled, delayed the development of the city.

Copyright @ 1998 by Margaret Harriman Clarke
ISBN 978-1-5316-0860-6

Published by Arcadia Publishing
Charleston, South Carolina

Library of Congress Catalog Card Number: 2003106984

For all general information contact Arcadia Publishing at:
Telephone 843-853-2070
Fax 843-853-0044
E-mail sales@arcadiapublishing.com
For customer service and orders:
Toll-Free 1-888-313-2665

Visit us on the Internet at www.arcadiapublishing.com

Contents

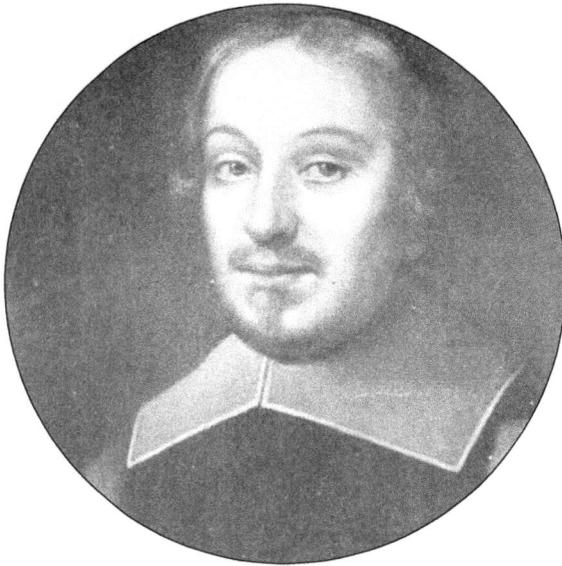

Above: Sir Henry Vane arrived in Boston in 1635 at the age of 24. He was elected governor the following year. For a brief time, he owned the 200 acres known today as Prattville. His sympathy with differing religious views soon made him suspect and he returned to England in 1637. His continued religious convictions led to his execution in London in 1662. A bronze statue of Sir Henry graces the entrance hall of the Boston Public Library.

Below: Richard Bellingham, a lawyer from Boston, England, came to Boston between 1634 and 1935. He held the positions of lieutenant governor and governor of the Massachusetts Bay Colony for a number of terms until his death in 1672. His main residence was in Boston, but he also kept a large farm at the foot of Powderhorn Hill. Upon his death, the farm was passed to his heirs.

Introduction

Settled in 1624, six years before the city of Boston, Chelsea has a long and fascinating history. Samuel Maverick was only 24 years old when he built his "palisade" house in Winnisimmet. In 1669, Maverick stated that it was still standing, "the antientist house in the Massachusetts Government," indicating that it was probably the first permanent home in the Massachusetts Bay Colony. Maverick came from England with a group called the "Council for New England," a private colonization and trading company that was given a grant of land covering the area from Nahant to East Boston. Maverick's reputation was as a kind and hospitable man, a friend to the local Sagamore tribe, and a welcoming host to any traveler who found himself in the area. Governor Winthrop was entertained at Maverick's house when he first came to Boston from Salem in 1630.

After marrying widow Abiel Townsend, Maverick sold his land to Governor Richard Bellingham and settled on his wife's land, Noddles Island. Bellingham's 365 acres were divided into four large farms that were later named for the tenant farmers: Williams, Carter, Shurtleff, and Cary. Prattville was owned by another Provincial Governor, Henry Vane. By 1695, his land was in the possession of the Pratt family.

At that time, Winnisimmet, or Rumney Marsh, covered a considerably larger territory than the present city of Chelsea; it included Revere, Winthrop, and part of Saugus. The town center developed in Revere, where the largest cluster of inhabitants resided. The area of lower Broadway was referred to as Winnisimmet or Ferry Village, and Winthrop was known as Pullen Point.

In 1631, ferry service was begun between Winnisimmet and Boston, the first ferry in the country. The overland route from Boston to Winnisimmet was a trip of over 20 miles, often taking two days. Only a mile across the Mystic River, the ferry from Boston to Winnisimmet was a much faster journey. Travelers then could take a carriage north to Salem, where the General Court was located, as well as important commercial activities. When the river was iced over in winter, the trip was sometimes made by horse-drawn sleigh. The ferry ran for nearly 300 years, from 1631 until 1917.

Still part of Boston in 1739, Rumney Marsh petitioned to become a separate town, to be known as Chelsea. Revere and Winthrop later broke away from Chelsea to become independent towns themselves. With only about 2 square miles of its original land, Chelsea became a city in 1857. By that time it had begun to develop the industrial character that would change it from a way station between Boston and Salem to one of the most industrialized cities in the United States.

Major changes are often the result of improvements in transportation, as was the case with Chelsea. Especially important were the construction of the Salem Turnpike in 1803, the steam powered ferry in 1832, and the arrival of the railroad in 1847. The turnpike consisted of a bridge across the Mystic River from Charlestown and a direct route along Broadway and up the north shore to Salem. Tolls were collected in Chelsea, Lynn, and Salem for passage along this new "highway." The turnpike along lower Broadway was high and narrow, having been built up to avoid the flooding that would occur when the river and creek overflowed. There were stone posts and a rail on each side to keep carriages from slipping into the marshy lowlands.

In 1832, Winnisimmet was primarily a land of farms and quiet activity. It did not have a church, school, or a store of its own. Ferry Village had only a tavern and a few houses. With the arrival of the steam ferry it was possible for Boston residents to migrate and businesses to expand by simply crossing the river. The town welcomed the opportunity to grow. First to develop was the area around the ferry. The Shurtleff and the Williams farms, two of the town's largest, were purchased by the Winnisimmet Company in the 1830s and sold off for building lots. The Shurtleff farm sold for $50,000 and the Williams farm for $22,500. The marshland west of Walnut Street sold for $13,000.

The Winnisimmet Company built a sea wall along the waterfront and enclosed the flats, which in time were filled in. This became the city's first wood and coal wharf. The deep harbor made it ideal for shipping. A dam closed off the Island End River, which made development of the area west of Broadway possible. Until that time land flooded from Walnut to Fifth Street, and along Washington Avenue as far as Cary Square.

The Chelsea Street Bridge to East Boston was erected in 1834, followed in 1855 by the bridge at Pearl Street. These served as an alternative to the ferry and accelerated development of this area of town. Marginal Street was laid out in the 1840s and Eastern Avenue in the 1850s.

In 1882, local historian Simeon Butterfield reminisced about the beauty and simplicity of life in the village in the early 19th century, of church meetings, walks through the countryside, and a strong sense of community. There were lilac bushes on the high banks of the Mystic River when he first arrived as a boy in 1834; the river itself was often used for baptismal purposes by the Baptist Society. He recalled the excitement of climbing Powderhorn Hill (also called Thornbush Hill) to look over the surrounding land and sea.

In the 1830s, the population of Winnisimmet, Rumney Marsh, and Pullen Point was about 770. By 1840 it had tripled to 2,182, and in 1850 it was over 6,000. Chelsea's population had tripled again by 1870 to over 18,000, and in 1900 the city had more than 34,000 people within its 2 square miles.

A number of the families who would serve the city well in the last half of the century came to Chelsea between 1830 and 1860. The "City Fathers" had the welfare of Chelsea very much at heart. Mayors served one-year terms and often managed successful local banks and businesses. There was a proliferation of social clubs, and great attention was paid to providing churches, schools, and public utilities to accommodate the various needs of the citizenry. By the end of the 19th century Chelsea was a popular suburb as well as one of the most productive cities in the country. The fire of 1908 forever changed a significant part of the old city, destroying many of the important residences, schools, and public buildings that contributed to its beauty and diversity.

I have chosen to cover the development of Chelsea from its beginnings until the early 20th century, as it was evolving from a sleepy hamlet to an industrial giant. Many of the photographs in the book are from archival collections that have never before been made public. I hope that you will share the excitement that I experienced as I began to uncover these images a few years ago. As you see the buildings that were once part of the city, I think you will have a renewed appreciation for the wealth of early architecture that still remains—from the old school buildings to the handsome homes to the venerable industrial sites. They are everyone's history, our link with the past. They tell us where the city has been. They need to be valued and preserved as the city moves into the future.

The
Early
Years

This idyllic image shows "Howell Place," the 18th-century home of Henry Howell Williams, in the vicinity of Beacon Street. Mr. Williams came over from Noddle's Island in 1800 and purchased the estate of the Watts family, operating a dairy and poultry farm. By 1831, the former mansion house had become a popular tavern, called Taft's Tavern and later the Chelsea House, frequented by people from Boston. Here they would bowl on the lawn, play billiards, and watch hot-air balloon ascensions and fireworks. By 1850, the tavern was demolished and the land was developed into house lots. The hill on which it stood was removed and used as fill to create Medford and Front Streets. (Courtesy of the Boston Athenaeum, hereinafter referred to as the BA.)

The old Toll House stands alone at the foot of Broadway in an area once teeming with activity. Built at the terminus of the Salem Turnpike, its function was to collect tolls when the road was constructed in 1803. Not one to stand in the way of progress, Mr. Williams himself was on the committee to plan the turnpike. It is the second oldest house in the city.

Note the familiar streets in this 1836 surveyor's map—Beacon, Walnut, Broadway, and even School Street, which still retains some remarkable early houses. Everett Avenue had not yet been laid out and part of Williams Street is named Malden. After construction of the dam, the marshland dried out and development of the area began. Between Broadway and Winnisimmet Street is the Williams' "Mansion House." (Courtesy of the Society for the Preservation of New England Antiquities, hereinafter referred to as SPNEA.)

The original of this remarkable lithograph is still full of vibrant color, although it dates back to 1845. It provides an unusual view of the development of one of the marshy areas of Chelsea as seen from the Everett line. The land belonging to Nathaniel Sands was leveled and laid out into 2,000 building lots, becoming Spruce, Maple, and Carter Street and their connecting streets. The large hill is the back side of the Naval Hospital Hill, 15 years before the familiar brick hospital building was constructed. To the left of it are spires of the early churches in Chelsea; to the right is the Old North Church, the State House, the Bunker Hill Monument, and the Island End River. (Courtesy of the BA.)

At the right in this view across the Mystic River more than 150 years ago is the Bunker Hill Monument in Charlestown, dedicated in 1843. The State House, built in 1795, crowns the top of Beacon Hill. The bridge from Chelsea to Charlestown was part of the 1803 construction of the Salem Turnpike.

This oil painting of the waterfront by Robert Salmon, dated 1832, was commissioned by the Sigourney family, who lived in the small house at the left (two of Mr. Williams' daughters married into the Sigourney family). The house existed into the early 20th century. On the hill to the right is Howell Place. In the early 1800s many people kept rowboats here to carry milk, eggs, and produce to Boston to sell. (Courtesy of SPNEA.)

Jonathan Green came to Chelsea from Stoneham in 1769 to live in this house on Naval Hospital Hill. Located just across the Mystic River from Bunker Hill, it was an extraordinary viewing point for the battle in Charlestown on June 17, 1775. In fact, soldiers were quartered in Mr. Green's house and barns from September to December 1775. Mr. Green later returned to Stoneham to live. (Courtesy of SPNEA.)

At the intersection of County Road and Washington Avenue was another early homestead. This was the farm of Deacon Daniel Watts, c. 1750; in later years it was the Carter farm. Mellen Chamberlain and Levi Slade built their homes on the site during the last half of the 19th century. Powderhorn Hill looms off to the right.

A rare interior photograph of the front hall of the Pratt House shows the typical layout of First Period houses (those built before 1725). The entry hall was narrow, with a steep winding stair that led to the upper chambers. When built, it was probably two stories high and one room deep, with a lean-to added later for storage. (Courtesy of SPNEA.)

Built about 1660, the Pratt House was the last house in Chelsea with significant remnants of its early architecture intact. It was occupied by descendants of the Pratt family into the 20th century. After standing for more than 300 years, it was demolished in the 1960s. The small building on the right is said to have been slave quarters. Modern buildings cover the site just off Washington Avenue, across from Kimball Road. (Courtesy of SPNEA.)

This image of the sitting room at the Cary House was taken c. 1875. At that time the house was illuminated by gas light and decorated with fine furniture and paintings. The straw floor covering was typically used in summer months. Judge Albert Bosson was very active in the preservation of the house.

Chelsea's earliest surviving home is the Governor Bellingham/Cary House on Parker Street. Although built at the same time as the Pratt House, it was remodeled and enlarged during the 18th century into a hipped roof Georgian mansion. It was the summer home of Governor Bellingham in the 1660s and occupied by the Cary family from the late 1700s until the early 1900s. The awning imitates the popular "piazza."

Left: In 1874, this advertisement was circulated announcing the availability of "Desirable Building Lots." The house lots, part of Governor Bellingham's original estate, did not sell as quickly as was first expected. The Civil War and the 1872 depression probably accounted for some of the delay.

Below: The elderly surviving children of Samuel and Sarah Cary sold most of the land that surrounded their home in 1853 for $150,000, significantly less than its actual value. For some years the only other homes in the neighborhood were the mansion of Eustace Fitz, which is still standing on Parker Street, and the home of Frank B. Fay at the corner of Clark Avenue.

two

Chelsea
Square

With the powerful new steam ferry bringing goods and travelers from Boston, the area known as Winnisimmet Square was the first to be settled. It began to develop in the 1830s, and soon became the most densely populated part of the city, with both residential and commercial buildings clustered around the harbor. This photograph commemorates the Fourth of July Celebration in the square in 1868. The brick building on the immediate left is still standing on Broadway; for many years it was Rice's Dry Goods. Further up on the left, at the corner of Third Street, is the First Baptist Church. Along the right is the First Congregational Church. The now familiar Stebbins Fountain was not constructed until the end of the 19th century. (Courtesy of SPNEA.)

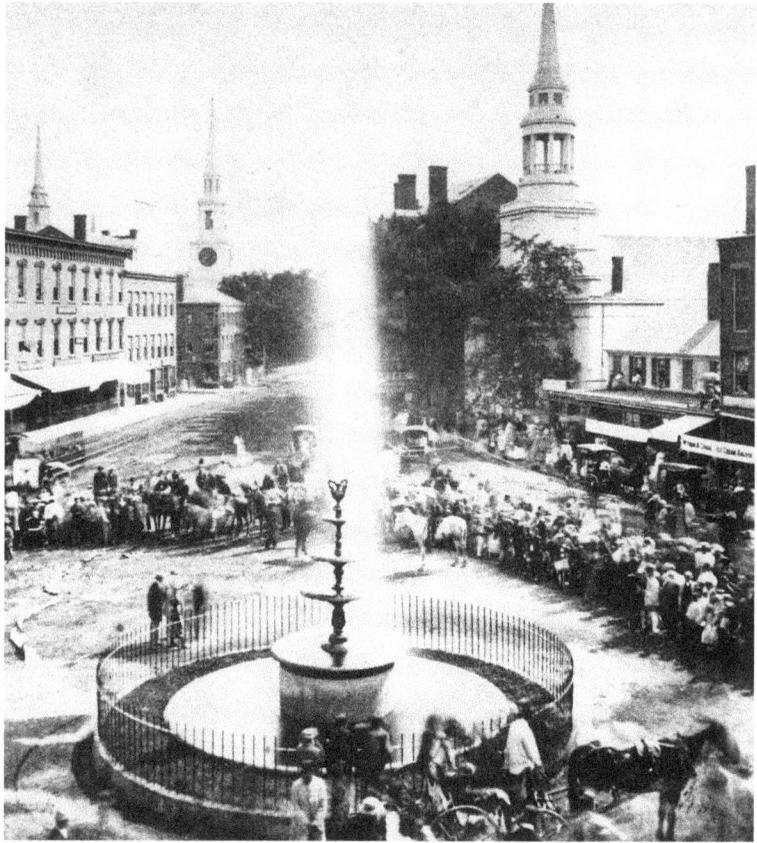

Chelsea Square was the town's gathering place for many years. In this view looking toward Park Street, a contingent of military troops has assembled, led by the band, for some commemorative event. The Armory was nearby on Second Street. The Gerrish Block, at the left, was used for shops, warerooms, and as a meeting place. The immense Grand Army Hall was built in 1841 and was originally the Park Street Methodist Episcopal Church. The market buildings to the right were most likely built by the mid-century as residences. All that remains today is the Gerrish Block. (Courtesy of SPNEA.)

Opposite, below: This view and the one opposite give an extraordinary picture of Chelsea Square c. 1875, prior to the construction of the green space of the Winnisimmet Parkway. Looking toward Bellingham Square, at the left, is a wonderful jumble of awnings and storefronts, a few of which still survive, including the Wheeler Block and M.E. Rice's Store. At the far right is the Gerrish Block (used by the Salvation Army), the Broadway House Restaurant, and the long brick building that housed the Academy of Music. The music building had a theater seating 1,350 people. (Courtesy of the Chelsea Public Library, hereinafter referred to as the CPL.)

This view is down Winnisimmet Street toward the ferry landing. The ancient cobblestone street is one of a few that still exist. The late 19th century commercial buildings on the left are also still in place. In the 1830s and '40s boat races from here to the South Boston Bridge were a popular sport, but the heavy consumption of alcohol that accompanied the event gave rise to the Temperance Movement.

GO BY THE FERRY TO BOSTON.

And escape dust, horse blockades, bad air, cold feet, sudden and dangerous changes of temperature. In WINTER, good, comfortable waiting-rooms and warm cabins, ample seating capacity, steady, quick and sure passage. In SUMMER, charming views, airy, cool—a pleasant harbor excursion in ten minutes.

Two boats Saturday nights until 11.30 o'clock with police protection on each boat thus assuring order and affording most desirable conveyance to and from Boston.

THE BEST ROUTE, SUMMER OR WINTER, DAY OR EVENING.

WINNISIMMET FERRY COMPANY.

After many years, once again you can "Go by the Ferry to Boston." In the late 19th century, the Winnisimmet Company encouraged ridership by advising the traveler to "escape dust, horse blockades, bad air and cold feet" by taking the boat to Boston. The old ferry gave way to progress and ceased regular operations in 1917.

J. M. LINSCOTT. **G. F. SALSIBURY.**

BICYCLES!
FOR SALE OR RENT.
CASH OR INSTALMENTS!

Bicycling was an extremely popular sport, especially with its late-19th-century improvements like pneumatic tires. Special clothing was designed for women so they could ride along with men. Like almost everything else, this very modern bicycle could be purchased downtown in Chelsea.

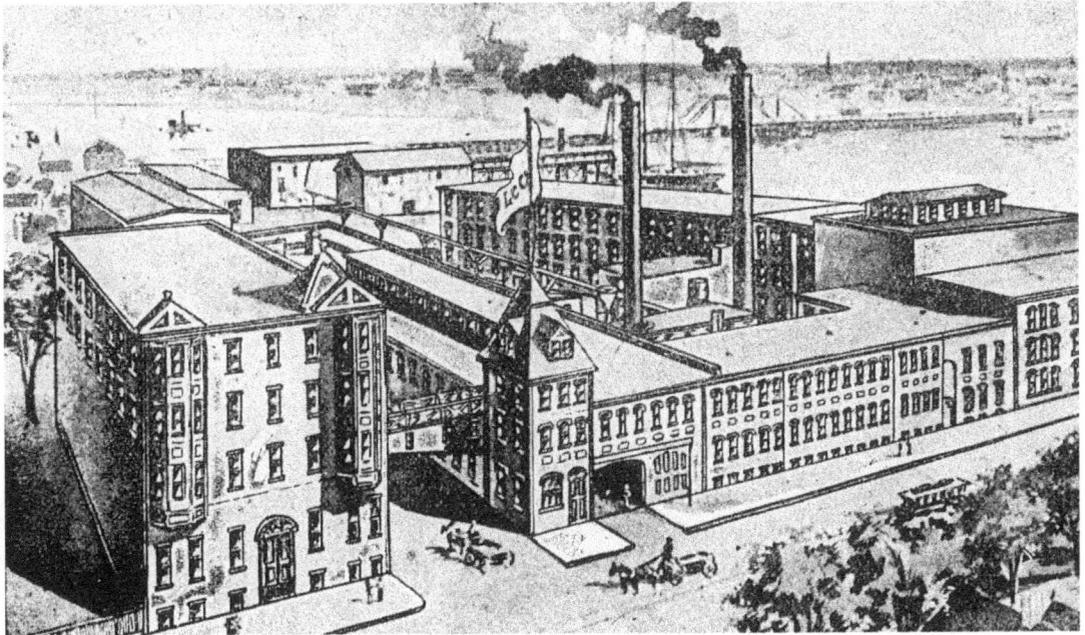

Formerly part of the Boston Rubber Company, two of the buildings of L.C. Chase & Co. remain at the water's edge along Winnisimmet Street. Their specialty was bicycle tires. The brick building at the left, originally the company office, has been adapted for reuse as condominiums.

GEO. D. EMERY,
Mahogany and Cedar Lumber.
CIGAR BOX LUMBER A SPECIALTY.
Office, Mills and Wharves, Nos. 1 to 35 BROADWAY,
CHELSEA, MASS.

This c. 1890 advertisement was for Emery's lumber mill, located on the waterfront.

J. CAMPBELL & SON,

Wholesale and Retail Dealers in

Anthracite & Bituminous Coal,

ALSO, KINDLING WOOD

OFFICES, at Post Office, 268 Broadway,

AND

12 Winnisimmet Street, near the Ferry, Chelsea.

This advertisement was printed c. 1880.

Along the end of Broadway was the enormous plant of George D. Emery, the largest mahogany works in the United States. His ships went between Chelsea and Nicaragua buying mahogany for cigar boxes and furniture manufacturing. Notice the trolley making its way up Broadway in this 1898 lithograph.

Another important business along the water was the Campbell & Co. coal wharves. Coal was used for heating and gas production and Campbell's large distribution facility was a major supplier. By the later 19th century the waterfront was becoming too valuable for residential or recreational use, and homes that once faced the river now faced industrial buildings.

23

Left: Dr. William G. Wheeler had his home and office at the corner of Broadway and Second Street. As a young doctor, 27 years of age, he came here from New York in 1848 to practice medicine. He had a long and distinguished career as city physician, staff member of the old Frost Hospital, and consulting physician at the Soldiers' Home.

Below: The Wheeler Block was originally built without the conical tower, which was added in the 1890s. Its Gothic arched windows, slate Mansard roof, hooded dormers, and iron roof cresting make it a Victorian architectural treasure and important landmark in Chelsea Square. Blackstone's Market next door later moved to the corner of Third Street. (Courtesy of the CPL.)

This late-19th-century view is down Second Street from Broadway. On the left are the bay windows of the Wheeler Block. One of the city's oldest schools, the Cary School, can just be seen at the corner of Walnut Street. The horse-drawn cart is typical of small delivery wagons of the period.

The City Armory was located at the corner of Second and Chestnut Streets; it can also be seen in the previous photograph. The marshy area nearby was a favorite place for the militia to hold target practice. In the early 20th century, this simple little building was replaced by an enormous brick turreted structure on Broadway and City Hall Avenue.

Born in Revere in 1826, James S. Green was in business in Chelsea Square from the 1850s until the early 20th century. Having gone to sea at the age of 17, he sailed to Cuba and South America. Before settling down, he also traveled to California during the 1849 "Gold Rush."

Below: This c. 1880 advertisement was for one of the shops in Green's Block.

CHARLES FOSS,

PROVISIONS,

GREEN'S BLOCK,

BROADWAY SQUARE,

CHELSEA,

MASS.

This large stable was built by Mr. Green in 1853 at the corner of Broadway and Second Street. Conveniently located just up from the ferry, it was able to provide horses and carriages for passengers in need. Before the area was settled, haymakers would come to cut the salt grass in the nearby marsh, camping in tents until their work was done. (Courtesy of SPNEA.)

Mr. Green enlarged and remodeled the original stable around 1870, incorporating a real estate business, stores and apartments, and a residence for himself. Measuring 60 by 120 feet, for a time it was the largest building in the city.

Above left: Mr. M.E. Rice came to Chelsea in 1880, and within a short time was sole proprietor of the city's largest dry goods store. He was originally from Brookfield, Vermont. His home in Chelsea, across from the high school at the corner of Crescent and Clark Avenues, is still standing.

Above right: What a treat it must have been on a Saturday morning to wander the aisles of ice's, looking at the books, velvet handbags, and gold-trimmed umbrellas! The prices reflect what a dollar could buy in 1910.

Opposite above: Mr. Rice's Store on Broadway, the long brick building just before the corner of Everett Avenue, is still standing. He bought out the adjoining store to make this very large establishment. The building was damaged in a 1908 fire, but was later rebuilt and reopened. The fire stopped in this general location, sparing the old buildings in Chelsea Square.

Opposite below: This view of the interior of Mr. Rice's store gives some indication of the wide selection of merchandise available locally that made it possible for shoppers to purchase most of what they needed without having to travel into Boston. That unique phenomenon created a city where people became very familiar with one another, much like in a small town.

BROADWAY ⚏ HOUSE,

Broadway Sq., next Academy Music,

Chelsea, Mass.

LADIES' AND GENTS'

RESTAURANT

Open from 6 a.m. until midnight.
Open on Sundays from 8 a.m. to 10 p.m.

GEO. R. HODGDON, . . *Proprietor.*

Permanent Boarders Accommodated at Reasonable Rates:
Checks Sold at a Discount.

Rooms To Let by the Day or Week.

Hot Stew or Chowder always to be found in Gent's Cafe. Remember that all meats, vegetables, etc., of first quality. and all butter, milk, and eggs strictly fresh and pure; no oleomargarine ever used in this house. Prices moderate for the quality of goods. Polite attention; first-class trade solicited. Special rates made to troupes.

This advertisement was for one of the many "dining saloons" in Chelsea Square.

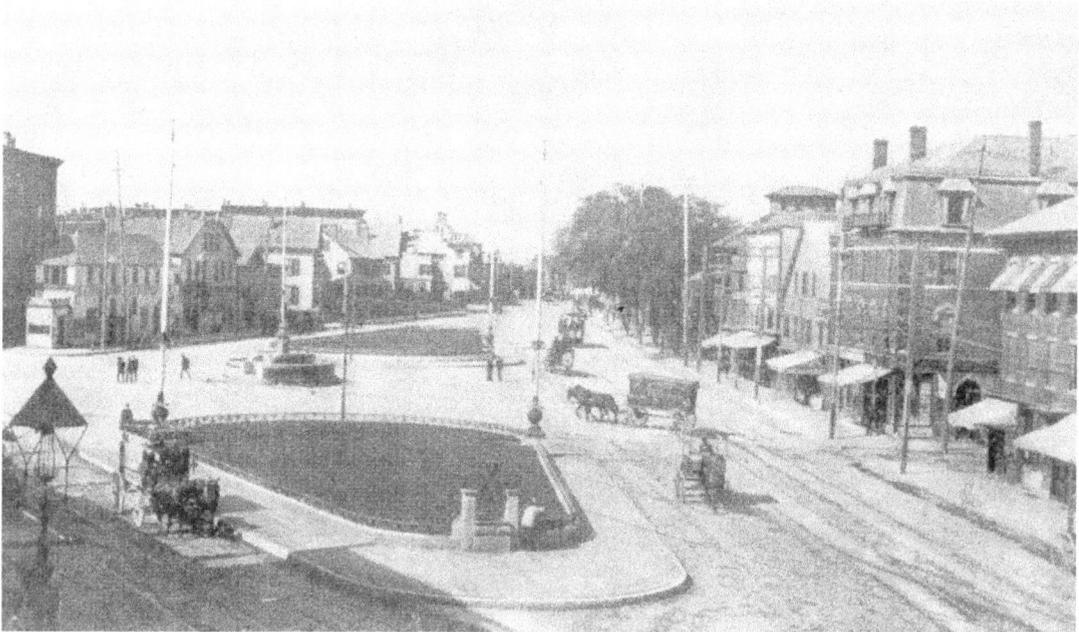

By 1898, the newly completed Winnisimmet Parkway and Stebbins Fountain added beauty to the large old gathering place. Looking along the left on Park Street, however, one can see that the Court House had not yet been built, nor had the now-familiar tower been added to the Wheeler Block on the corner of Second Street.

A few of the buildings in this 1907 panoramic view of Chelsea Square still survive, including the mainstay of the square, the 1844 Gerrish Block, where Abraham Lincoln spoke at a Whig rally in 1848. The white stone block replaced half of the music building that burned down in 1905, and held the Odd Fellows Hall and the post office; there was also a bowling alley in the building. The First Congregational Church (shown earlier) had been demolished. All the buildings to the right on Park Street are now gone, including the immense GAR Block. Looking up Park Street one can see the octagonal cupola of the city hall on Central Avenue; the church spire across from it is the First Baptist Church on Central Avenue. (Courtesy of SPNEA.)

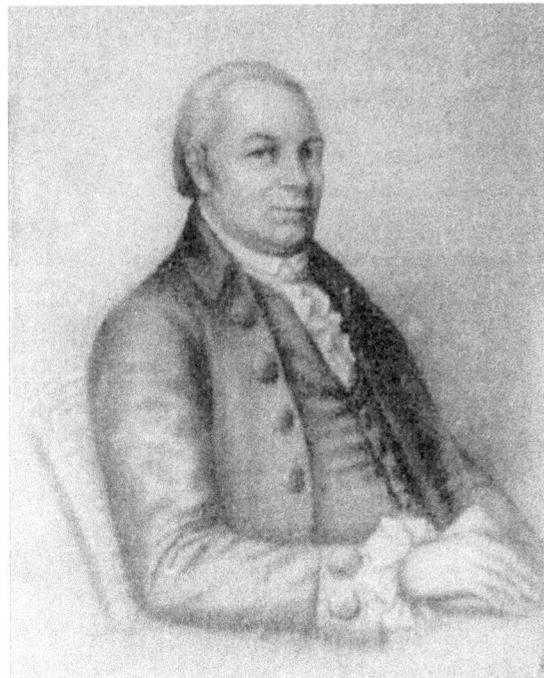

Early settler Henry Howell Williams would have been very surprised to see the changes that had taken place in the rural village he called home in 1800.

At the corner of Broadway and Everett Avenue was the grocery store of C.L. Noyes & Co. This was the site of the city's first store, dating back to 1832. Notice the horse and wagon at the side door, waiting to collect an order for home delivery, a popular service right into the 20th century.

Inside Mr. Noyes' store one could purchase a large pot of jam for 50¢, coffee at 34¢ a pound, or choose from a large selection of canned goods. Notice the familiar Quaker Oat figure on top of the display at the right rear of the store. These photographs date to 1898.

three

Down
Broadway

Left: At the corner of Broadway and Congress Avenue was Chelsea's oldest bank, the Chelsea Savings Bank, incorporated in 1854. Its first president, Francis B. Fay, was also the city's first mayor in 1857. The bank began with assets of just $10,000. This Romanesque Revival-style building was constructed in 1895.

Opposite, below left: Built in 1837, the First Baptist Church was located at the corner of Third Street and Broadway. This simple Greek Revival building was the first church erected within the present city limits. In the early years, baptisms were performed in the Mystic River.

Opposite, below right: By 1900, the addition of Guy's Furniture and Carpet Company obscured the handsome temple front of the historic First Baptist Church. It appeared that nothing could stand in the way of progress. The steeple was removed, but its clock stood as a reminder of earlier, quieter times.

Below: At different times in the 19th century, both the First National Bank and the Chelsea Trust Company occupied this handsome building at the corner of Broadway at Everett Avenue. The "Quick Lunch" wagon to the left was the forerunner of the diner. (Courtesy of the Boston Public Library, hereinafter referred to as the BPL.)

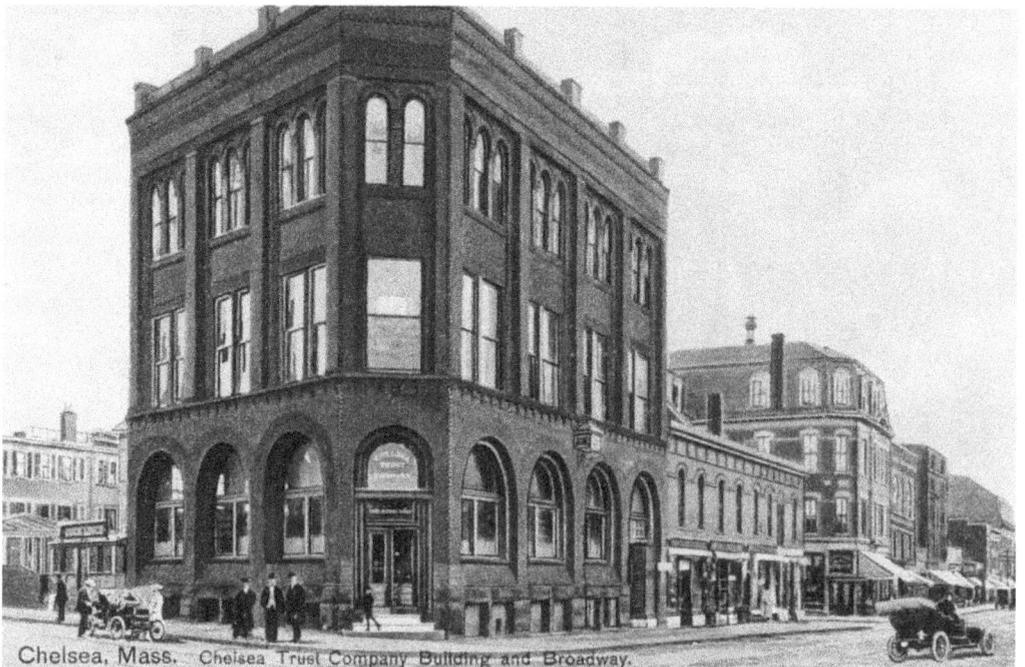

Chelsea, Mass. Chelsea Trust Company Building and Broadway.

Right: Chelsea's main street, Broadway, was originally lined with residential housing. With the increased need for goods, stores were added to the house fronts and the once-quiet street became a congested and lively scattering of shops. Pictured here is the establishment of D.H. Atwood at 377 Broadway, taken about 1875. Although his store was listed in the local directory as a "variety store," Mr. Atwood appears to have dealt primarily with photographs. A number of local images have been identified as coming from his shop during this period. Like many other small shopkeepers, he lived above the store. (Courtesy of SPNEA.)

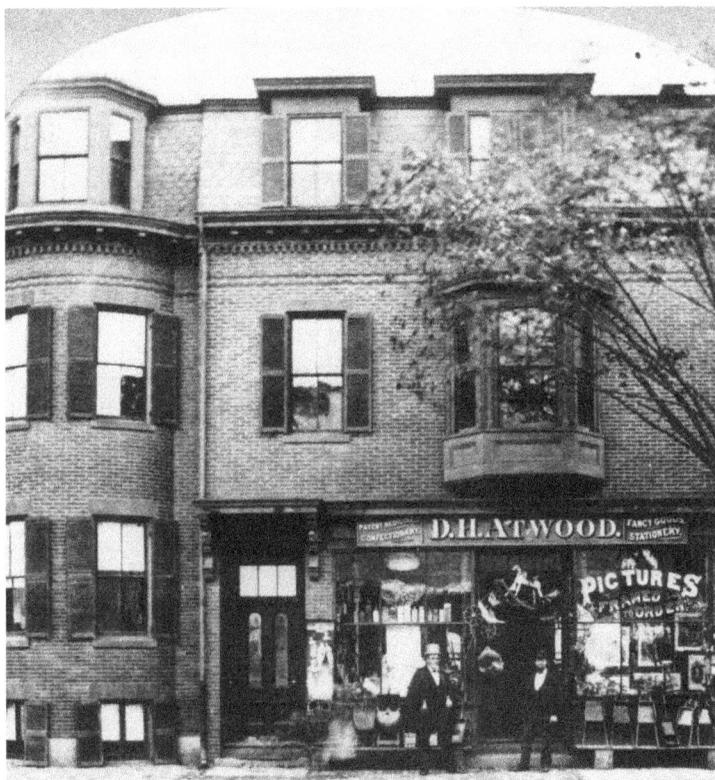

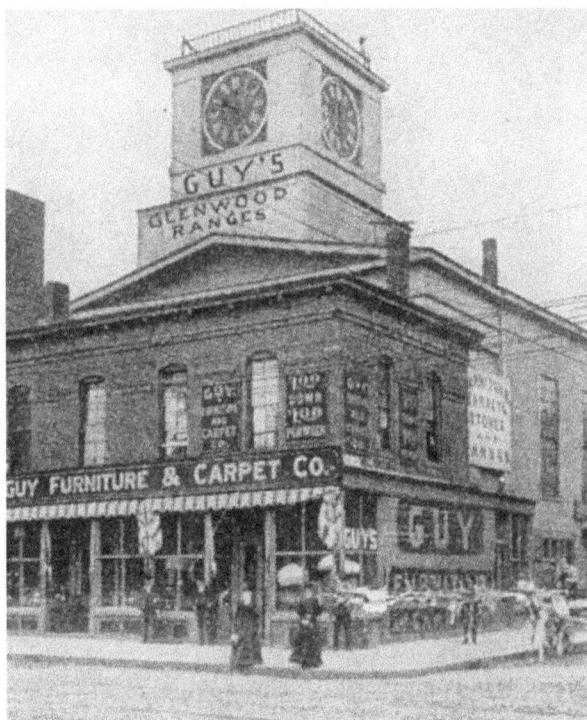

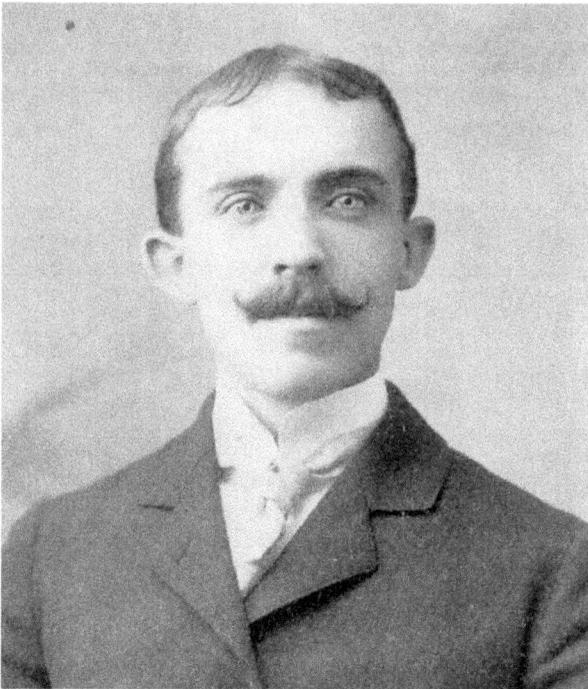

Located above the Chelsea Trust Company building was the dental office of Robert I. Davis. The 22-year-old Harvard graduate and son of School Superintendent Eben H. Davis set up his practice in 1896. He lived with his family in the elegant Italianate-style home at the corner of Washington Avenue and Carmel Street.

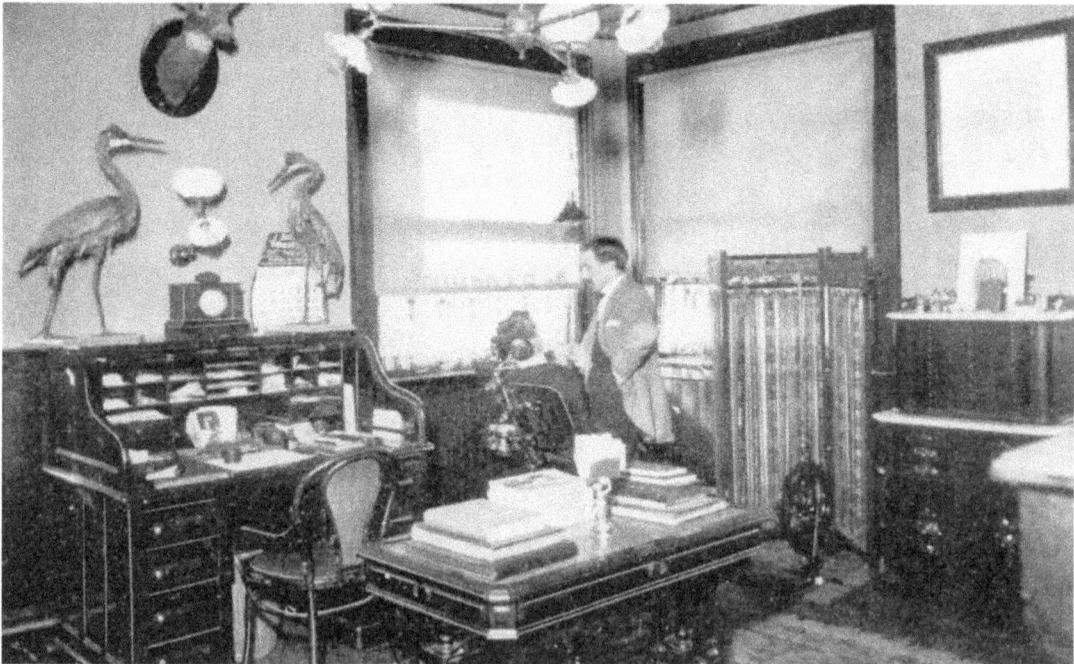

Dr. Davis' office of 100 years ago, with its stuffed animal trophies and mahogany furniture, bears little resemblance to any medical facilities of today. Dentists were often called upon for minor surgery such as removing corns and tonsils. In front of the folding screen is what appears to be a foot-powered drill.

William C. Cutler, M.D., was a homeopathic physician with a home and office at 10 Everett Avenue, just off Broadway. He was intensely interested in disease prevention and had a large laboratory in which he developed of a number of vaccines. He also established a fruit plantation in Cutler, Florida; the southern city was named for him.

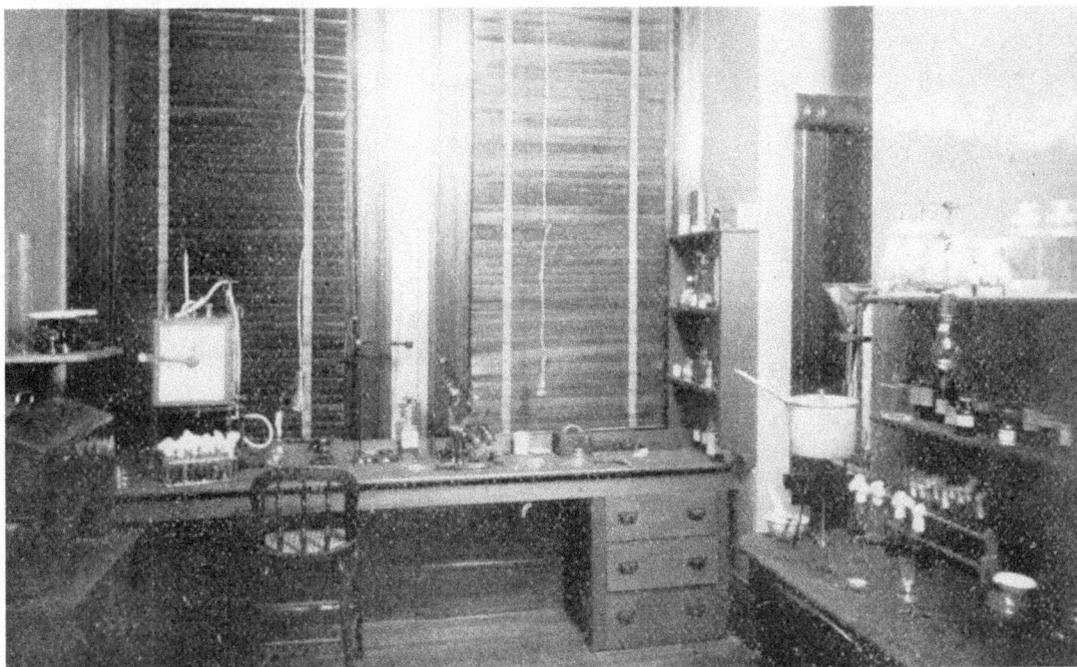

A vaccine to protect against smallpox was produced in Dr. Cutler's laboratory at the New England Vaccine Company. By the 1890s, before entering school, children had to be inoculated against this "Contagious and Mortal Disease." Dr. Cutler's company was one of the few of its kind in the country and his vaccines were used throughout the world.

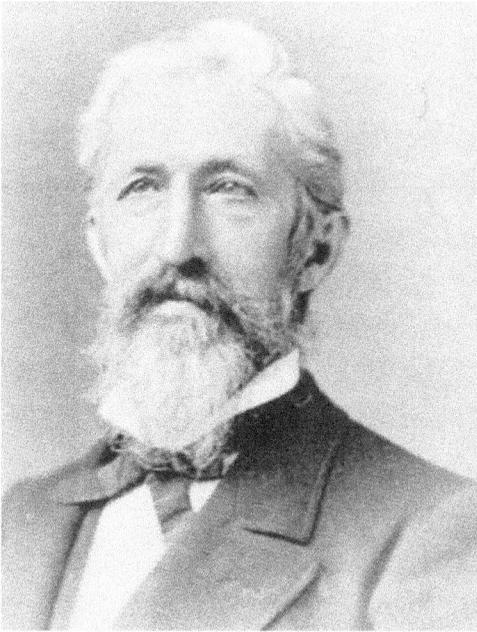

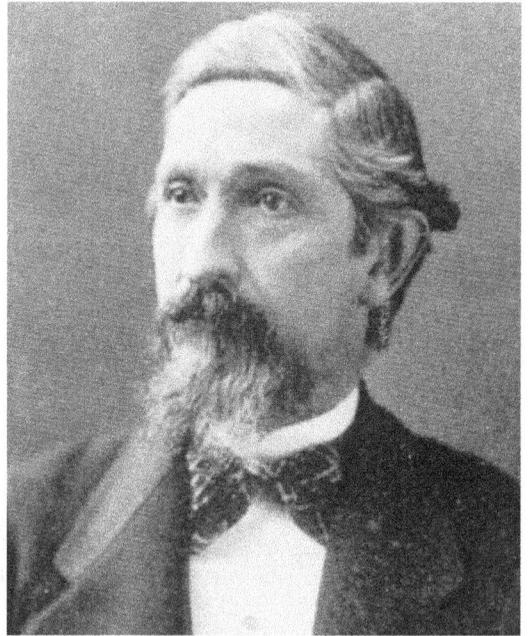

David and Levi Slade owned and operated the tide water mill that had been built along Mill Creek by Thomas Pratt in 1735. One of the mill's early offerings was snuff, a popular tobacco product. The brothers eventually began grinding and selling spices at their grocery store at 281–283 Broadway, near Fifth Street. They were one of the largest importers and distributors of spices in the country. The old Slade Mill is still standing today along Mill Creek in Revere.

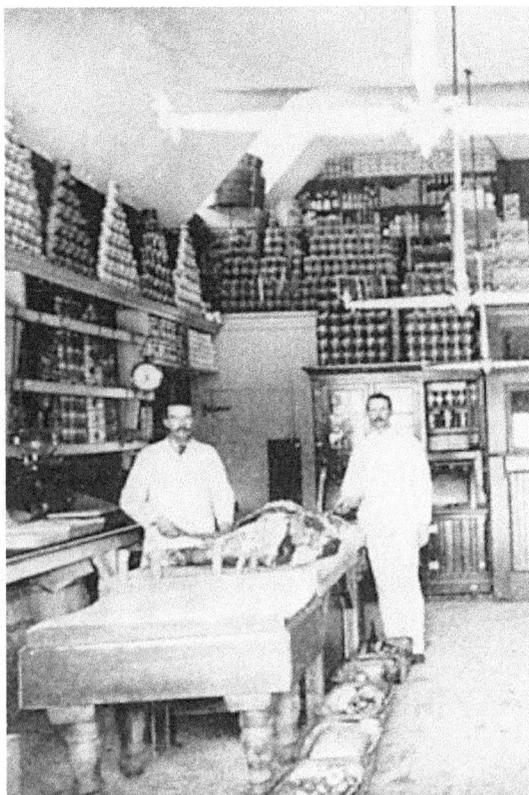

W. R. BENNETT,

DEALER IN

PROVISIONS AND GROCERIES,

TEAS, COFFEES and FLOUR.

No. 803 Broadway, - - cor. Eleanor Street,

CHELSEA, MASS.

At the other end of Broadway, hard-working W.B.Bennett, just 22 years of age, went into business for himself. With $365 he had saved from working in a grocery store, he purchased the old Grace Chapel at the corner of Eleanor Street, remodeled it, and opened it in 1888. Still in operation as a corner market, it is one of Chelsea's long-running establishments.

CHAS. E. CLARK & CO.,

DEALERS IN

CROCKERY,

CHINA, GLASS, PLATED WARE,

AND

TABLE CUTLERY,

Paper-Hangings, Window-Shades, Canvas
Carpets, Wooden Ware, and House-
Furnishing Goods,

Granite Block,

Broadway, - - - - Chelsea, Mass.

This 1874 advertisement is for one of the many stores that were located in the
Granite Block, an important commercial establishment along Broadway.

In the 1890s, John H. Wilkinson was the largest real estate owner and taxpayer in Chelsea. He was a self-made man who left his home in North Berwick, Maine, in 1829, when he was just ten years old. He came to Chelsea in 1845 and contributed a great deal to the city during his lifetime.

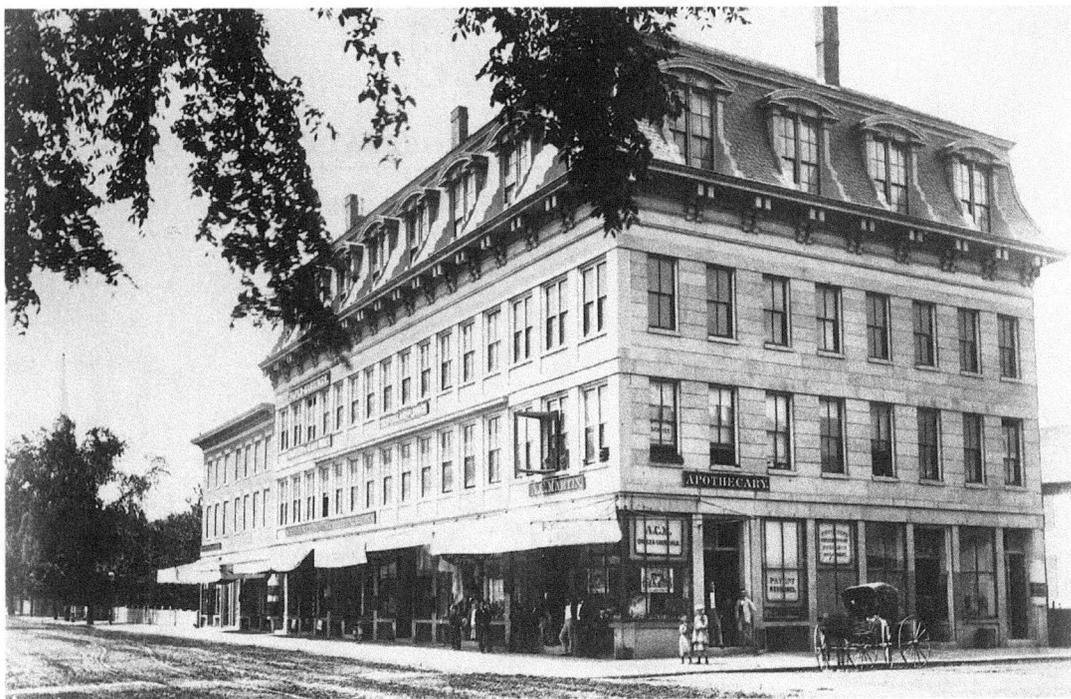

This enormous structure, called the Granite Block, was originally located at Washington and Court Streets in Boston. Formerly known as the Sears Building, Mr. Wilkinson purchased it in 1868, and had it moved to the corner of Broadway and Fourth Street. It housed a number of local businesses, but was so badly damaged by the 1908 fire that it had to be dynamited. A parking lot is currently on the site. (Courtesy of SPNEA.)

ICE CREAM

FOR

Parties, Weddings, Receptions, Etc.,

CALL AT

Babson's

CHOCOLATES
AND
BON BONS

282
BROADWAY

CHELSEA

Telephone 149-2. WHOLESALE and RETAIL.

A treat following an afternoon of shopping might have been a stop at Babson's for ice cream and "bon bons."

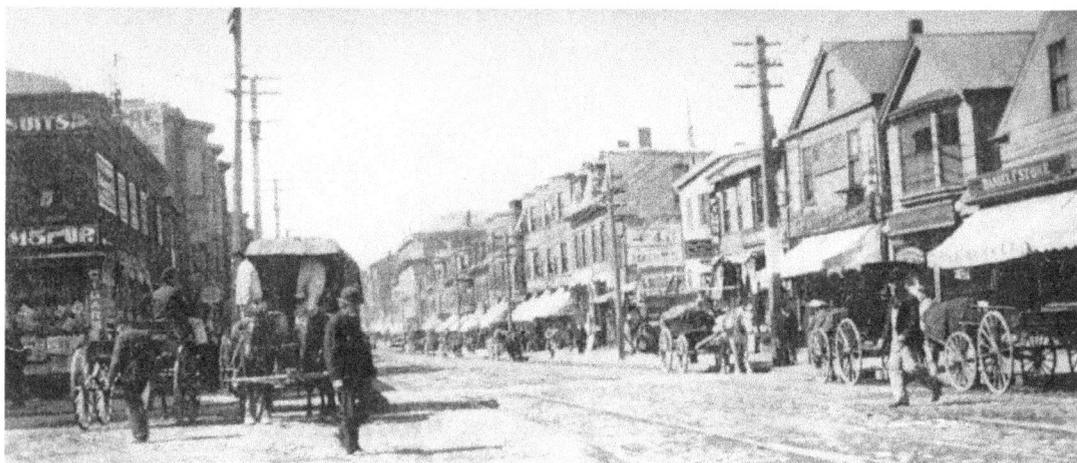

This view was taken from Bellingham Square, looking down Broadway toward the Granite Block on Fourth Street, *c.* 1900. On the left is the intersection of Hawthorn Street where the drugstore and clock now stand. The wood frame buildings on the right were originally built as private homes. In 1843, lots were sold in Bellingham Square for 5¢ a foot "for the sake of making a beginning in that direction."

At the far left is the corner of Fifth Street and Washington Avenue at the turn of the century. In the 1840s a favorite place for berry picking was on Blackberry Hill, a knoll down Fifth at Ash Street. When the first public school was built on Washington Avenue and Chestnut Street in the 1930s, it was considered a long way from the center of town.(Courtesy of the BPL.)

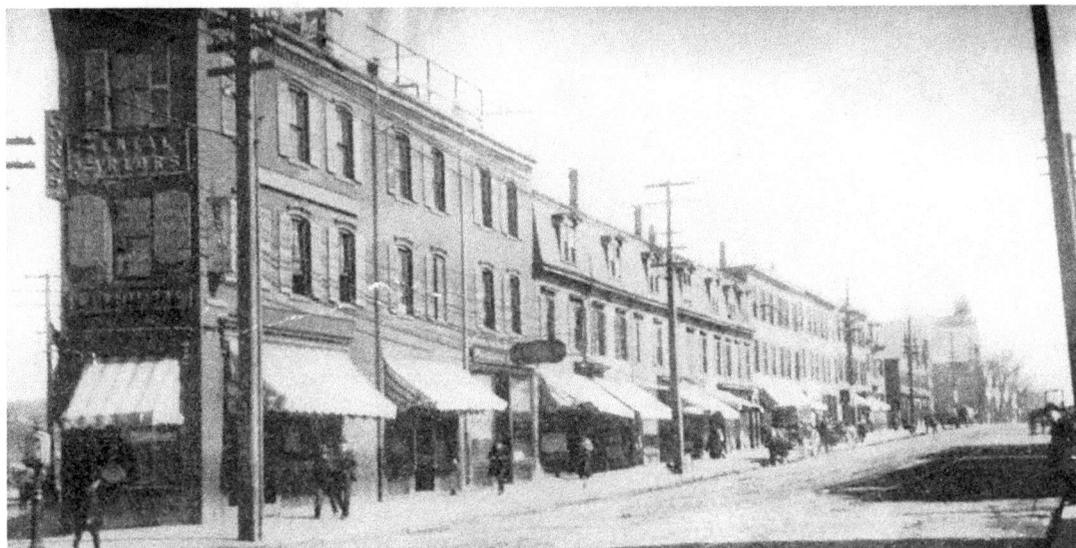

The "Dental Parlors" and the adjoining buildings shown here were in Bellingham Square, the triangular site currently occupied by the city hall. St. Rose Church is barely visible at the far end of the block. This area was leveled in the 1908 fire and the current city hall, replacing the one that burned down on Central Avenue, was erected in the new center of the city.

This huge structure, with its crenelated towers and fortress-like appearance, was the Armory at Broadway and Armory Street (later City Hall Avenue). No sooner was it completed than it was destroyed by the fire. This is the one that was rebuilt in 1910. St. Rose Church is at the far right.

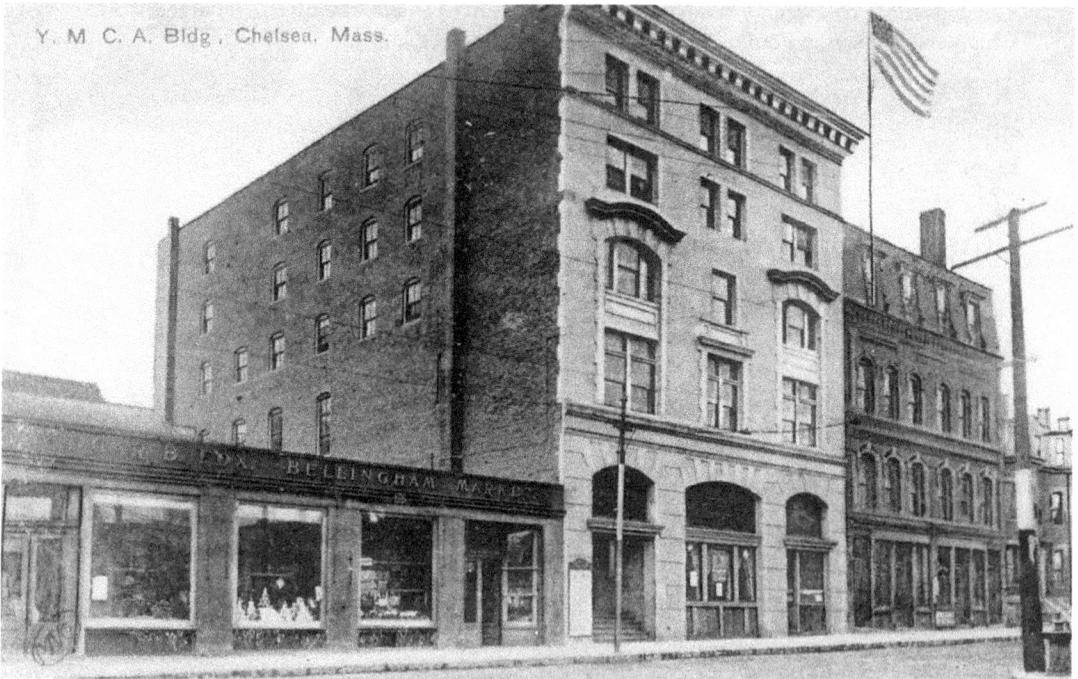

The YMCA occupied the Masonic Building at 270 Broadway, near the corner of Third Street. The building also appears in the earlier photograph of the Chelsea Trust Company.

four
Street
Scenes

Benjamin P. Shillaber was a well-known humorist and writer whose advice columns appeared in the *Boston Post* newspaper under the pen name "Mrs. Partington." He also wrote for the *Saturday Evening Gazette* and the *Carpet-Bag*, authored a number of books, and was often in demand as a speaker at local events.

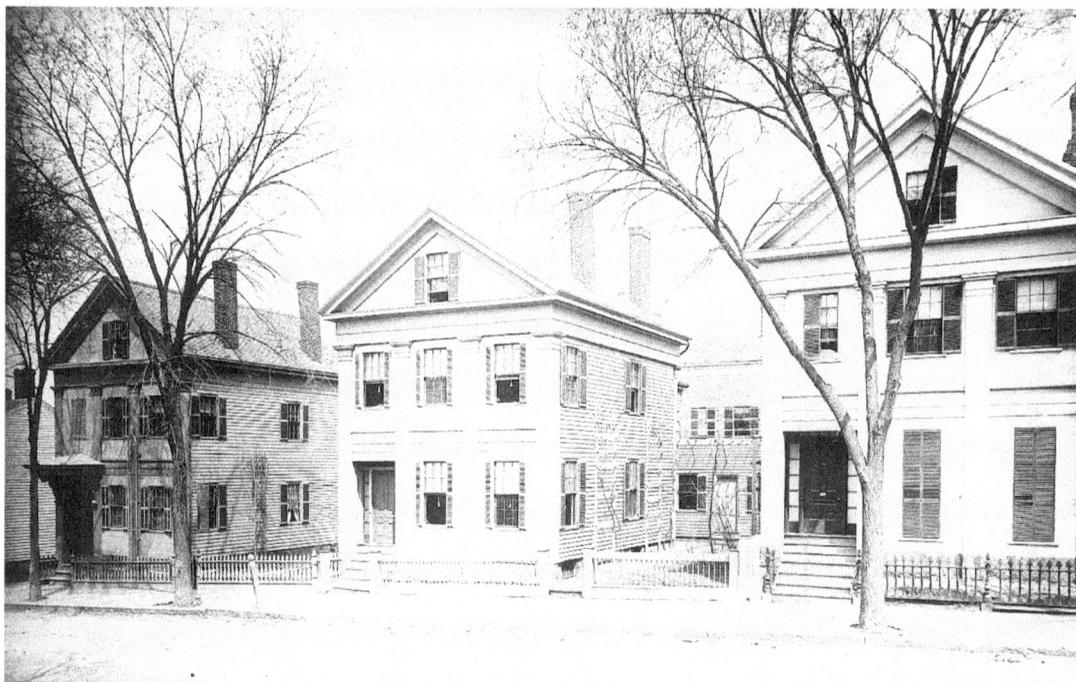

Mr. Shillaber lived at 121 Williams Street, the home in the center of the photograph, *c.* 1880. Although these homes between Walnut and Ash Street are no longer standing, there remain three very similar houses across from this site. The Greek Revival style was very popular; many such homes were built in Chelsea between the 1840s and 1860s. (Courtesy of SPNEA.)

Thomas Strahan was born in Scotland in 1847, and began his wallpaper career in Boston in 1868. Along with owning and managing one of the best wallpaper firms in the country, he had two successful terms as mayor, was chairman of the school committee, an active supporter of the temperance movement, and trustee of the Chelsea Savings Bank and the Fitz Library.

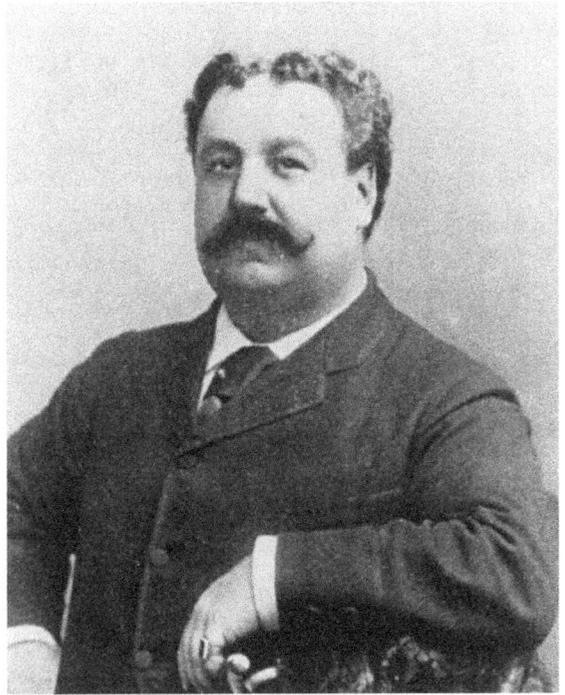

A remarkable and picturesque home, with towers, stickwork, and decorative friezes, was built for Mr. Strahan *c.* 1890. It was just over the crest of Bellingham Street, as the hill slopes down toward Willow Street. All its beautiful furnishings and treasures, collected during the Strahans' world travels, were lost in the fire of 1908.

This outstanding double bay Mansard-roofed residence with side porch, *c.* 1880, was the home of Charles Severance. Early atlases indicate that it was on the corner of Franklin Avenue, just as it turns up from Washington Avenue. A similar house on the site today may incorporate part of this building. The carriage house is at the rear.

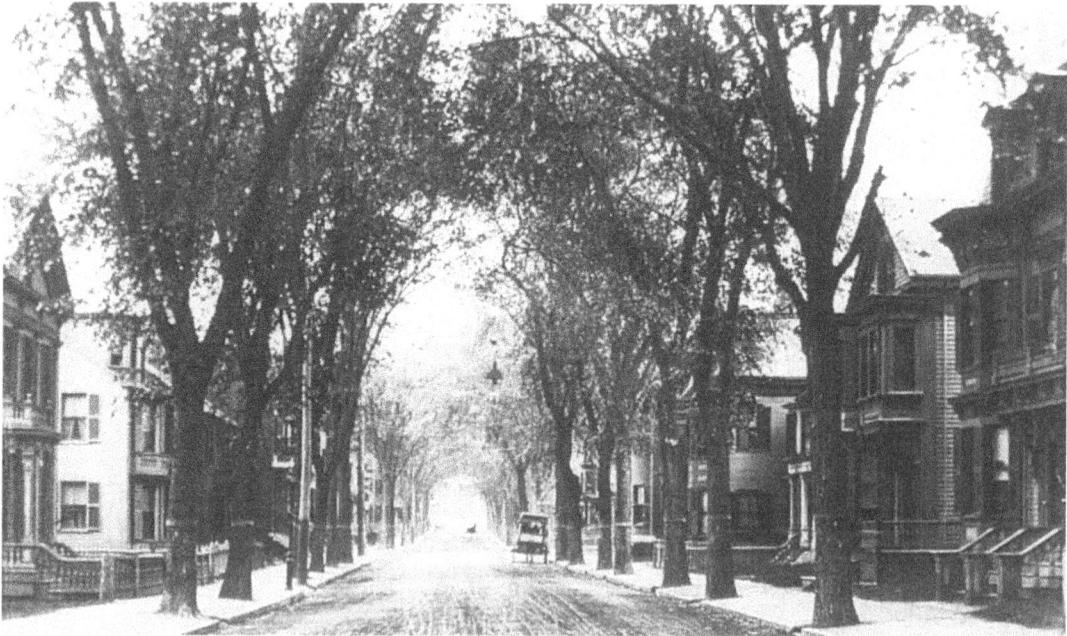

Shurtleff Street was a lovely residential area, lined with wood frame houses under a canopy of tall trees. This view appears to have been taken from the intersection of Shurtleff Street and Central Avenue, looking toward Broadway. At the end of the street would have been the new Armory at the corner of City Hall Avenue.

The Grand Junction Railroad crossed Everett Avenue in 1849. This sealed its fate as primarily a commercial thoroughfare, eliminating earlier suggestions to make the street a wide residential avenue. The Rogers Shoe Company occupied the building along the tracks at the left. The Massachusetts General Hospital is currently at the right, where the brick row houses are in the photograph.

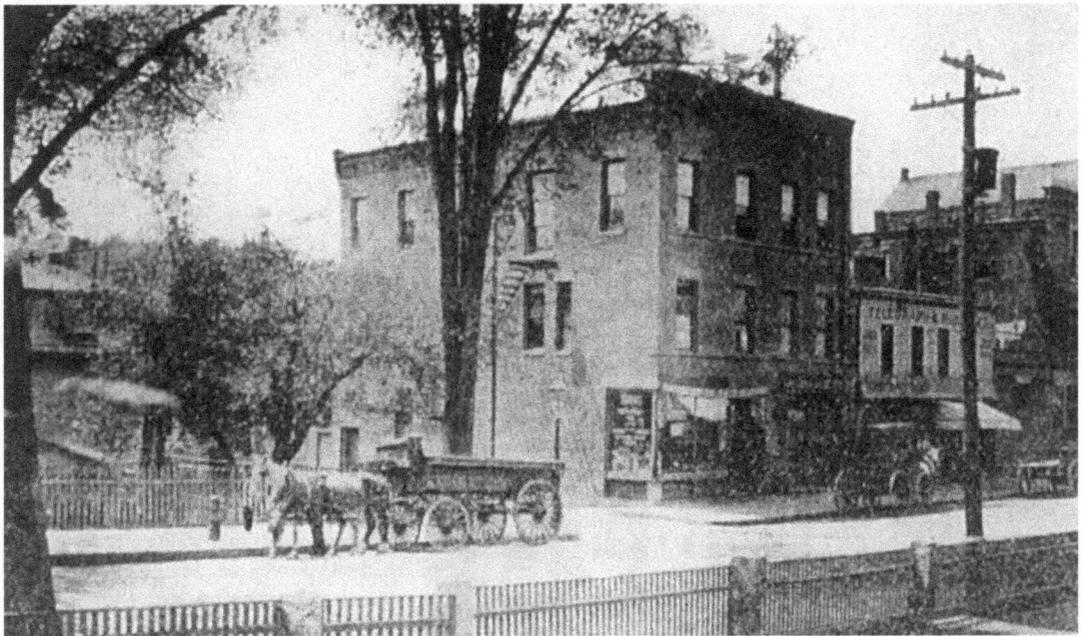

The small building at the right in this *c.* 1900 photograph of Fourth Street was the office of the *Telegraph and Pioneer Newspaper*, which moved from the flatiron building in Chelsea Square at the end of the century. The office at 18 Fourth Street was also the home of the *Chelsea Record* for many years.

Photographed in the 1880s, this appears to be one of the Greek Revival-style homes that was constructed along Marginal Street to take advantage of the scenic waterfront. Built in the 1840s, the house exhibits especially handsome Ionic columns, ironwork porch rails, trellises, and fencing. It is very likely there were lilacs blooming in the yard. Note the vine-covered arched doorway along the side of the house. (Courtesy of the CPL.)

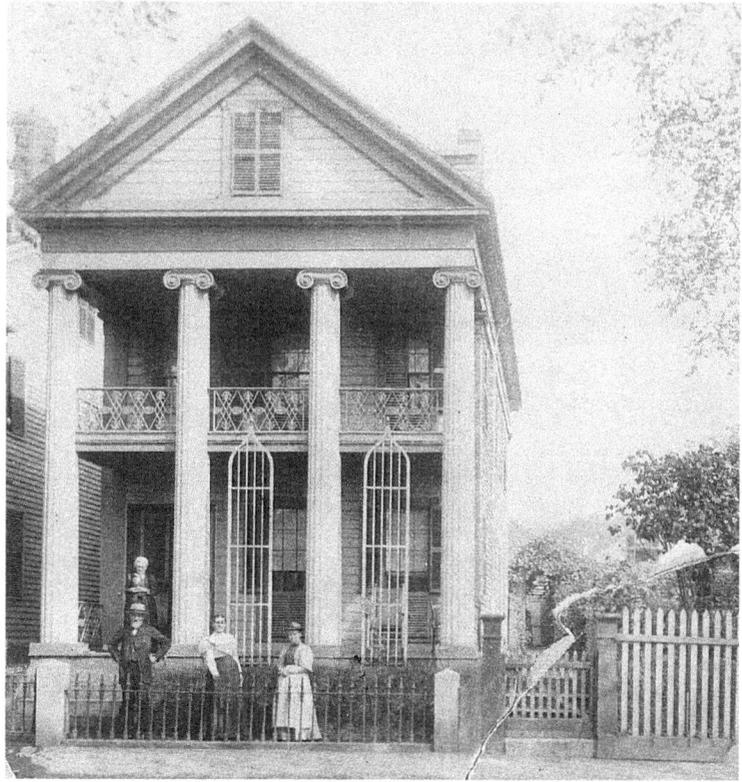

By the time this photograph was taken in the early 20th century, industry had moved into Marginal Street. Factories, with their noise and soot, had taken over the area, trapping the elegant little mansions. Much altered, this home near the corner of Shurtleff Street still exists, as do the double row of stairs to the right. The house that they led up to has been demolished. (Courtesy of SPNEA.)

The Chelsea Depot was situated along the railroad tracks just under the bridge on Washington Avenue. It survived the 1908 fire because it had been relocated from one side of the tracks to the other, and was on the site until very recently. These heated waiting rooms, with refreshments and newspapers, made train travel a pleasant experience.

The city's watering cart, supervised by City Engineer Mr. C.H. Black on horseback, is wetting down the streets to keep the dust under control, *c.* 1882. The flags make it appear that it is a holiday of some kind. The cart has stopped between two large Greek Revival double houses on Grove Street. A few of these classic houses still exist in Chelsea, including one in Chelsea Square near the police station. (Courtesy of the CPL.)

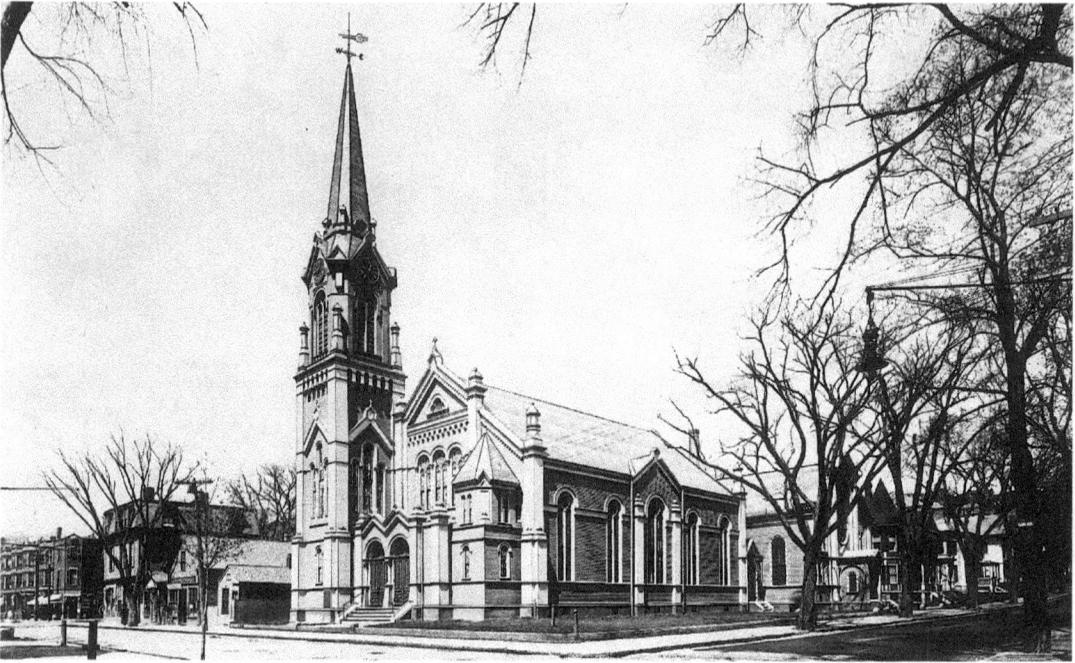

This nice early-20th-century view from the intersection of Cary Avenue and Tudor Street includes some buildings at the corner of Garland Street that no longer exist. The ornate Cary Avenue Baptist Church was later the First Methodist Episcopal Church, and is currently Temple Emmanuel. At present the steeple has been removed and much of the original detail is missing. (Courtesy of SPNEA.)

With its welcoming ivy-covered front porch, this neat little house sat at the corner of Cary Avenue and Tudor Street. It is typical of late-19th-century middle-class suburban homes built in the area. In the early 20th century, it was demolished to make room for the Christian Science Church. The Baptist/Methodist church is to the left. (Courtesy of SPNEA.)

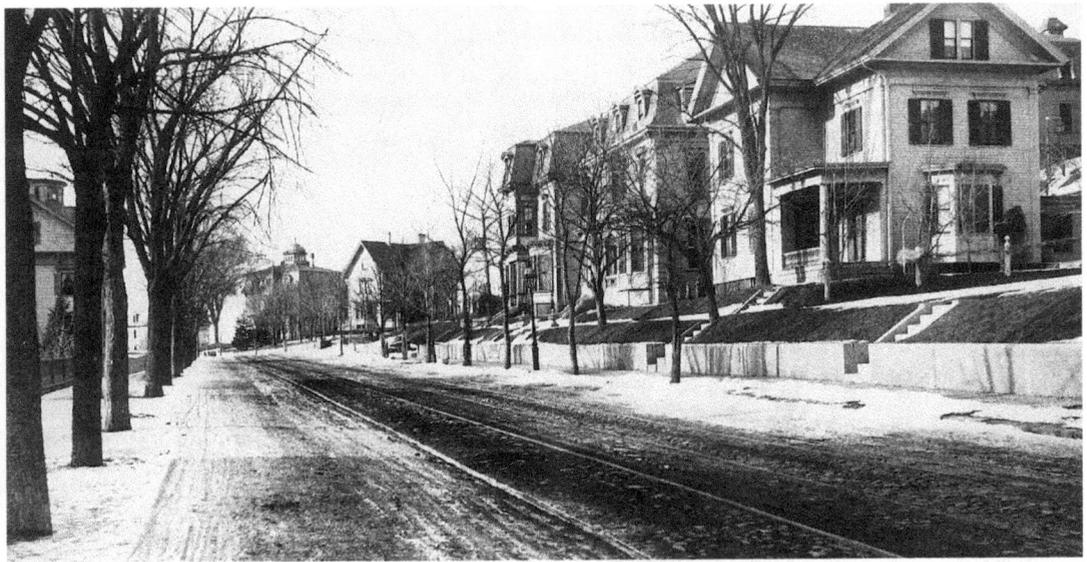

The homes of Levi Slade and Mellen Chamberlain can be seen in the distance in this view looking up Washington Avenue, c. 1885. Development began here about 1870, as the city's prominent families looked for a quieter place to build their large homes, away from the more densely populated downtown. The hills were always favored for the more substantial residences. (Courtesy of SPNEA.)

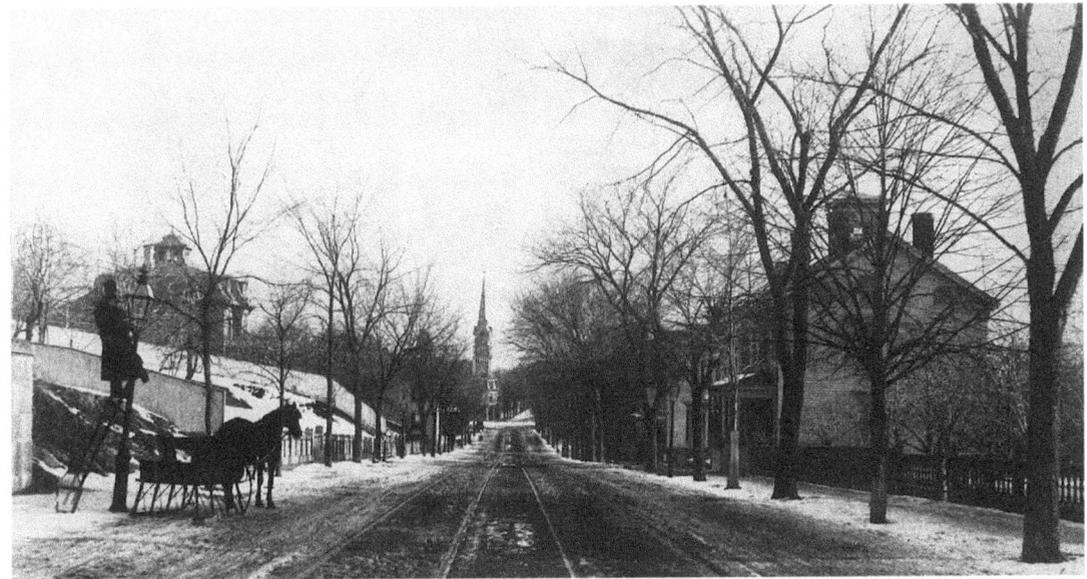

This photograph appears to have been taken at the close of a winter's day, as the lamplighter made his rounds to light the gas lamps along Washington Avenue. The Cary Avenue Methodist Church is at the center in this view looking toward Cary Square. Most of these homes and their stone walls survive today; the lamplighter, cobblestones, and trolley tracks are no more. (Courtesy of SPNEA.)

The County Road residence of Mayor John C. Loud was a handsome Queen Anne-style dwelling, with a front veranda, side porches, and a corner tower. Somewhat altered over the past 100 years, it nevertheless remains one of the city's architecturally significant homes. Mayor Loud held office in 1896 and also owned a large baking company at 449 Broadway.

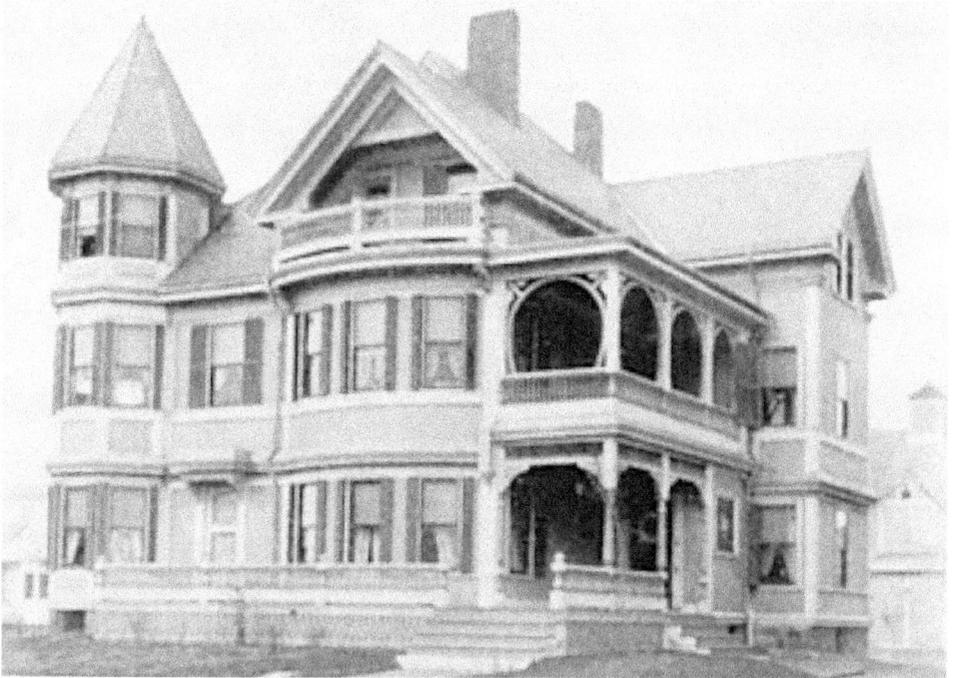

The nicely detailed Second Empire-style home of Mr. C.A. Campbell, local coal and shipping magnate, was at the corner of Washington Avenue and County Road. It featured a centered wing and a delicate crown of fancy iron work. The house is no longer standing; its vacant lot overlooks the expressway to Boston. The houses on either side still exist. (Courtesy of the CPL.)

Mr. C. Henry Kimball made his fortune by developing a heated rail car in 1885 that kept potatoes fresh while being transported. He later founded a number of successful stock companies, and was instrumental in organizing an early electrical power company. Like many other local businessmen, he came to Chelsea as a child and developed a real devotion to the city. His house on Washington Avenue is the ultimate expression of the Queen Anne-style home. Built *c.* 1890, it was embellished with every delightful detail the craftsman could imagine—patterned brickwork, stained glass, a slate roofed tower—a just reward for the successful Mr. Kimball. It survives intact today, right down to the round windows in its adjacent carriage house.

To take advantage of the cool breezes and the spectacular views of Boston, the islands, and the countryside from Bellingham Hill, this delightful observatory was built *c.* 1850. The wooden Gothic tower, 40 feet high, was commissioned by residents of the hill. Opening ceremonies included "soul-stirring music" by the Chelsea Brass Band, after which "The liberal-hearted gentlemen in the vicinity opened their houses, and provided a bountiful repast for all." Some of Chelsea's finest residences were built here, away from the noise and bustle of the downtown.

Although the location of this 1890 photograph is not identified, the sign on the office reads, "Washington Ave to Chelsea Ferry 2 mi." This was most likely one of the depots at Washington Avenue and Webster Street, which later became the Revere Beach Parkway. These "express companies" were the UPS and Federal Express of their day. (Courtesy of SPNEA.)

This 1910 photograph is identified as "the last blacksmith shop in Chelsea," owned by John A. Stiles and located on Sagamore Avenue. With the advent of the automobile, this centuries old trade began to die out. Horses played a major role in transportation until replaced by the motor car. (Courtesy of the BA.)

This c. 1890 photograph was taken from Washington Avenue at Hancock Street, facing the Parkway. Silhouetted against the sky are two of the houses on County Road. You can almost feel the heat of the summer day as the sign "Cool Drinks" beckons from across the street. There is currently a coffee shop and restaurant on the site; the house at the right on Hancock Street is still there. (Courtesy of SPNEA.)

The home of Caleb Pratt IV was built in 1847 on Franklin Street. Notice the familiar cupola that was so popular during this period. In 1897, it was moved back and turned to face Nichols Street, and a new house for Hermon Pratt was built on the site. This house is no longer standing but in the yard remain three old trees, most likely planted by the family many years ago. (Courtesy of the CPL.)

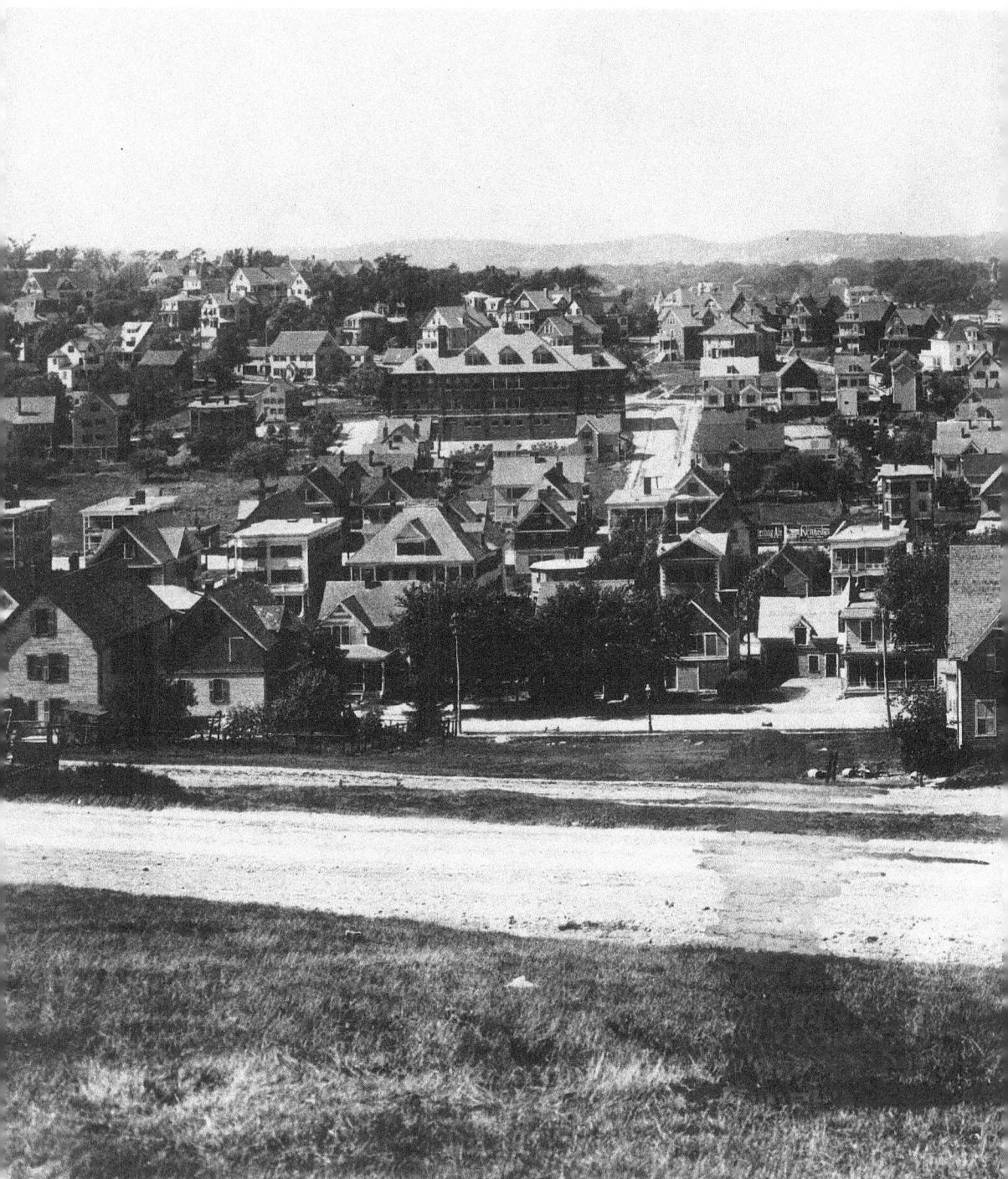

This extraordinary panoramic view of Prattville appears to have been taken from Powderhorn Hill
c. 1905. The rear of the Prattville School on Washington Avenue is on the left, between Murray Street
and Ingleside Avenue. Lambert Avenue is in the center while Garfield Street runs along to the right.
Most of the homes pictured still exist. With a magnifying glass it is possible to decipher the old Pratt

Farmhouse in a cluster of trees in the right third of the image; it is off Washington Avenue, across from Kimball Road. At one time much of this area was part of the 200-acre Pratt Farm. The hills of Revere in the distance are quite sparsely settled. (Courtesy of SPNEA.)

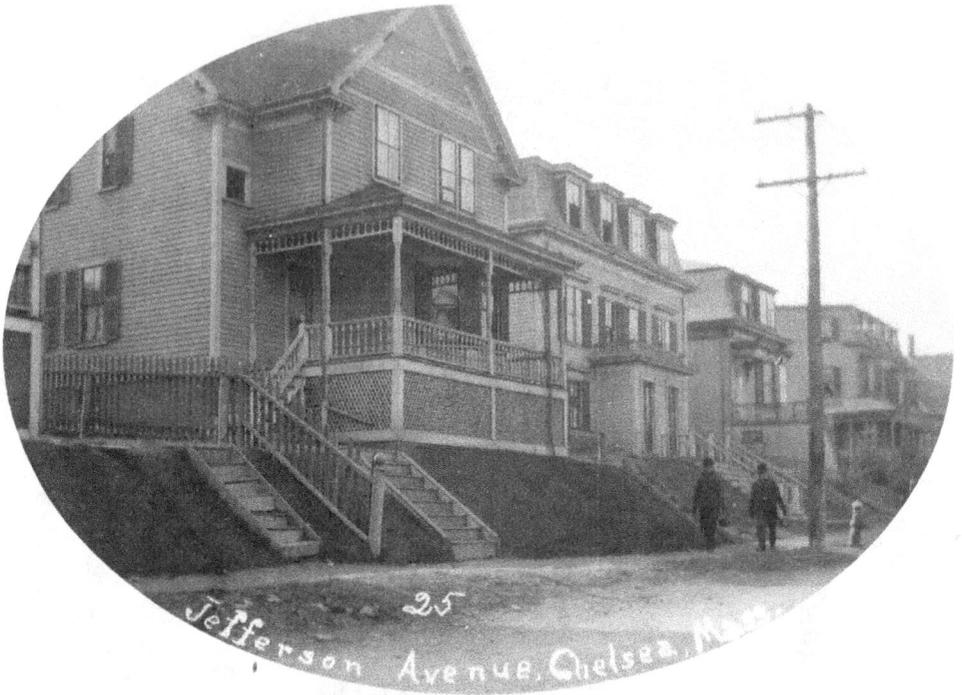

It was possible to have postcards made of one's own house, as "Aunty & Uncle 'Syd' " did in this signed, but undated postcard. The message on it reads, "We still live in the same place." The house at 25 Jefferson Avenue is still there.

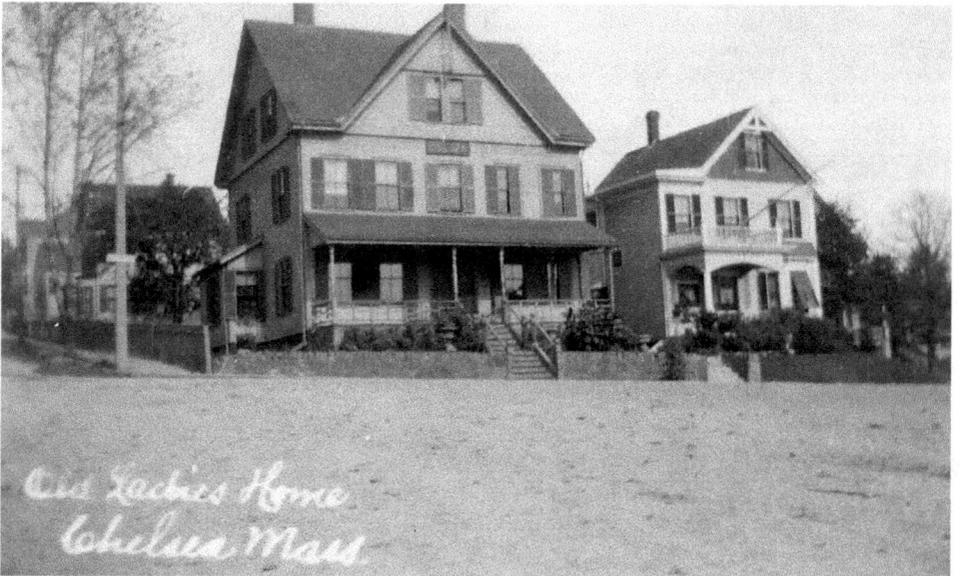

Another postcard/photo shows "The Old Ladies' Home" (as the sign said over the door) on Nichols Street overlooking Washington Park. The home was provided by a bequest to the city and opened in January of 1887. It had accommodations for about 10 women, who could live out their years in quiet dignity.

In this turn-of-the-century view are some of the nicely detailed homes along Gardner Street, looking toward Cary Avenue from the corner of Parker Street. Remodeling over the years has somewhat changed their original appearance.

Harvard Street in Prattville also boasted some handsome architecture. These homes were built *c.* 1900, somewhat later than the homes at the top of the page on Gardner Street. The larger and more elaborate Colonial Revival style featured expansive porches, Palladian windows, and lighter paint schemes.

This panorama of the April 12, 1908 fire shows some of the incredible devastation that took place. At the far left are the ruins of St. Rose Church and school. To its right are the remains of the recently completed Armory on Broadway and City Hall Avenue. In the distance behind the church and school is what was left of Bellingham Hill; it was virtually levelled. The road from the center of the picture to the right is Chestnut Street, heading toward Washington Avenue. The damage is almost incomprehensible.

At the left in this half of the photograph is the intersection of Chestnut Street and Washington Avenue. Of the four homes pictured in the center on Washington Avenue, three still exist. The tree-lined area of Union Park on Sixth Street survived the fire. At the far right is the small bracketed roof and cupola of the Chelsea Depot. Much of the oldest and most heavily populated part of the city was all but destroyed. (Courtesy of the Chelsea City Hall.)

Schools and
Churches

THE DAVIS SERIES OF READING-BOOKS.

THE

BEGINNER'S

READING-BOOK.

BY
EBEN H. DAVIS, A.M.,
SUPERINTENDENT OF SCHOOLS, CHELSEA, MASS.

ILLUSTRATED.

NEW YORK:
UNIVERSITY PUBLISHING COMPANY.

Although there is evidence that there was a school in Chelsea as early as 1790, the first recognized school was built about 1834 at the corner of Chestnut Street and Washington Avenue. Called the Village School, it began with 30 students, and was also used for church services on Sunday. Five years later, the Ferry District School was built on Park Street. The school committee was the overseer of the local schools until 1874, when Chelsea appointed its first superintendent. Eben H. Davis held that position during the 1880s. He wrote the four-volume-set *The Davis Series of Reading-Books*, teaching by what he called "the thought method." (Courtesy of the BPL.)

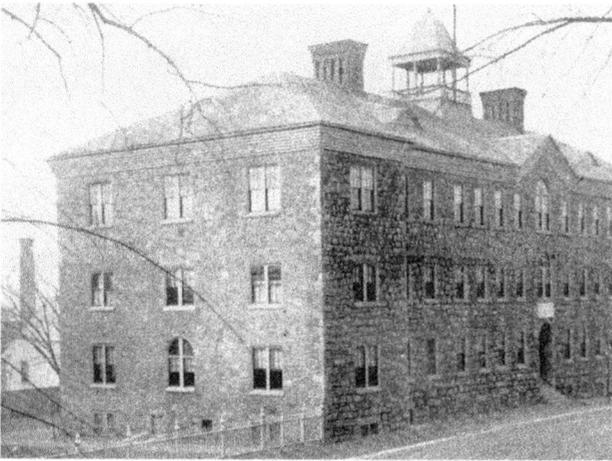

This enormous granite building was constructed in 1827 on Essex Street and originally served as the Marine Hospital. In the 1850s it was purchased and renovated by the city, becoming the first Shurtleff School. It was known briefly as the Hawthorn School or the Girls' Grammar School; for a time the boys were taught separately at the Williams School.

Quigley Park occupies the site of the first Shurtleff School. During the 1860s the schools began to be named for the farms that had once occupied the city (Bellingham, Carter, Cary, Shurtleff, and Williams). In the background is the old stable on Hawthorn Street that was recently renovated. The row of brick housing at the right, which is extant, was erected *c.* 1870.

Although the photograph is identified as "Carter School 1890" it is more likely the Shurtleff School, which was of the granite block construction visible in the background. Such serious little faces. Having their picture taken must have still been an uncommon experience for many. (Courtesy of the CPL.)

1894. SHURTLEFF SCHOOL. 1895.

Fourth Grade Room, 13

Report of Edith Fay

	Abs.	Tard.	Dept.	Read.	Lang.	Spell.	Sci.	Geog.	Hist.	Arith.	Draw.	Writ.	Parent's Signature.
Sept. Oct.			E	E	E	E	E	E		E	E	E	Chas E. Fay.
Nov. Dec.													
Jan. Feb.			E	E	E	E	E	E		E	E	E	Chas E. Fay.
Mar. Apr.			E	E	E	E	E	E		E	E	E	Chas E. Fay.
May June			E	E	E	G	E	E		E	E	E	Chas E. Fay

E signifies excellent ; G, good ; F, fair ; P, poor ; V P, very poor.
Pupils whose record is below Fair are not entitled to promotion.

Shurtleff School fourth-grader Edith Fay earned a report card of which she could be justly proud, nearly all E's. Congratulations, Edith!

This sixth-grade class posed in front of the Williams School building in 1894. By this time, class sizes were rather large, averaging 42 children per teacher. As the population of Chelsea increased, the more than 20 small primary schools that were scattered throughout the city were replaced by larger buildings that could hold more students. (Courtesy of the CPL.)

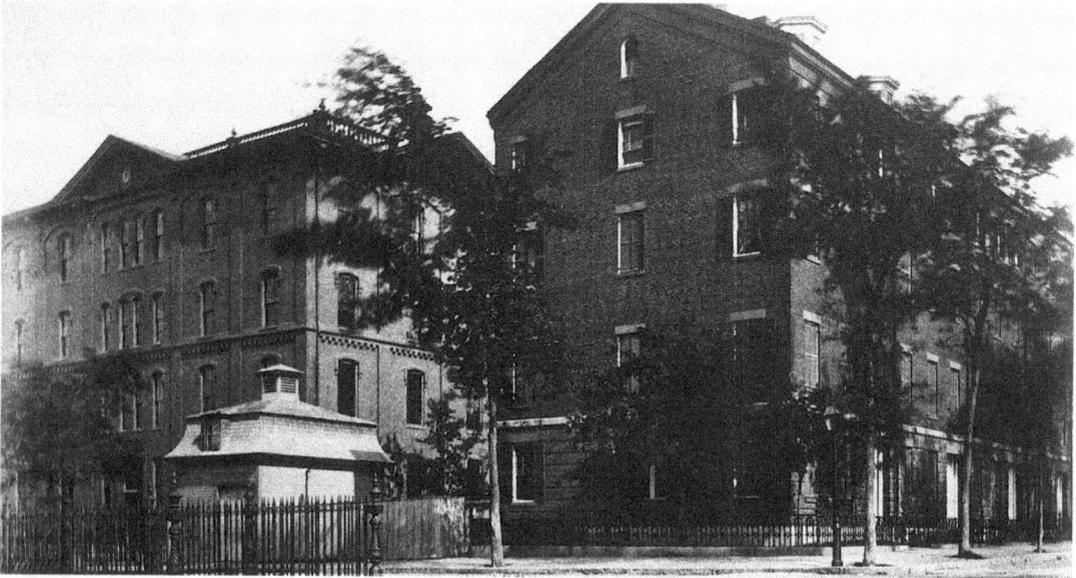

The Williams School, at the left in this rare *c.* 1870 photograph, was built in 1860 on Walnut Street, between Fourth and Fifth Streets. It was originally called the Boys' Grammar School and thought to be "palatial" by one student compared with the earlier buildings. An unfortunate victim of the 1908 fire, it was replaced by another school across the street from this one. The new complex is on the site of the second Williams School. (Courtesy of SPNEA.)

Could these possibly be junior high students of one hundred years ago? Nicely dressed and preserved by the camera in front of the Carter School in 1893, they were just a year or two away from attending high school. (Courtesy of the CPL.)

Built in 1868 on Forsyth Street, the Carter School kept one of the city's old one-room schoolhouses on its property, "The Old Skule House," built around 1845. Carter was a mixed school, i.e., used by both boys and girls. It was replaced in the 20th century by another of the same name, which burned down in 1970. The Carter Heights Apartment building is currently on the site. Much of the surrounding neighborhood remains the same. (Courtesy of SPNEA.)

The Highland School, at the corner of Cottage and Highland Streets, was designed by the architectural firm of Wilson & Webber *c.* 1890. The firm also designed the Prattville School. Nearby factory work brought more families to this area so a larger school was necessary to educate the neighborhood children.

The Bloomingdale Street School was built about 1880 to accommodate children in the old Carter Farm district. This area had been considered quite remote from Ferry Village, where most of the earlier schools were located. The building was just up from the corner of Carmel Street, where #106 and #110 Bloomingdale Street are today.

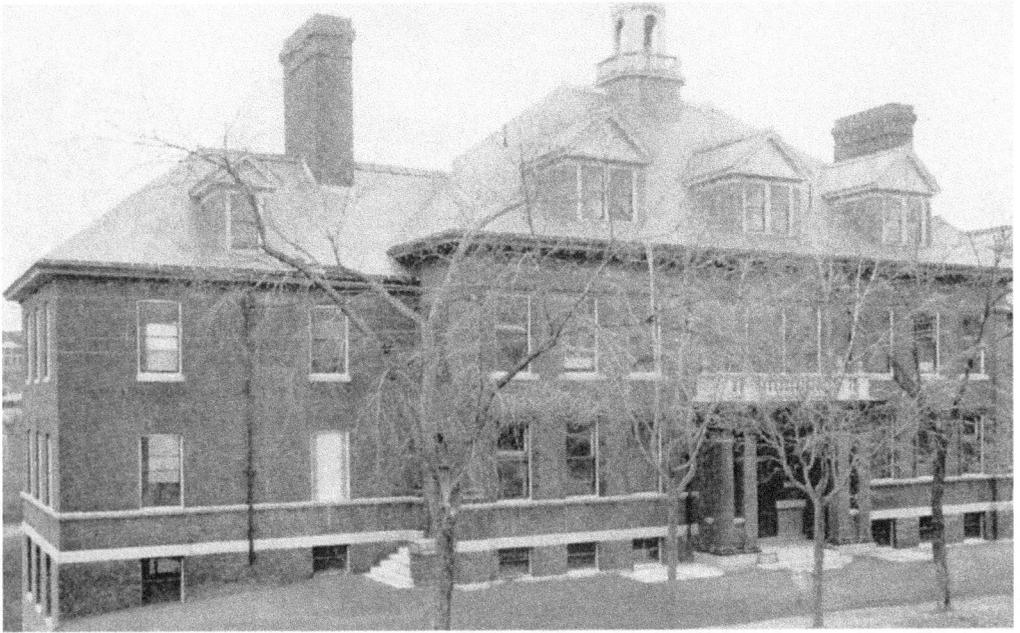

Built in 1897, the Prattville School on Washington Avenue is now vacant. The school remains an important part of the neighborhood, and significant as one of only two of Chelsea's schools that survive from the 19th century. Many cities have adapted vacant school buildings for new uses as community centers or condominiums.

Originally called the Spencer Avenue School, this building was renamed in 1937 for Mary C. Burke, a World War 1 Army nurse who died in 1918. Built in the early 1880s, it is an unusual example of English Tudor Revival architecture, with its timber, brick, and stucco exterior. Adapted for reuse and beautified with appropriate landscaping, it could be an outstanding focal point for the surrounding neighborhood.

Located at Walnut and Second Streets, the Cary School was the city's earliest high school. Eighteen students made up its first graduating class. When the new Bellingham High was completed in 1873, this building was enlarged and used as a grammar school. Simple and elegant, it was photographed c. 1870. On the site is a parking lot alongside the Tobin Bridge. (Courtesy of SPNEA.)

Left: Since the graduating class was rather small, each student participated in the high school graduation exercises in 1865 by reading an essay or poem. In his commemorative booklet, Abbot Bassett made a note next to the name of Helen Drew, the young woman who was to become his wife a few years later. Although he moved away, he kept track of his fellow students for some 50 years.

The Roman Catholic population in Chelsea grew significantly in the second half of the 19th century. Along with a school behind the church, St. Rose Parochial School held classes in this building on Spencer Avenue, near Stockton Street. It was later the French Naturalization Club.

Right: Graduating from grammar school was an important event in a child's life in 1889, celebrated at special exercises. For some, this was the end of any formal education they would have, as they often went to work to help support their families.

Cora Templeton

GRADUATING EXERCISES

OF THE

Chelsea Grammar Schools

JUNE 26TH, 1889.

The Bellingham Chelsea High School was dedicated on January 2, 1873. This stately building was located on Bellingham Street, across from Shawmut, and cost $68,000 to build. It was a source of pride to the city as it continued to care for increasingly large numbers of residents. There is fine architectural detail in both the school building and the neighboring homes. By 1904, the building could not accommodate the growing school population, so a new high school was constructed on Crescent Avenue. This building became the Bellingham Grammar School. The fire destroyed it in 1908. Bosson Park is currently on the site. (Courtesy of the CPL.)

This rare photograph of the teachers at the Bellingham High School was taken in 1893. In the event there are people who might remember them, they are identified as follows: (front row) Misses Wood and deRochemont; (back row) Mr. Bartlett, Principal Briggs, and Misses Winslow, Thyng, Keene, Allen, and Clement; (right side) Miss Biscoe, Mr. Gilley, and Miss Joslin. For many years, teaching was one of the few professions open to women, so there were always more female teachers than male.

High School Principal Alton Elliot Briggs came to Chelsea after teaching in Somerset, Lynn, and Nahant. A graduate of Dartmouth College, he was only 27 years old when he assumed leadership of Chelsea High School in 1891. He remained principal into the early 20th century and was very involved in the enormous task of rebuilding the city after the fire.

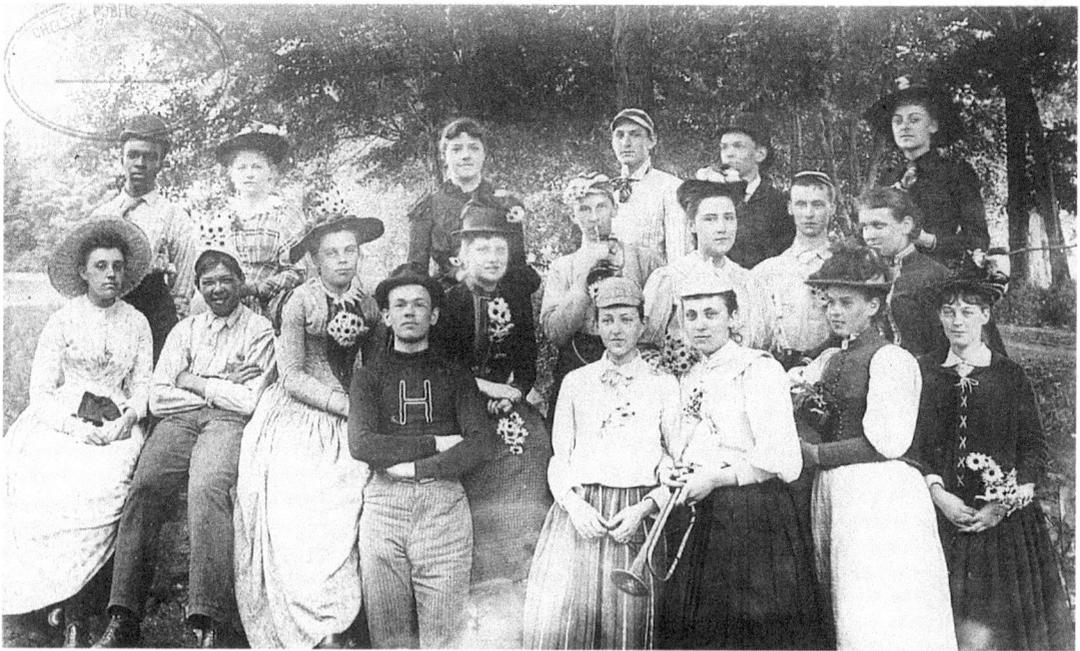

To complete the picture of local students, above is a group of high school students in the late 19th century. They appear to be enjoying a school holiday, decked out in sporty attire and fresh flowers. A few in the group have managed a smile as they near the end of their school life. (Courtesy of the CPL.)

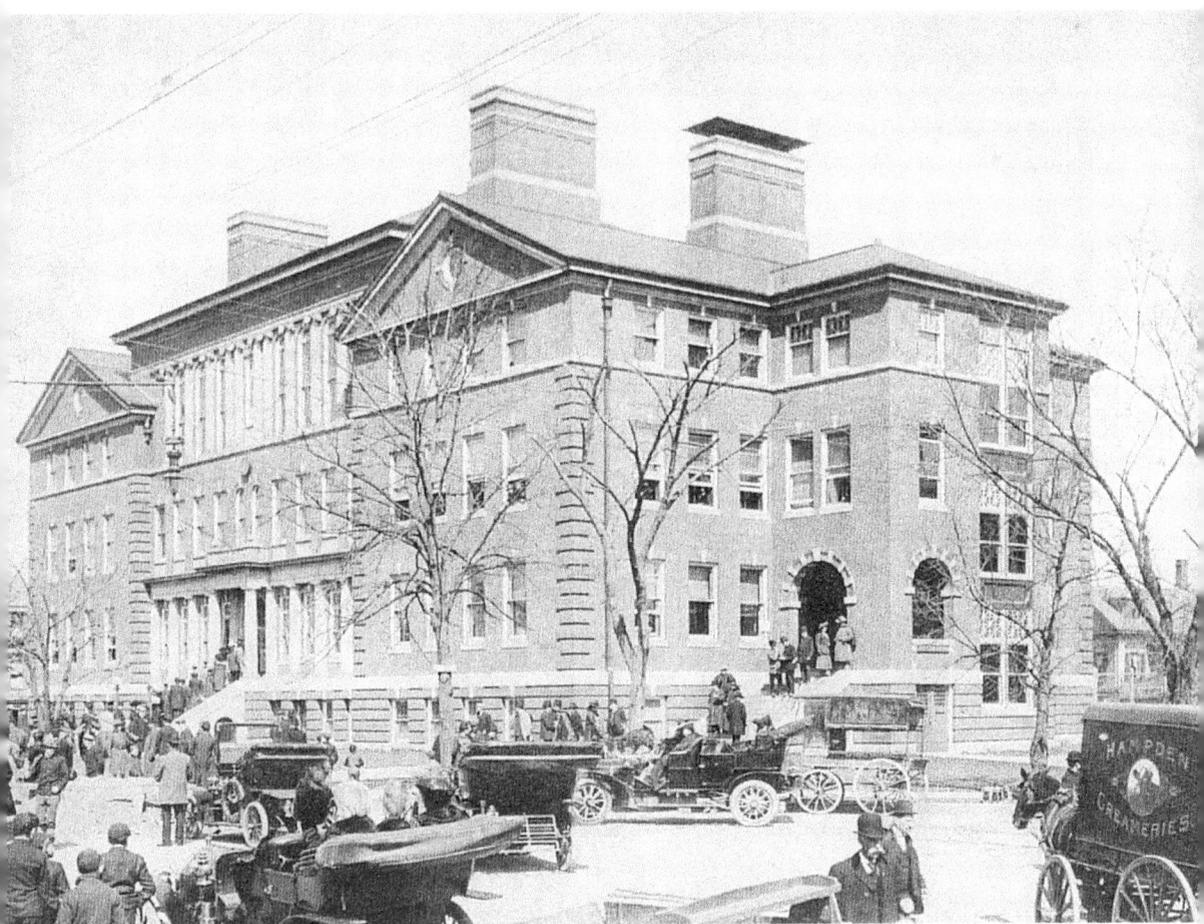

In 1904, Chelsea High School was designed by local architect Samuel E. Eisenberg, part of the continued expansion to larger schools. Before the 1924 addition to the building, entrance was through a central or side doorway at the front of the school. The building was used as the headquarters of the Central Relief Committee in the aftermath of the 1908 fire. Information bureaus were set up to collect names and addresses where families made homeless by the fire could be found, to process insurance claims, and to help people find a place to live. Clothing was distributed and there were meals for residents and the hundreds of volunteers who had come to the city's aid. For days there were long lines of people in and out of the building, trying to put their lives back in order. (Courtesy of the CPL.)

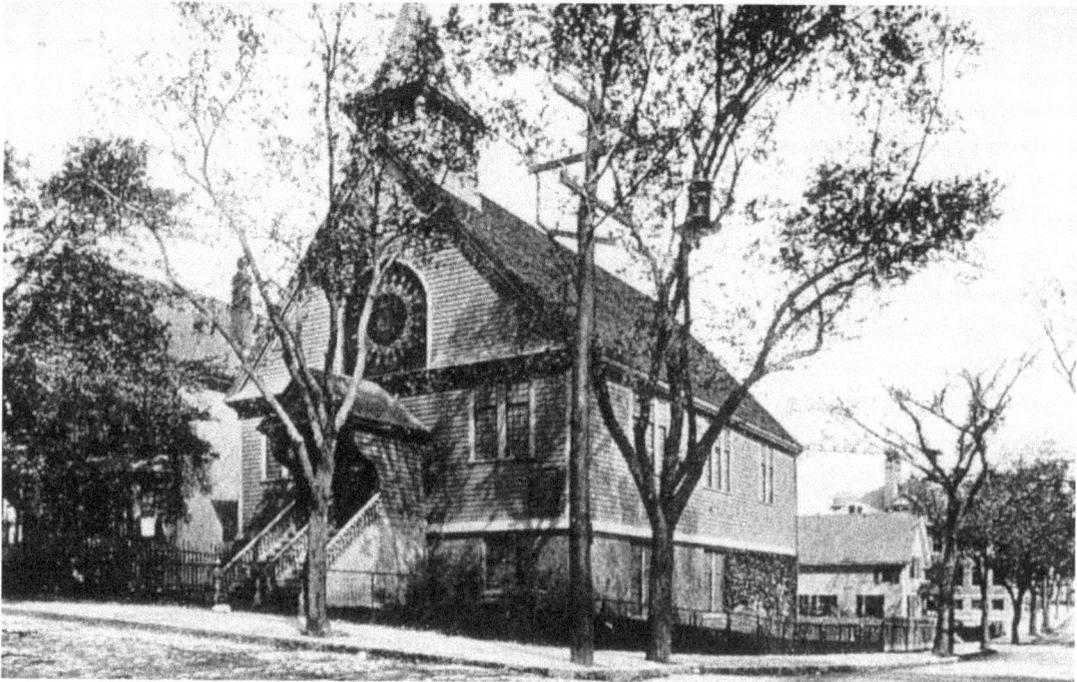

Opposite, above: This rare photograph by Boston photographer Josiah Hawes is of the First Baptist Church, built in 1837 on Broadway at Third Street. As Chelsea's first church, it was constructed when the city had a few dozen houses and a single school. The clock was installed in 1846 to provide the correct time for people wishing to catch the ferry. The site is now a vacant lot. (Courtesy of the BA.)

Opposite, below: Horace Memorial Hall was built in 1887 by local industrialist Thomas Martin in memory of his son Horace, who died at the age of 20. He later donated the hall to the Baptist Society. The church still stands today, surrounded by many of the same buildings seen in this 100-year-old photograph, including the Mary C. Burke School.

Right: The Universalist church was built in 1860 on Fourth Street, at the corner of Chestnut. Organized in the 1840s, it was the parish of many of the old families, including the Pratts, Fays, Gerrishes, and Lows. Further down Fourth Street is the steeple of the Walnut Street Methodist Church. (Courtesy of the CPL.)

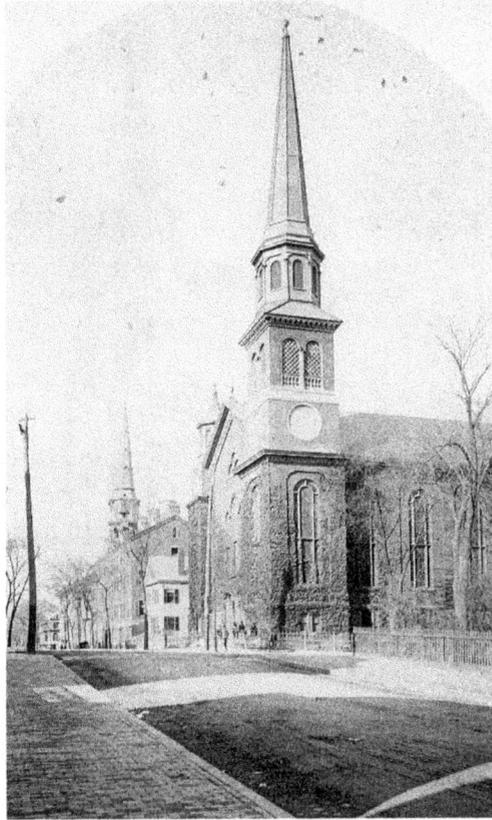

There was little left standing in the area after the 1908 fire. This is the view today at the location of the Universalist church, looking down Fourth Street from the intersection of Chestnut. The new Williams School is in the next block on Walnut Street.

77

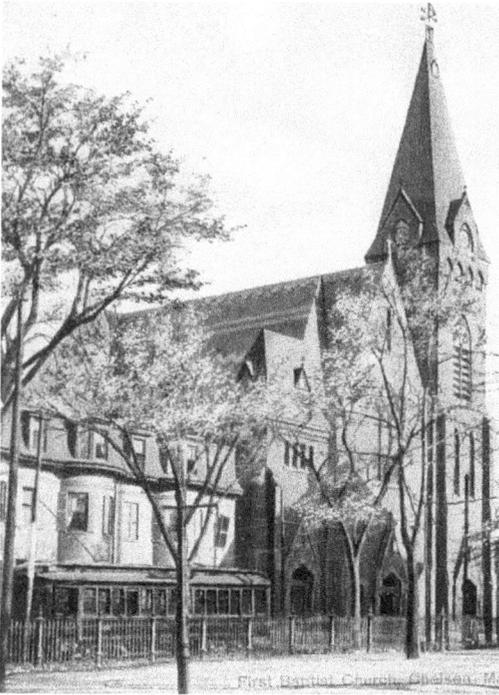
First Baptist Church, Chelsea

Left: In 1875, the First Baptist Church moved into this handsome building with a patterned slate roof on Central Avenue, at the corner of Shurtleff Street. Located across from the Chelsea City Hall, this had become a busy thoroughfare, as indicated by the row of apartments and the trolley car running along Central Avenue.

Opposite, above: This view of the interior of the Walnut Street Methodist Church reflects a simple serenity in its pale coloring, classical arches and recesses, and pairs of half-fluted columns.

Opposite, below: The beautifully carved altar of the Gothic-style First Baptist Church appears here, decorated in lavish Victorian fashion for a special event. Note the delicate stenciling that outlines the walls. Both of the Baptist churches were destroyed in the 1908 fire.

The Methodist congregation was founded in 1839, and built its first church in Chelsea Square, the Park Street Methodist (later the GAR Hall). The Walnut Street Methodist Church, shown here *c.* 1855, was erected at the corner of Walnut and Fourth Streets, diagonally across from the first Williams School. (Courtesy of SPNEA.)

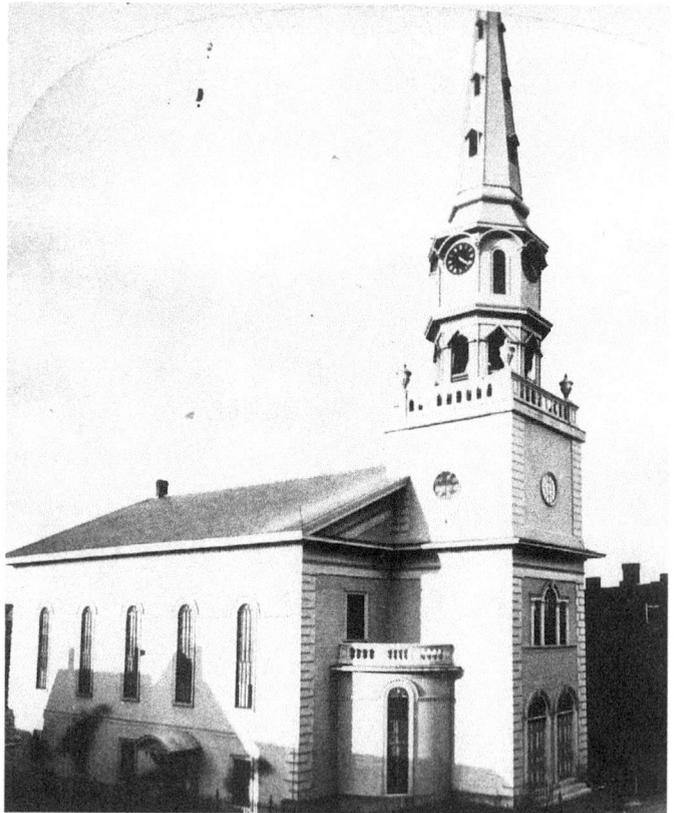

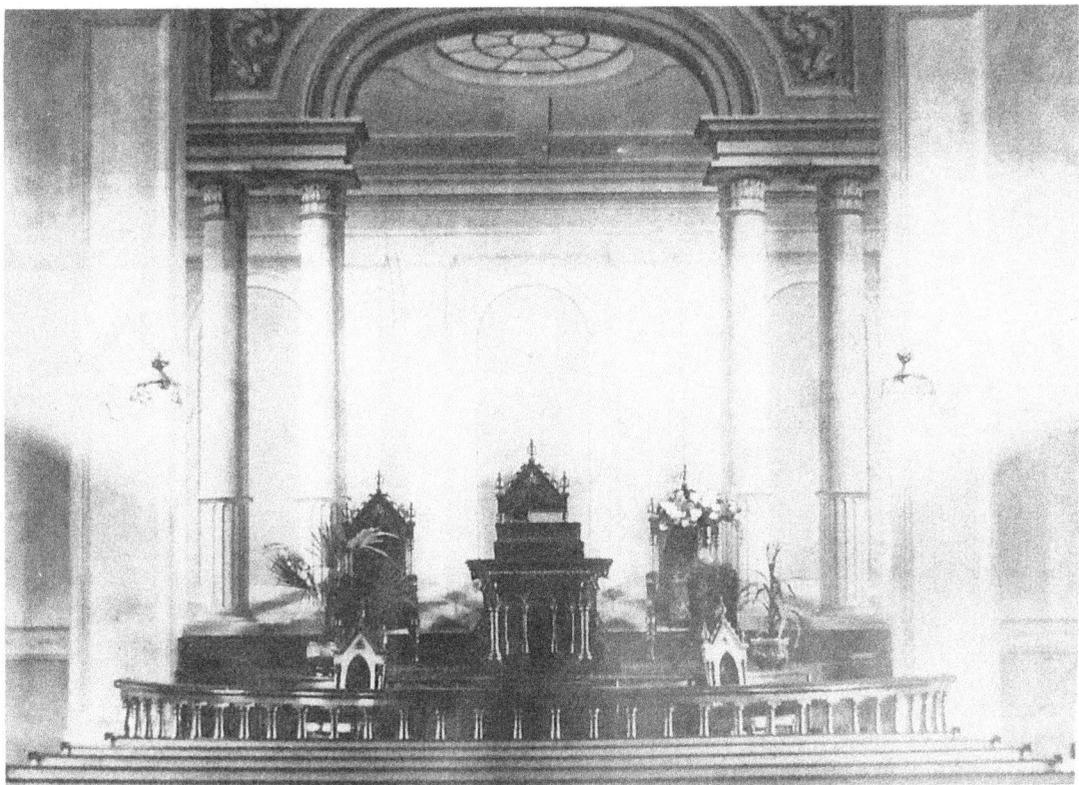

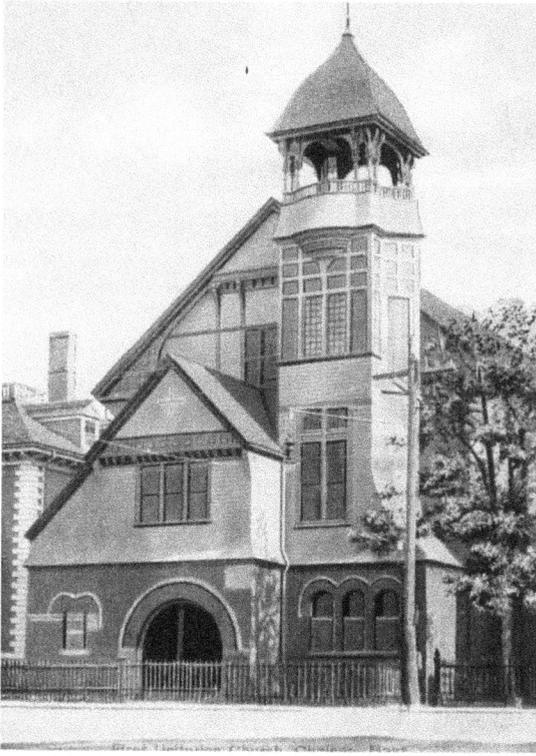

The Unitarian Church was established in 1838, and by 1880 the congregation had constructed this picturesque building on Hawthorn Street. With its round brick entry arch and upper stories of shingles, clapboards, and trim, it must have been a colorful sight at the head of Fourth Street.

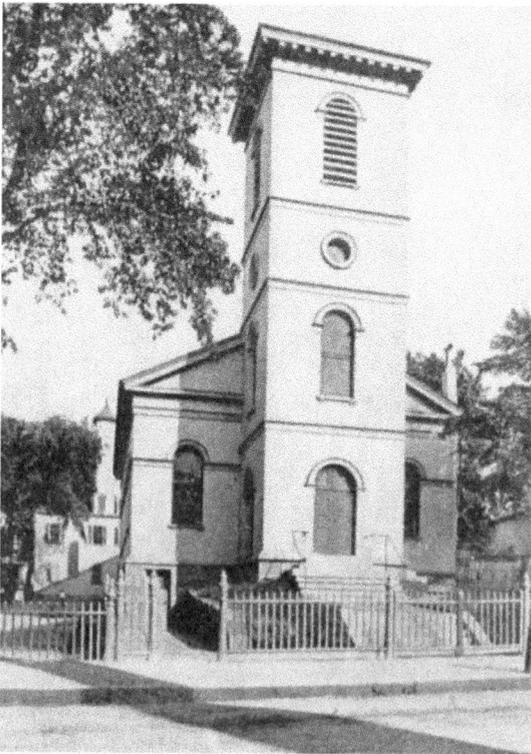

St. Luke's Episcopal Church was organized in 1841 and originally occupied a small building on Broadway. In 1864, it merged with St. Andrew's Church in this building on Hawthorn Street, designed by Arthur Gilman, the architect of the Arlington Street Church in Boston. The central portion of the Shurtleff School is now on the site.

Left: Albert D. Bosson and his family were generous benefactors of St. Luke's Episcopal Church. Judge Bosson was Chelsea's first democratic mayor; he was also president of the County Savings Bank, justice of the police court, and trustee and director of several prominent organizations. He was married to the daughter of local industrialist C.A. Campbell.

Below: The parish of St. Luke's built its current church on Washington Avenue in 1907 on land donated by the Bosson family. It was designed in the Gothic style by architect Frank Bourne, and is one of few concrete block churches in existence. A window to the memory of Samuel Maverick was installed in 1925.

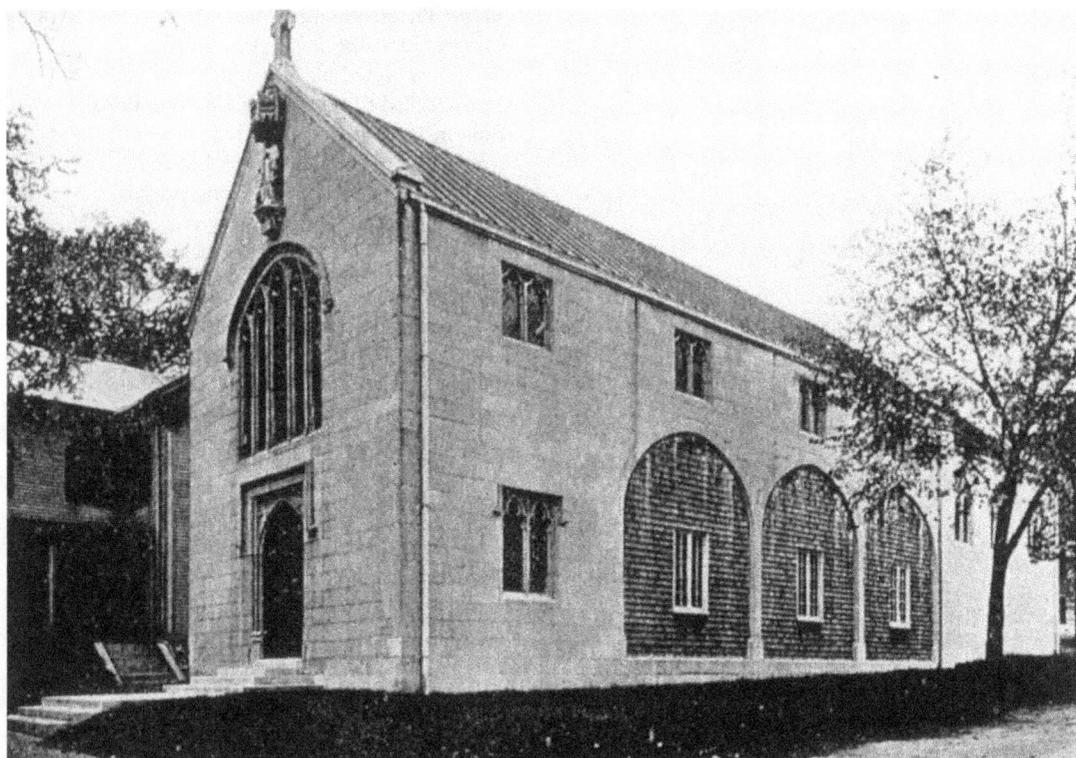

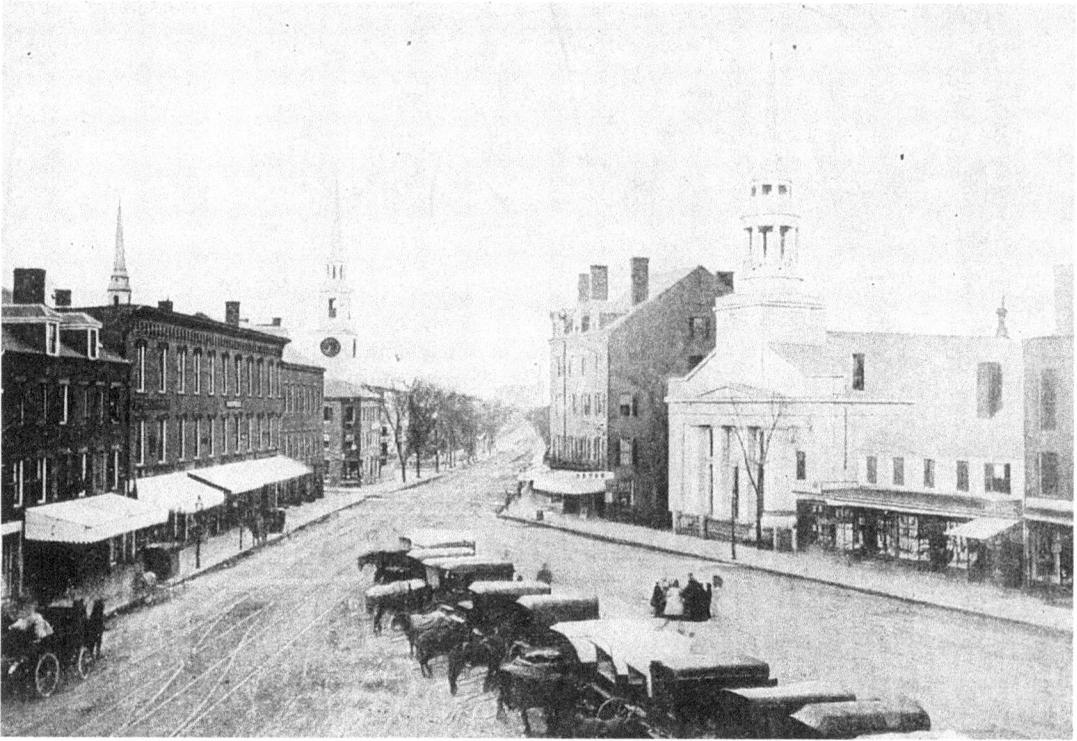

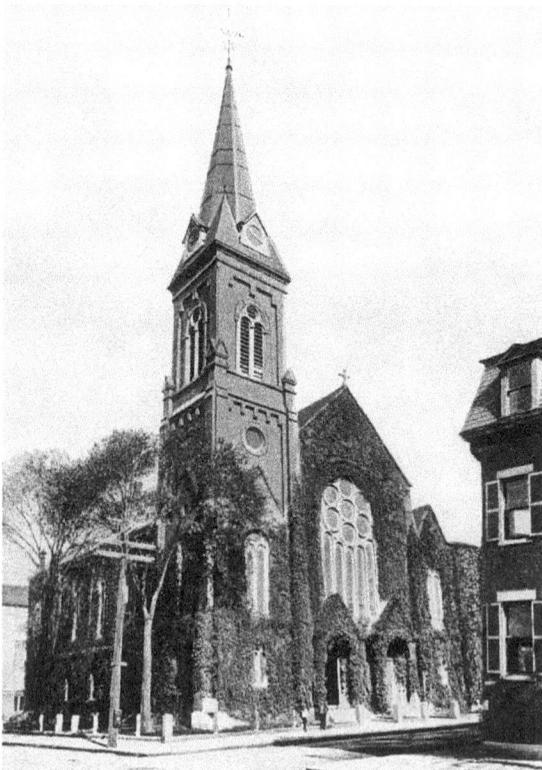

Above: The first home of the Congregationalists in Chelsea was this traditional New England church in Chelsea Square called the Broadway Congregational. Built in 1843, it overlooked the busiest part of town. An 1845 church booklet declared that "attending dancing parties, Theatrical Exhibitions, and playing games of Chance" were forbidden.

Left: The Central Congregational Church was organized in 1850 by members of the first church. Their services were held in this ivy-covered brick building, *c.* 1872, at the corner of Chestnut and Fifth Streets. The Salvation Army building is on the site today.

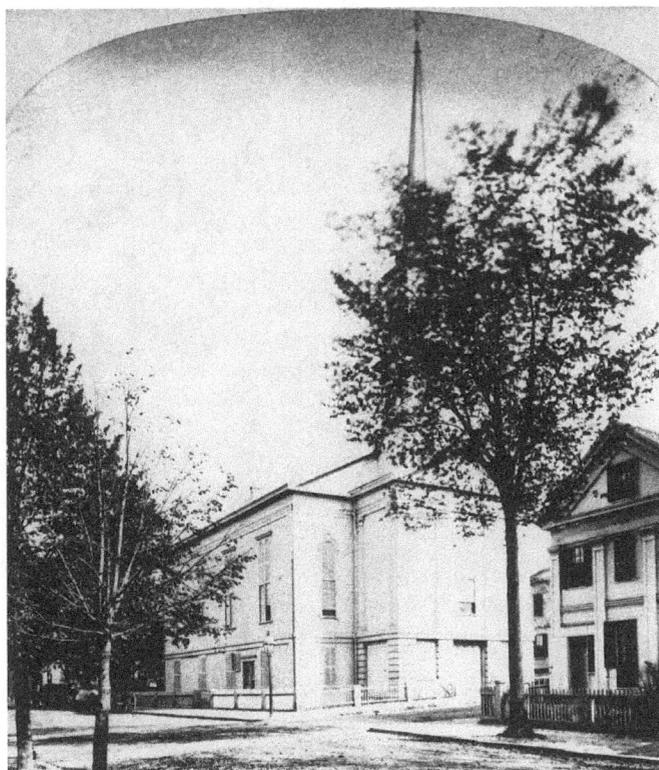

Above: As the population moved toward Prattville, the Third Congregational Church was built in 1880 on Reynolds Avenue. Neighbor and local historian Mellen Chamberlain was on the building committee. Later purchased by the Christian Science Church, the building is still on its original site, now sheltered by trees.

Right: The Mt. Bellingham Methodist Episcopal Church was built *c.* 1855 at the intersection of Bellingham and Shurtleff Streets. Across from the church, facing Shurtleff Street, is another of the city's many elegant Greek Revival houses.

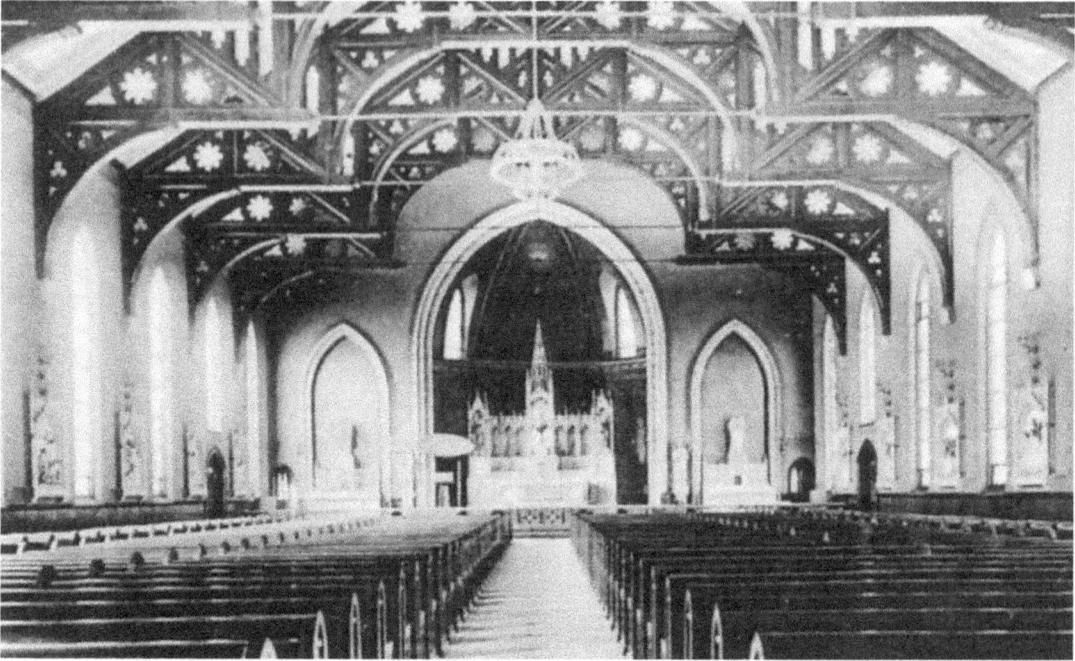

Organized in 1844, the Roman Catholic population was the largest in the city by the end of the 19th century. This view of the interior of St. Rose of Lima Church shows the original Gothic-style details that existed before the fire. Beyond repair, the interior was redesigned and rebuilt.

St. Rose Church was built on Broadway in the 1860s by church architect Patrick C. Keeley. Keeley also designed the Immaculate Conception and Holy Cross Cathedral in Boston. Much of the brick exterior of St. Rose survived the fire; the original lancet window was replaced but the small steeple was not rebuilt. The parochial school dates to about 1885. (Courtesy of the BA.)

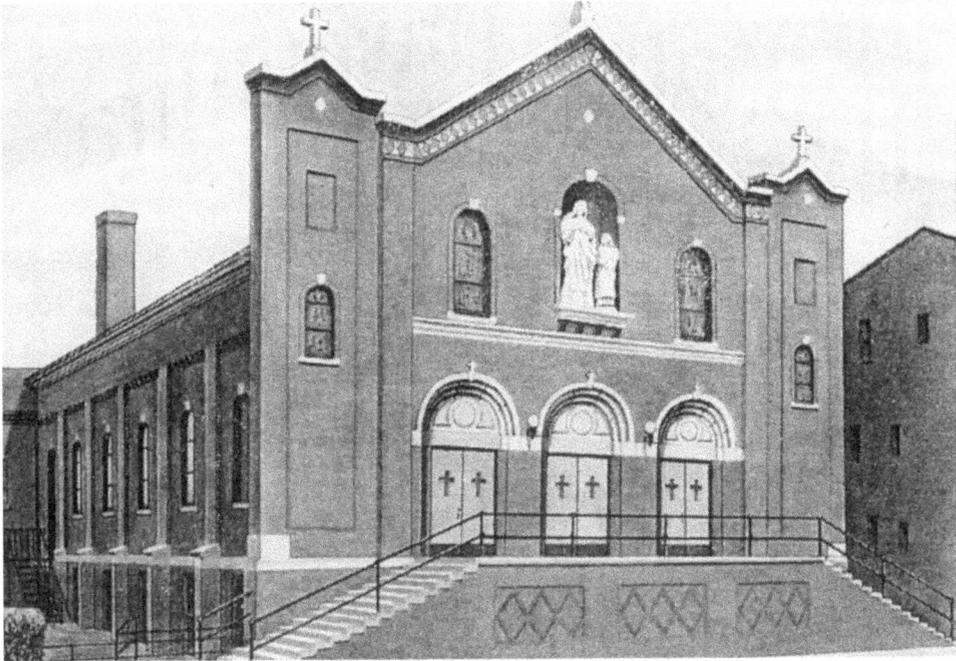

The Assumption Church was organized in 1907 to fulfill the desire of local French-speaking people to have their own parish. They worshiped at St. Rose until the fire, then constructed a basement for their own building, using that for services until the upper church was completed in 1925.

As the number of priests at St. Rose grew, this handsome house on Broadway and Crescent Avenue was purchased for a rectory. The church being so badly damaged, Easter Sunday Masses were held here after the fire. There is now an apartment building on the site.

Pamiątka Parafialna

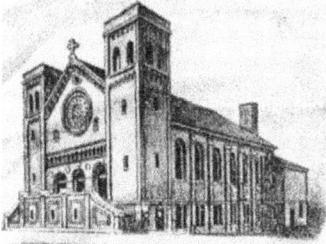

OBRAZ NOWEGO KOŚCIOŁA

ROK 1908

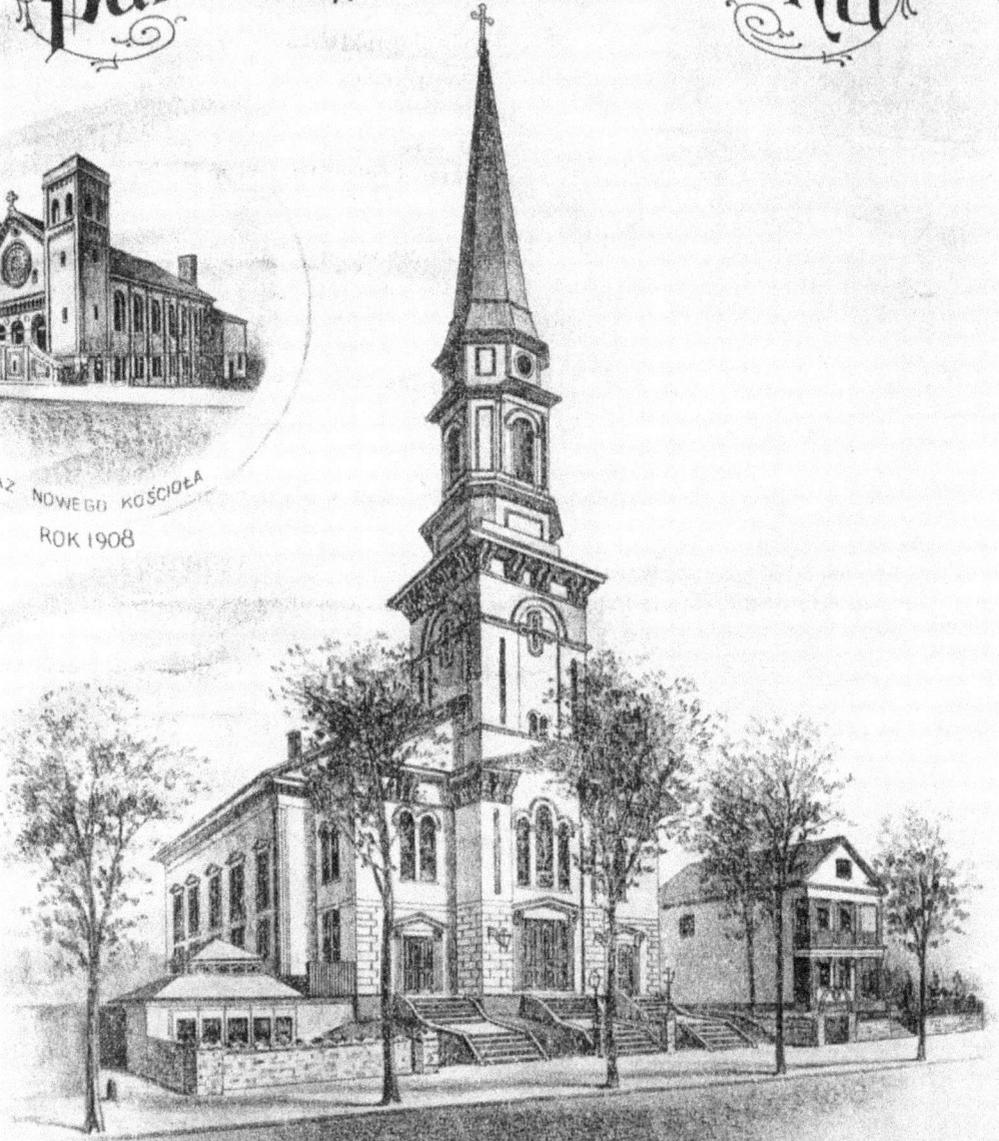

Koś. Ś W. Stanisława B. i M.
w CHELSEA, MASS.

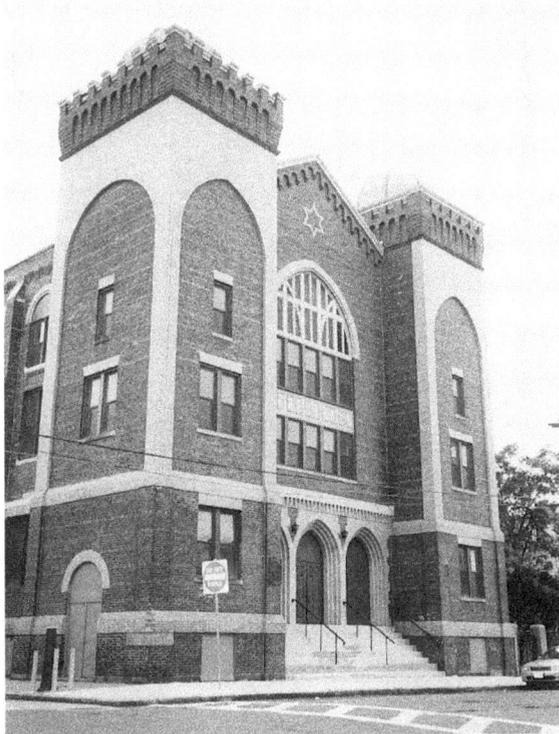

Left: Between 1890 and 1900 Chelsea's Jewish population grew from 100 to 3,000. By 1910, it was 10,000. Three synagogues survive, the oldest being the Walnut Street Synagogue, Agudas Sholom, built in 1909. Recently restored, it has services every day. The magnificent carved arks and bimoths at the Walnut Street and Orange Street Synagogues were made by Sam Katz in the 1920s.

Right: Shaare Zion, the Orange Street Synagogue, was built in 1924. When it opened, there were three major areas of Jewish settlement in the Boston area—the West End, Chelsea, and Roxbury. By 1900 Jewish families had begun to leave the congested Boston neighborhoods to find homes and jobs outside the city.

Opposite: Immigrants from Poland began to arrive in Chelsea in the 1860s. By 1903, there were 200 Polish families in the city and a church was purchased for their use on Chestnut Street, dedicated to St. Stanislaus. The building was constructed in 1855 for the Winnisimmet Congregational Church. When the church burned in 1908, the current St. Stanislaus was erected on the site.

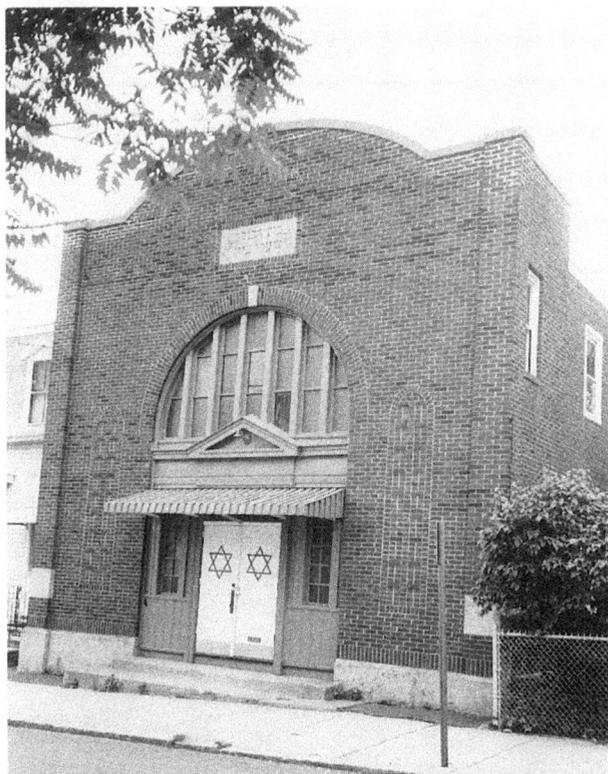

J. H. KIBBY & SON,

Building Contractors.

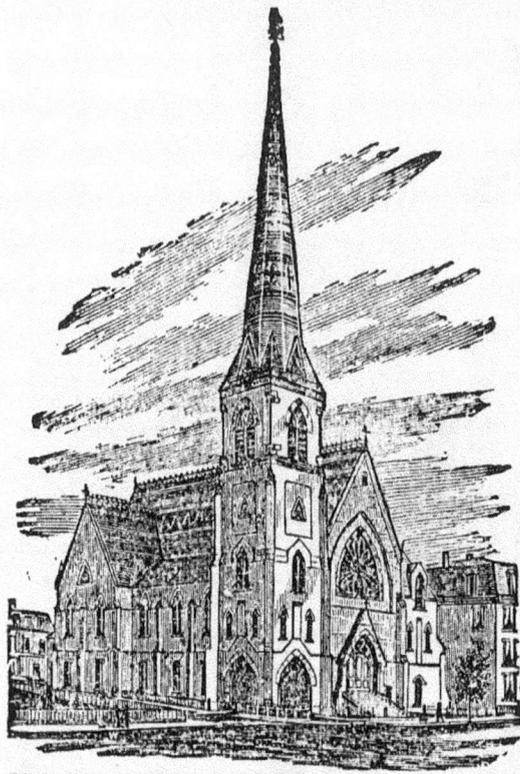

Building and Remodeling Churches a Specialty.

Any Society contemplating building or remodeling a church, will do well to consult with us, as we have had an experience of eighteen years, and are fully conversant with all parts of the business.

Post-Office address,

CHELSEA, MASS.

Shop, 22 Marginal Street.

CHELSEA

Book and Stationery Store,

121 WINNISIMMET ST. 121.

CONSTANTLY FOR SALE

School, Miscellaneous, and Juvenile Books of all kinds; English, French, and American Stationery, Envelopes, &c., of the finest quality;

And every variety of articles usually found in a first-class Book and Stationery Store, all of which will be sold as cheap or cheaper than they can be purchased in Boston.

This advertisement first appeared *c.* 1875.

Industry

Swett Car Wheel and Foundry Co.

CHILLED CAR WHEELS.

CHELSEA, MASS.

GEO. W. SWETT, PRESIDENT.

GEO. B. SWETT, VICE PRESIDENT.

FRED. W. SWETT, SEC'Y. AND TREAS.

This advertisement was first printed in 1895.

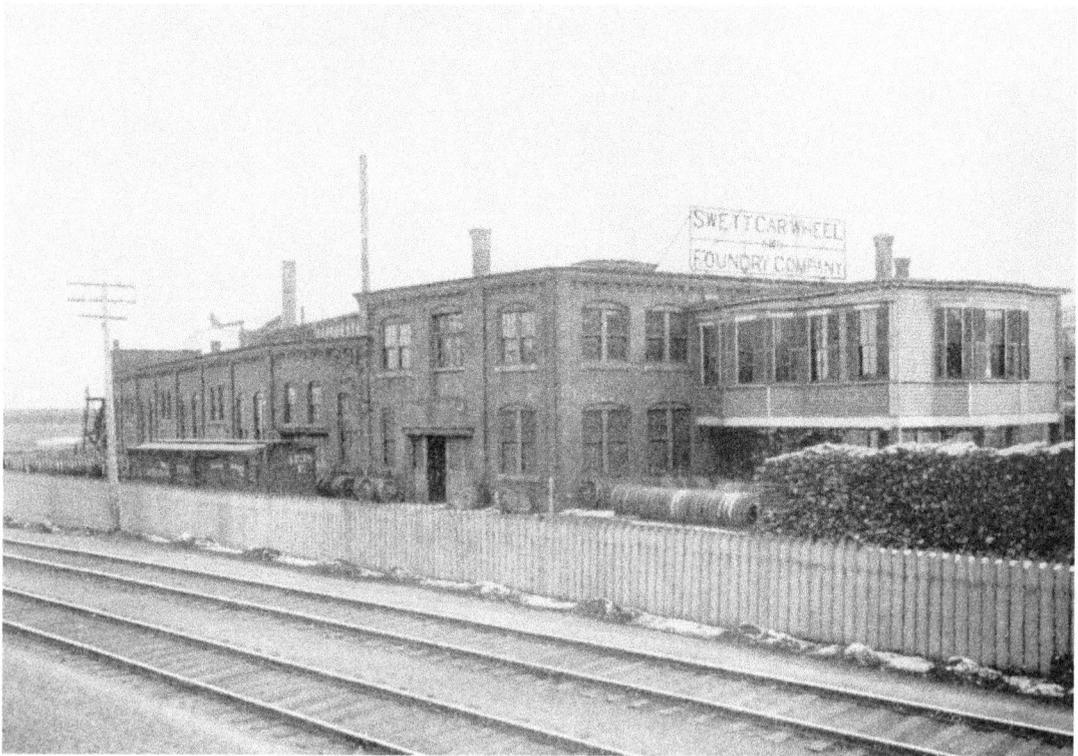

Barely visible from the railroad bridge near St. Rose Church is the Swett Car Wheel & Foundry
Company, at the junction of the old B&M Eastern and B&A Grand Junction Railroad lines. The
c. 1892 brick foundry manufactured chilled iron car wheels. In 1904, it became the Griffin Car
Wheel Company; by 1914 it was the largest of its kind in the world, with plants across the country.
Future development in the area might consider preserving this important vestige of one of Chelsea's
early industries.

S. K. LOVEWELL & CO.,
Machinists and Iron Founders.

SPECIALTIES:—Wood Working Machinery, Rope and Cordage
Machines, Jacquard and Plain Cam Looms, for all kinds of Narrow
Fabric, both Elastic and Non-Elastic Goods, of one, two and three
shuttle work. Machine Castings of every description at short notice.

Works, 928 to 934 Broadway, - - - Chelsea,
TELEPHONE CONNECTION.

Looms for the textile industry were an important part of Lovewell's business, which was founded in 1870. This advertisement was printed c. 1875.

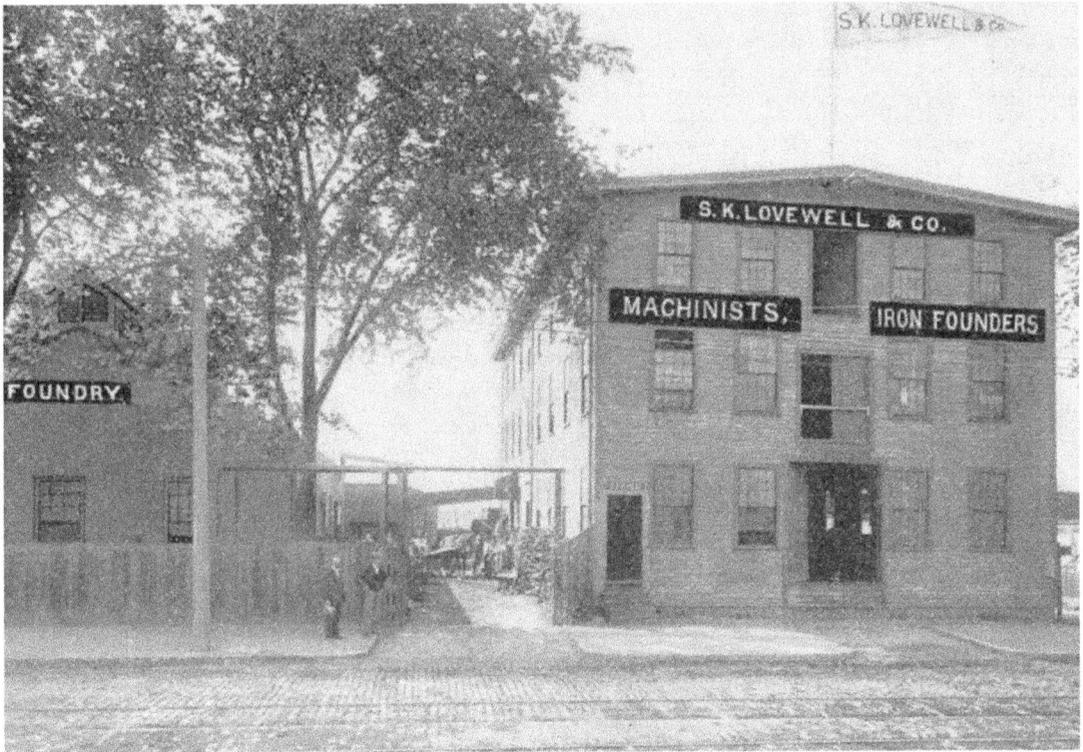

Heavy industrial machines that turned raw materials into finished goods were made locally at S.K. Lovewell & Company, at 928–934 Broadway. With the lumber mills, furniture factories, and laundries in Chelsea, Lovewell was kept busy making and repairing machinery. Presently on the site is the On Broadway Nursing and Rehabilitation Center.

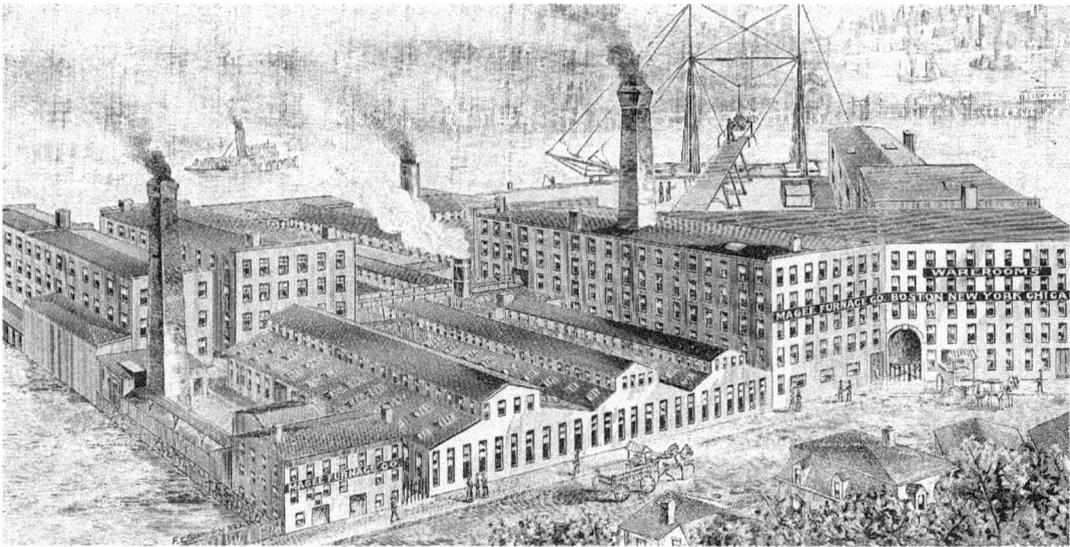

By 1900, the Magee Furnace Company covered a huge area along Marginal Street and was the largest stove and furnace manufacturer in the country. The company began in 1864 as the waterfront slowly changed from residential to industrial. Just down the street were the Greek Revival houses that had previously enjoyed unspoiled views of the waterfront.

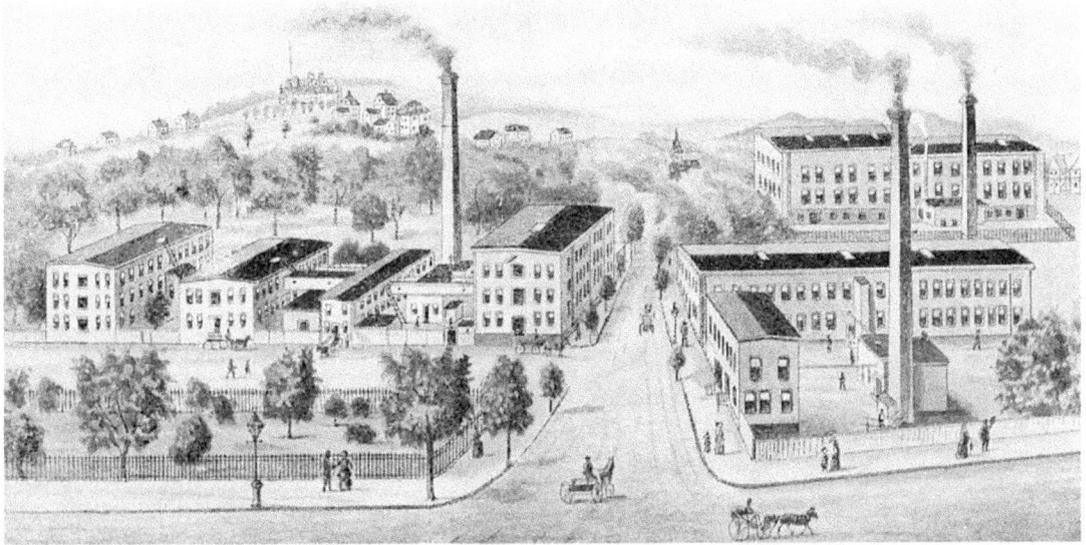

Established in 1874, Thomas Martin & Brother became the largest manufacturer of elastic webbing in the United States. The two original weaving buildings at the left remain on the Dudley Street site. Their work force grew from a dozen people to hundreds as they expanded into other states. After Thomas Martin's death in 1912 the firm was reorganized as Everlastik, Inc.

T. MARTIN & BRO.,
Elastic Web Manufacturers

AND ORIGINATORS OF THE

NEW CUSHION-BACK SUSPENDER & TRUSS WEBS,

Ladies' Silk Belting, Shoe Goring, Loom Webs, etc.

OFFICE & WORKS, WOODLAWN AV., COR. DUDLEY ST.,
CHELSEA, MASS.

Boston Office, 289 Devonshire Street, CHAS. F. WARNER, Manager.
New York Office, 325 Broadway, H. MARTIN, General Agent.

T. MARTIN. WM. MARTIN.

Eastern Elastic Gusset Co.,
—Manufacturers of—

ELASTIC SHOE GORING, Etc.,

ALSO, MAIL HARNESS FOR ELASTIC LOOM WEBS,

AND OTHER FABRICS.

Office & Works, Woodlawn av., cor. Dudley St.,
CHELSEA, MASS.

BOSTON OFFICE, 78 BEDFORD STREET.

Thomas Martin. William Martin. Alfred Hopkins.

CHELSEA WEB CO.,

Manufacturers of

Fancy Suspender Webs,

Cor. Woodlawn and Spencer avenues, CHELSEA.

THOMAS MARTIN. WILLIAM MARTIN. JOHN O. FRYER.

It is difficult for us today to appreciate the importance of elastic webbing, but it was a significant component in 19th-century clothing. This 1895 advertisement for the Martin Brothers companies lists some of its more obvious uses, in suspenders and shoes (high topped shoes often had elastic gussets to make putting them on easier).

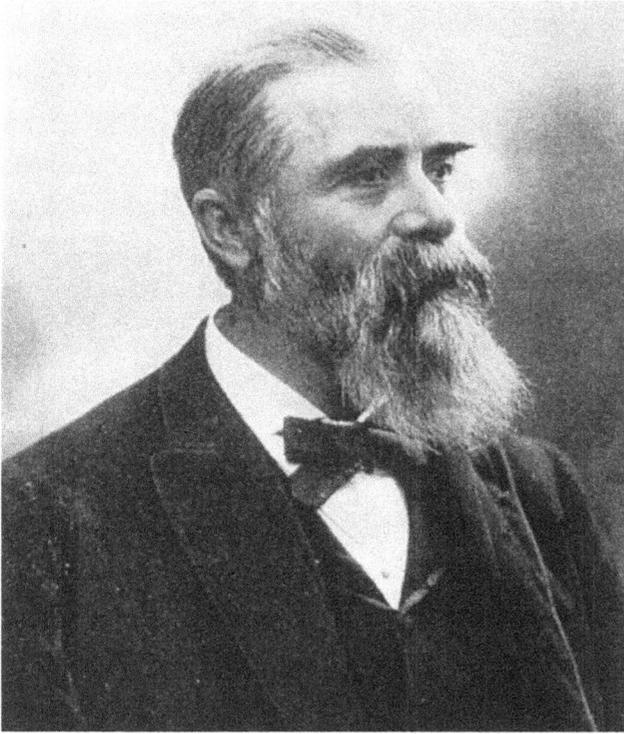

In 1865, Thomas Martin came to America from Leicestershire, the center of the elastic fabric industry in Britain, to manage a mill at Easthampton, MA. Within a decade he began his own company. He also served as president of the First National Bank and held a number of elected offices. His daughter married Alfred Fitz, son of Mayor Eustace Fitz.

Below: Thomas Martin built this delightful house at 146 Franklin Avenue, a Victorian home in the Second Empire style with a dormered Mansard roof, centered wing, and assorted towers rising at the roofline.

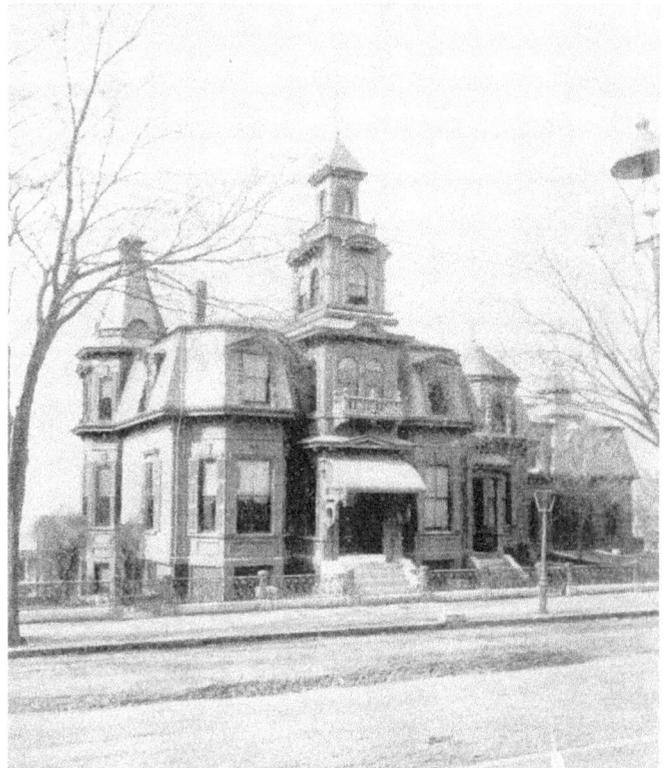

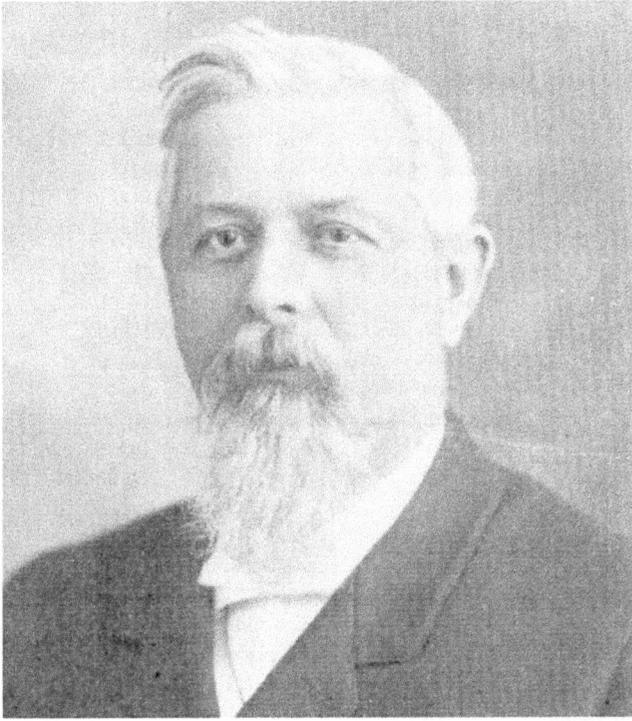

Learning their trade in England, William Martin and his brother worked for the Boston Elastic Fabric Company until 1874, when they started their own business. Former residents of Spencer Avenue, they moved to the newly developed Powderhorn Hill area in the 1880s.

Below: William Martin's house was just down the street from his brother, at 86 Franklin Avenue. His home was simpler and more restrained than that of his brother, a solid Queen Anne with a hipped roof, lower cross gables, and porches on each side of the house. It had a very nice view overlooking the city.

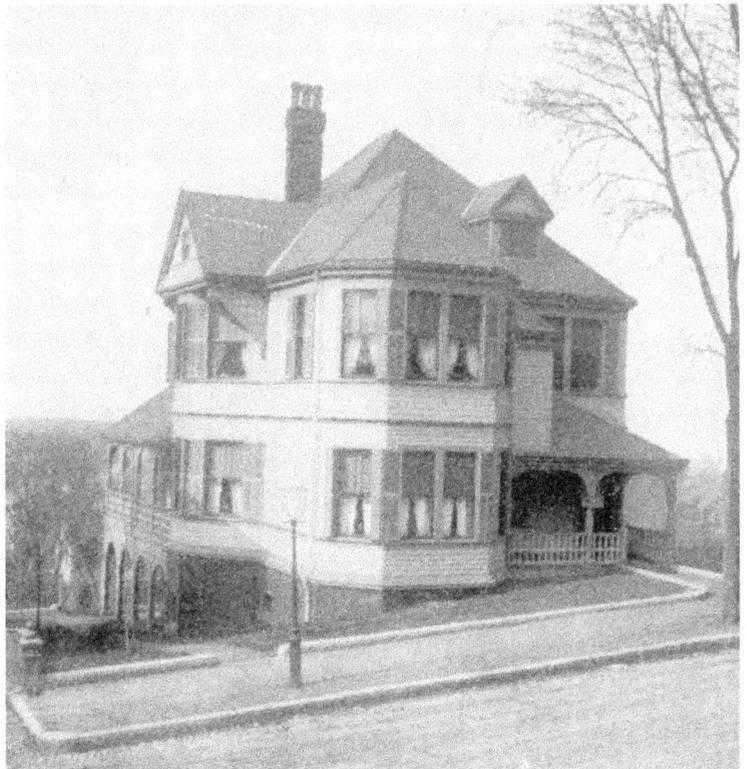

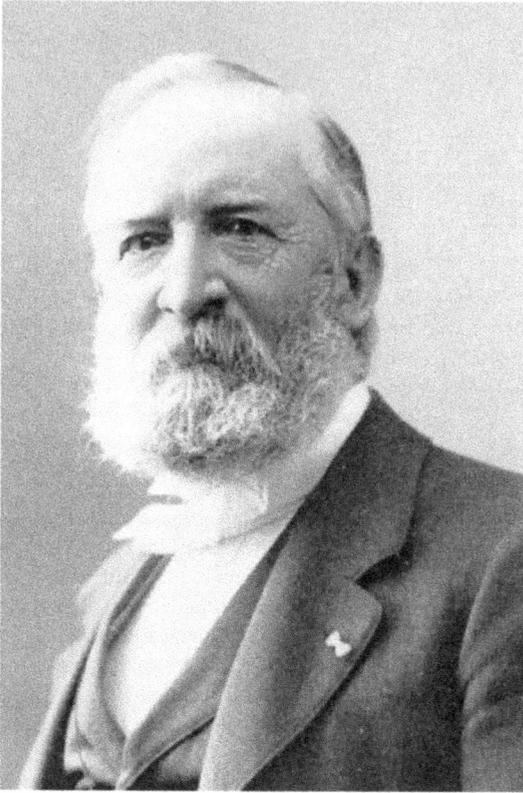

Left: John G. Low studied painting in Paris from 1858 to 1861 and with his father, John, created the world famous Low Art Tiles. They made their home on Clark Avenue, not far from the tile works. As part of the Arts and Crafts Movement, their work represented the return to high-quality hand-crafted objects for the home.

Below: Low Art Tile Works was located on Broadway, near Stockton Street, and was in operation from 1878 until Low's death in 1907. Along with tiles for fireplaces, stoves, and clocks, the company made extraordinary soda fountain apparatus which embellished many a marble-topped drug store counter in turn-of-the-century America. Within a short time of its reaching the market, their work won international recognition.

Opposite, below: Chelsea's beautiful Low Art Tiles can be still be found in numerous homes in Chelsea and beyond. These were installed in one of the fireplaces at the Chelsea Public Library in the 20th century. The tiles have recently been rediscovered by collectors and are highly valued for their color and design.

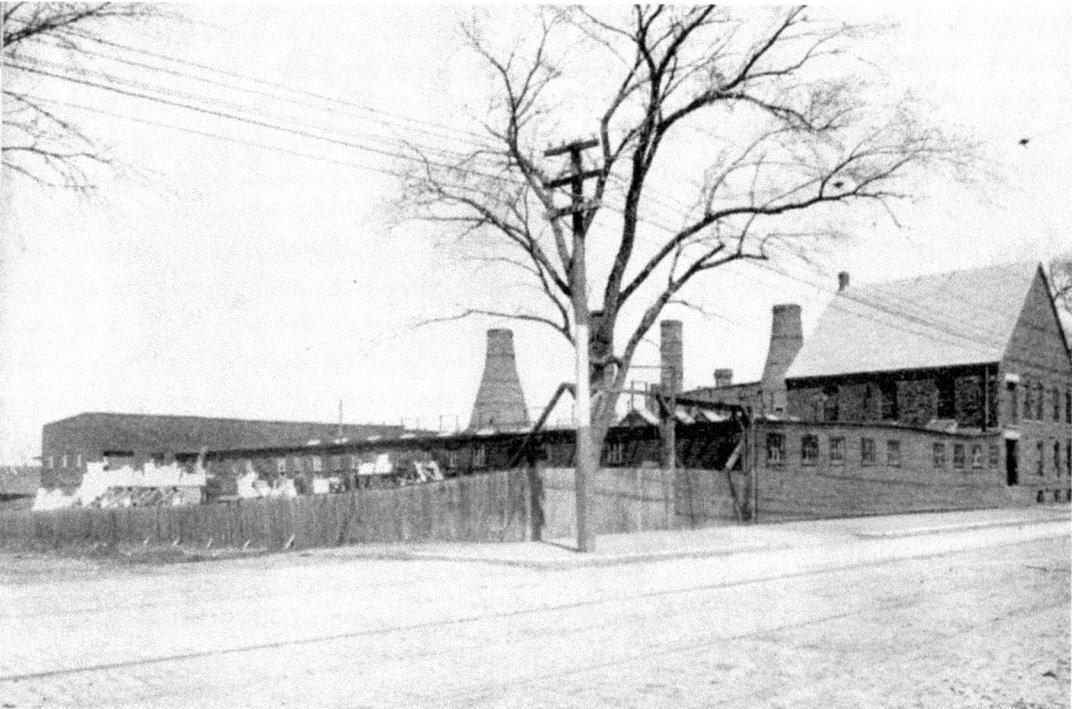

The title page from one of the Low Art Tile catalogs was done in a lovely artistic script. The tiles were made in a variety of designs—floral, geometric, portraits— and in a beautiful palette of colors, from pale yellows to rich blues to deep browns. Local clay, although available nearby, was not used in their work.

Art Tiles
Made by
J.G. & J.F. Low
Chelsea Mass.
U.S.A.

Copyright by J. & J. G. Low, 1881.
Copyright by J. & J. G. Low, 1882.
Copyright by J. G. & J. F. Low, 1883.
Copyright by J. G. & J. F. Low, 1884.

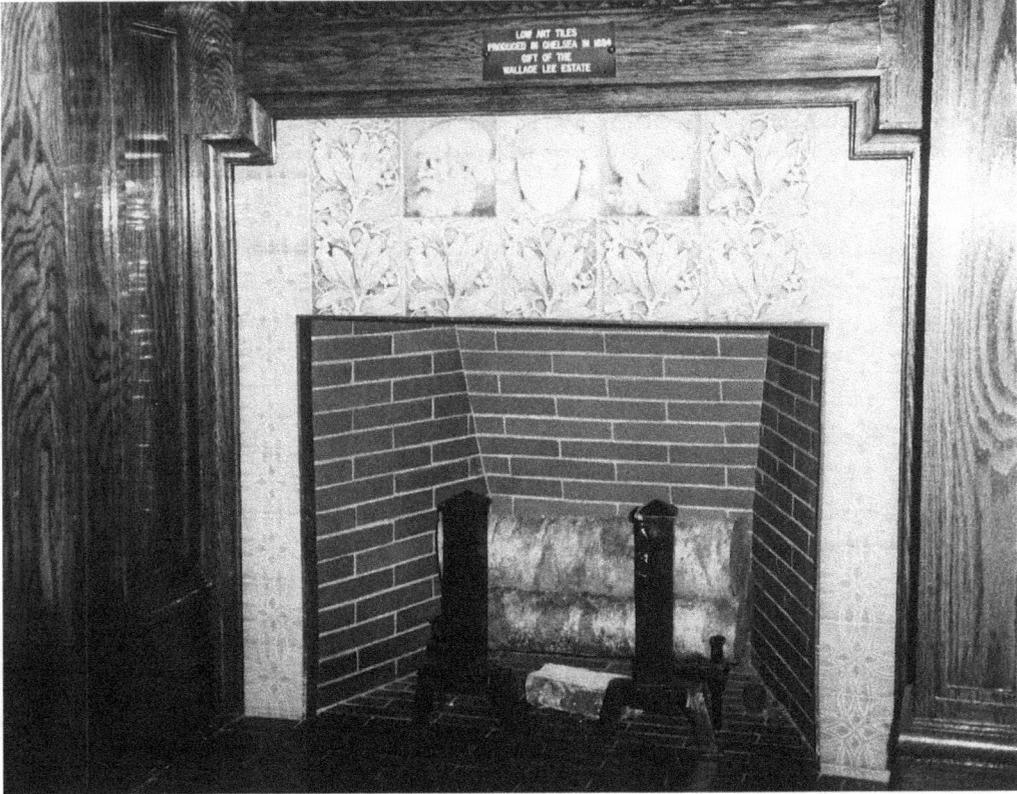

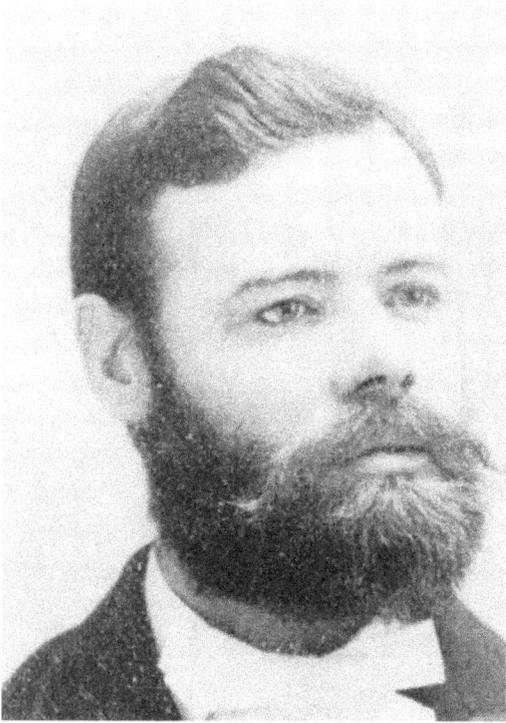

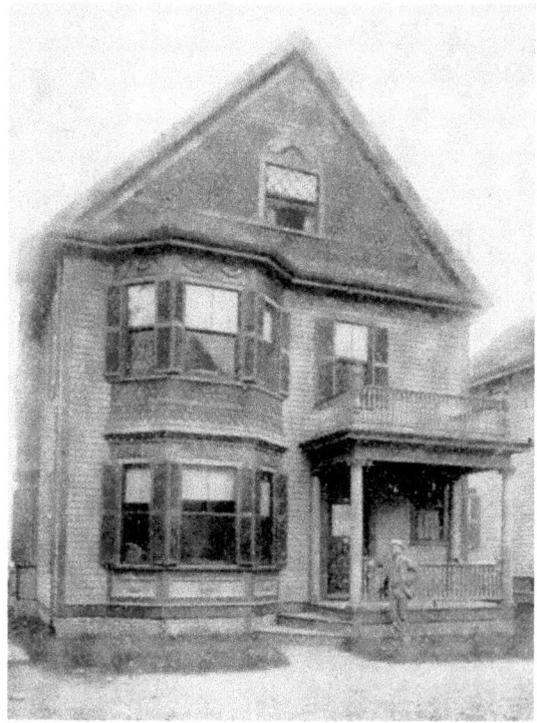

Roger Walton was a man with a vision. Coming from Lancashire, England, he saw a need for hot lunches for the working people of Boston. He opened the Walton Pie Bakery in 1887 on Cypress Street, cooking 660 pounds of chicken and 150 of mutton daily to be made into pies. These were brought to Boston restaurants and "lunch rooms" by his own delivery wagons. His house still stands at 132 Addison Street.

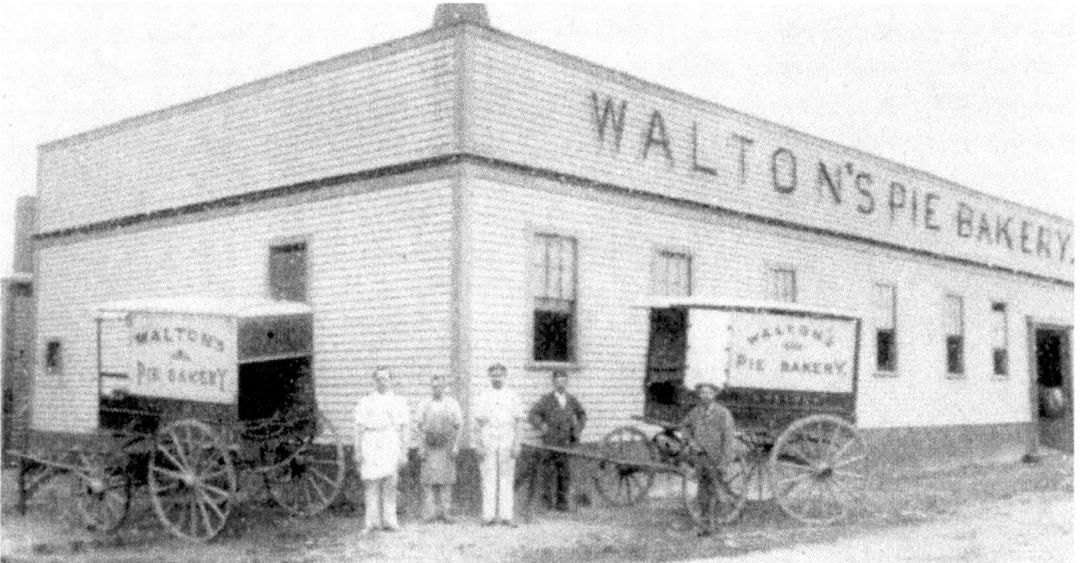

Jabez K. Montgomery and A.L. Howard came to Chelsea in the 1860s from Warren, Maine, where they made gunboats for the Union Army during the Civil War. Their firm in Chelsea made steamships for the Hingham, Fall River, and Nantasket lines, among others. Mr. Montgomery was also president of the Winnisimmet Company, while Mr. Howard spent his spare time on horseback, as a founding member of the Hawthorn Club Stables.

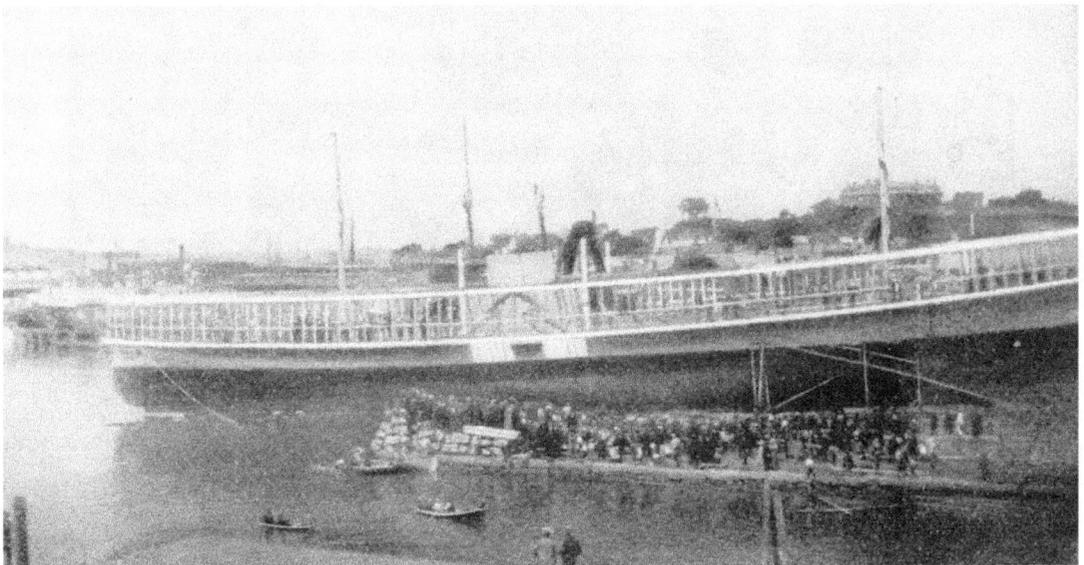

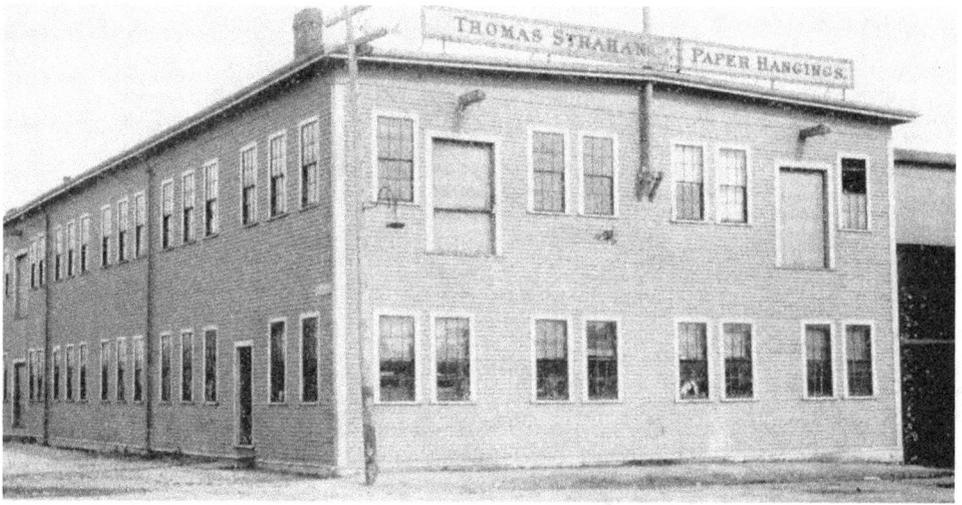

Mr. Strahan's wallpaper factory was, like Low Art Tiles, a local business with an international reputation for artistic work. Originally a wallpaper importer in Boston in 1868, the company began to design its own papers in this Chelsea factory on Spruce Street in 1885. Strahan's customers included large hotels, the Vanderbilt mansion, and the White House. This is one of the longest continually running local businesses still in operation today.

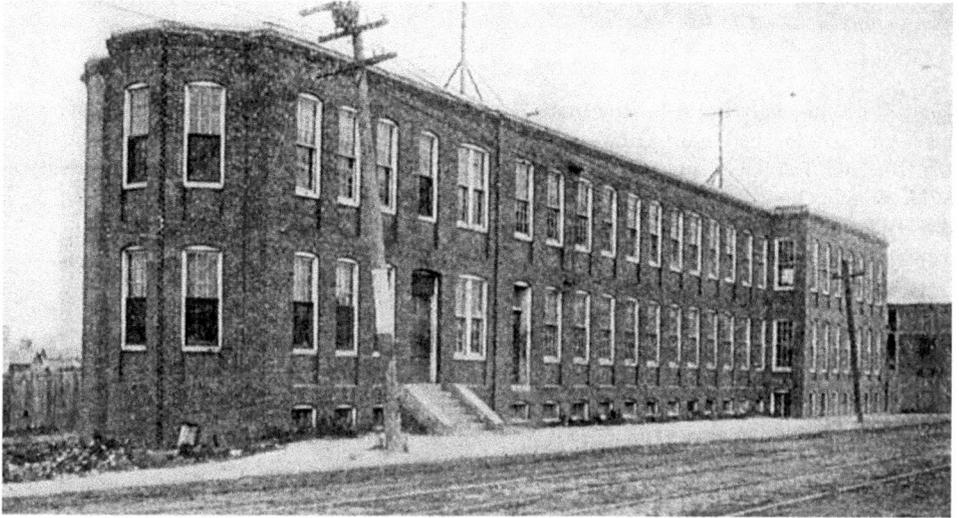

The Chelsea Clock Company came to the city in 1895 as the Eastman Clock Company, J.H. Eastman having started the firm in Boston in 1880. Reorganized and renamed the following year, it had great success with the manufacture of the ships' bell movement, the most reliable ever developed. Its reputation for quality remains unsurpassed and it is the only clock manufacturer whose product is made entirely in this country.

Opposite, top: Beginning in 1893, the Atwood & McManus Box Factory made all kinds of wooden boxes, from trunks to candy trays. It was one of the largest box makers in New England. The early buildings were burned, but later ones exist near the railroad tracks on Everett Avenue, the name "Atwood & McManus" still visible on the old brick walls. The office building, with a pyramidal slate roof, stands guard on Everett Avenue.

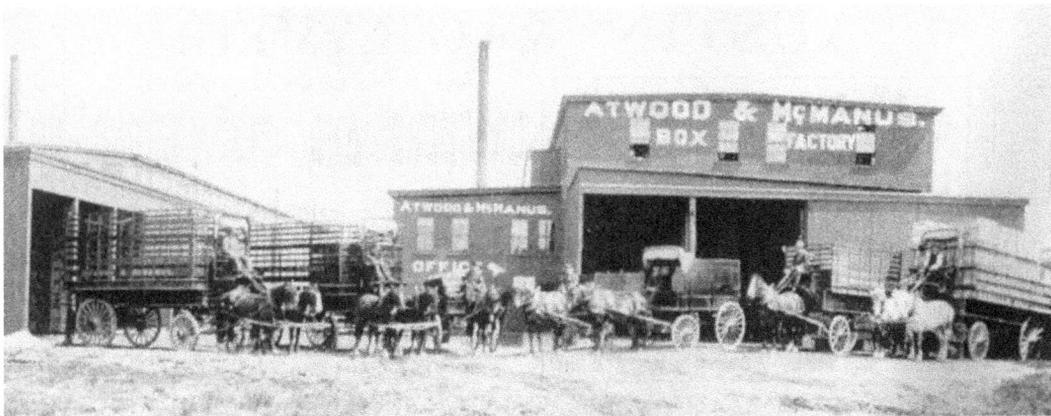

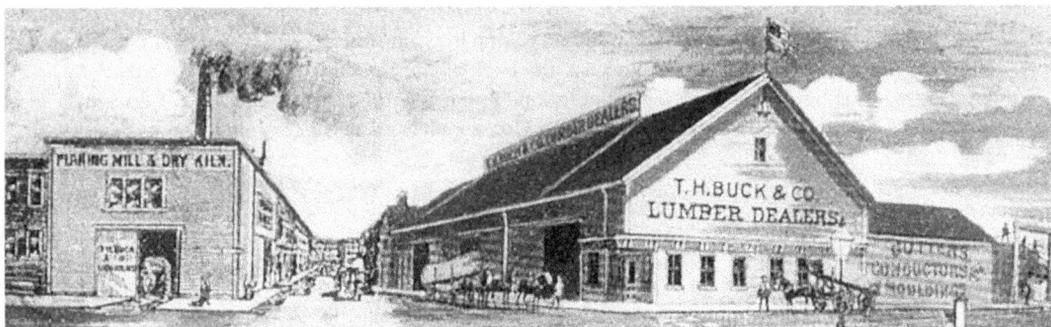

The Buck family, from Bucksport, Maine, owned a number of local businesses, including the family lumber company on Pearl and Marginal Streets. The deep harbor facilitated the receiving and distribution of all kinds of lumber products. With kilns for drying and storehouses on the property, this large business employed over 100 men. Recently, beams marked "T.H. Buck" were found in a 100-year-old home in Malden.

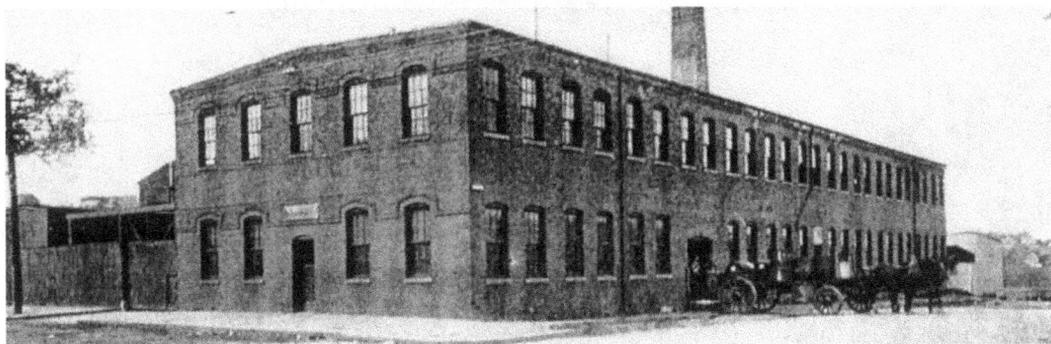

The United Indigo and Chemical Company, Ltd. did business in this simple brick building at 960 Broadway, near the Revere line. Constructed about 1890, it is typical of the dozens of small factories built before 1900 throughout Chelsea, many of which still exist today. One of their products, indigo, a blue dye, was used in laundering clothing. By adding bluing, clothes appeared cleaner and brighter. Chelsea had a number of commercial laundries as home washing machines were not yet common. One enormous complex, the Chelsea Laundry and Dye House, was built at Spruce and Williams Streets in 1852. The above building now houses the American Finish & Chemical Company. Powderhorn Hill is to the right in the distance.

AUSTIN & GRAVES,

MANUFACTURERS OF ALL KINDS OF

CRACKERS AND SHIP BREAD,

— ALSO —

Austin's Dog Bread.

No. 116 COMMERCIAL STREET,

BOSTON, MASS.

FACTORY AT CHELSEA, MASS.

The cracker factory of C.F. Austin & Co. began baking bread in Boston in 1825. In 1864 the company moved to Marginal Street to occupy the brick building pictured below. By 1885 their specialty was dog biscuits, the first bakery of its kind in the country to make such an item. In 1887 it became the Austin Dog Bread & Animal Food Co., a leading maker of dry animal food.

City Fathers
and
Their Domain

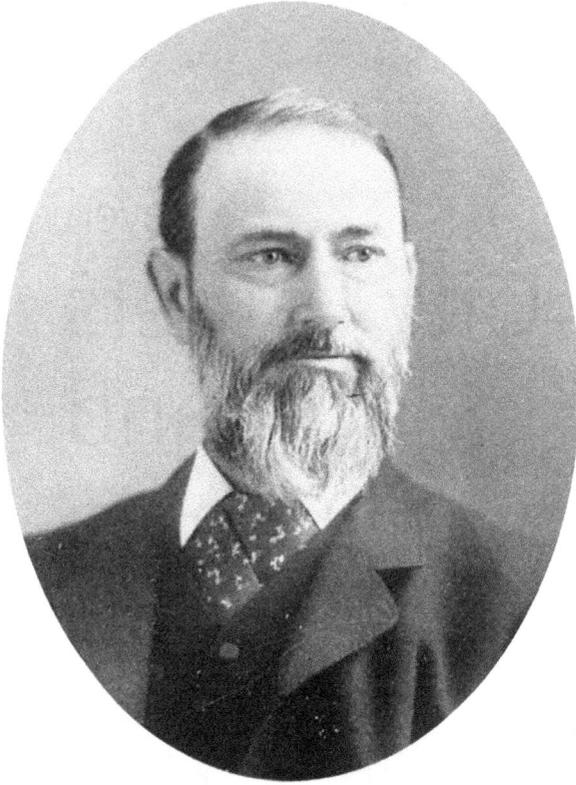

Left: Simeon Butterfield II moved to Chelsea in 1834 when he was a young boy. His family lived at the junction of Williams and Pearl Streets, in one of only six houses in the village. Mr. Butterfield wrote an interesting account of his half-century in Chelsea, providing valuable information about its changes from a rural village to a bustling city. He was a trustee of the public library and active in numerous social organizations.

Below: In the cellar of Mr. Butterfield's home at 27 Pembroke Street were remains of the old well that used to serve the Chelsea House. Successor to the Taft Tavern, it was a popular place formerly on the site. Mr. Butterfield recalled it to be 2.5 stories high, surrounded by a piazza. With a dance floor and dining room, it was the setting for many enjoyable indoor and outdoor events. His home was built in 1860.

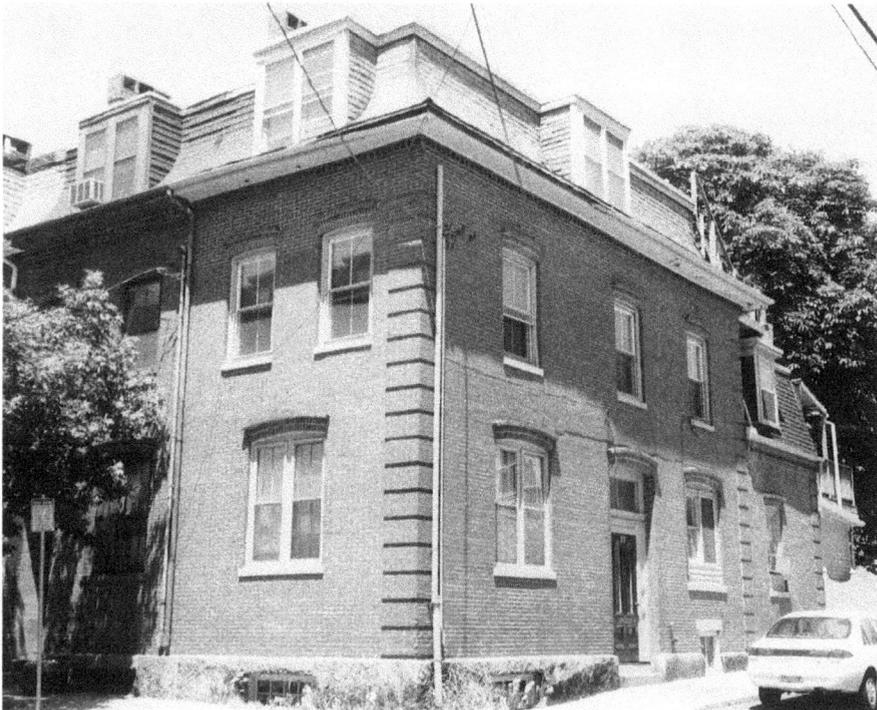

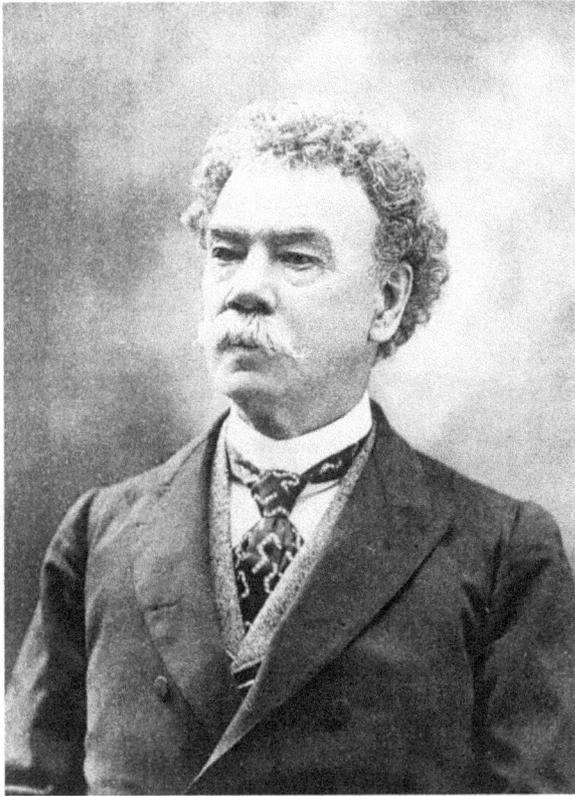

Left: Mellen Chamberlain returned to the city of his ancestors in 1849; from then on he took great interest in Chelsea. A Phi Beta Kappa graduate of Dartmouth College, he practiced law, was justice of the Municipal Court of Boston, and chief librarian of the Boston Public Library. In 1876 he began a history of Chelsea for the centennial. After decades of research, his book was published posthumously in 1908.

Below: For nearly 50 years, Judge and Mrs. Chamberlain's home was in Winthrop Square, at the junction of Washington and Jefferson Avenues. The granite wall and steps at the entrance to their home still remain in front of the current apartment building. Levi Slade, co-owner of Slade's Mill, lived in the home just to the left.

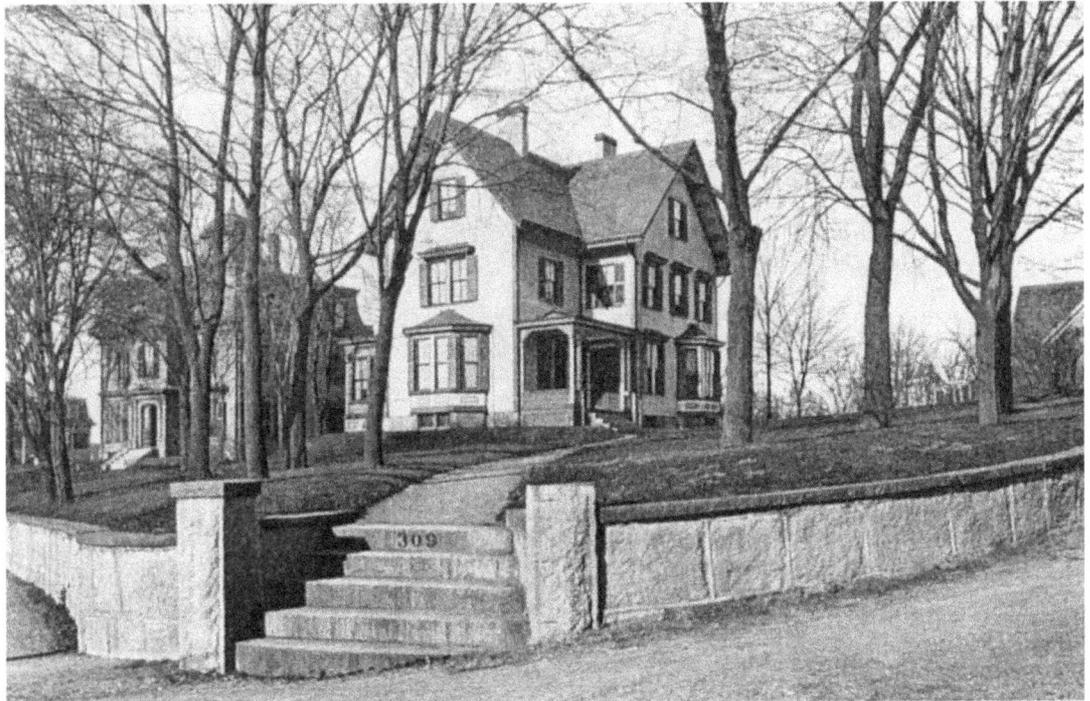

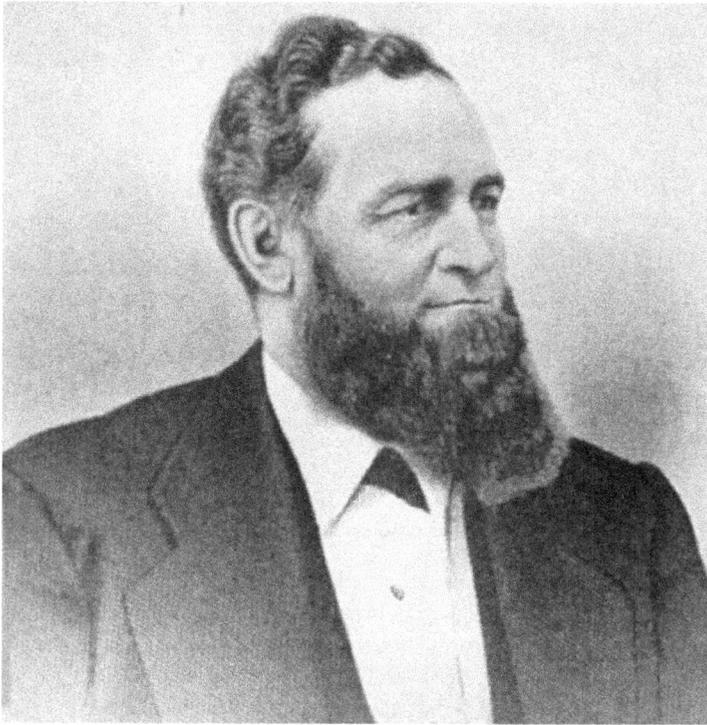

Along with seeing to the completion of Union Park on Fifth Street, Mayor Rufus S. Frost, accompanied by Mayor Shurtleff of Boston, entertained the Chinese Ambassador at the Chelsea City Hall on his visit to this country in 1868.

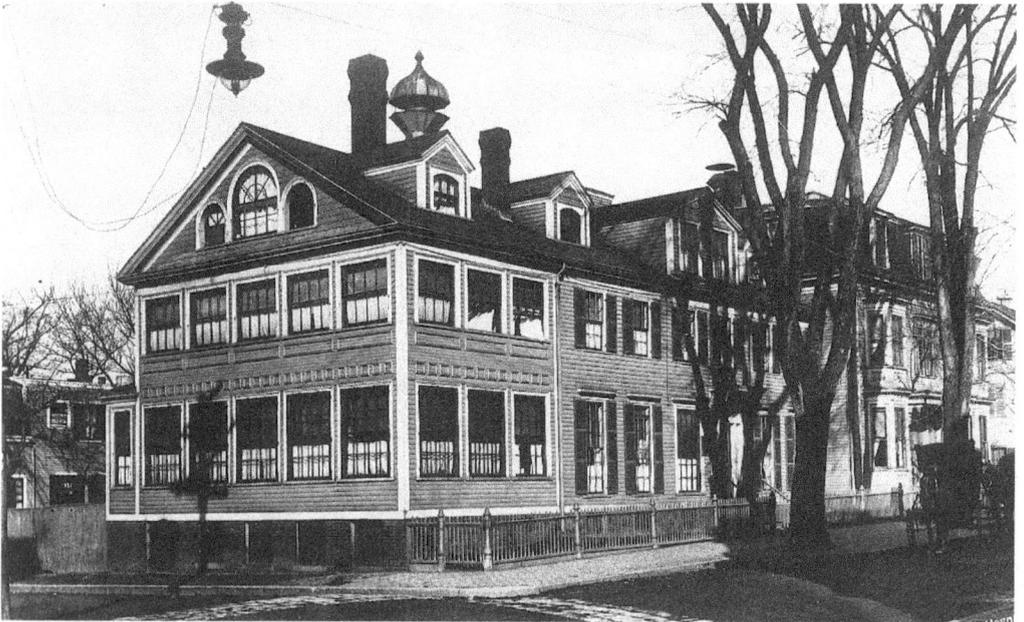

The Rufus S. Frost Hospital, diagonally across from the Garden Cemetery on Shawmut Street, was donated by its namesake. In 1890, he purchased two private homes for $27,000, which were renovated for use as a hospital. He later left his own estate on Bellingham Hill for the same purpose, but before it could be opened, it was consumed in the 1908 fire. A large copper beech tree on the hill may be original to the Frost estate. (Courtesy of SPNEA.)

106

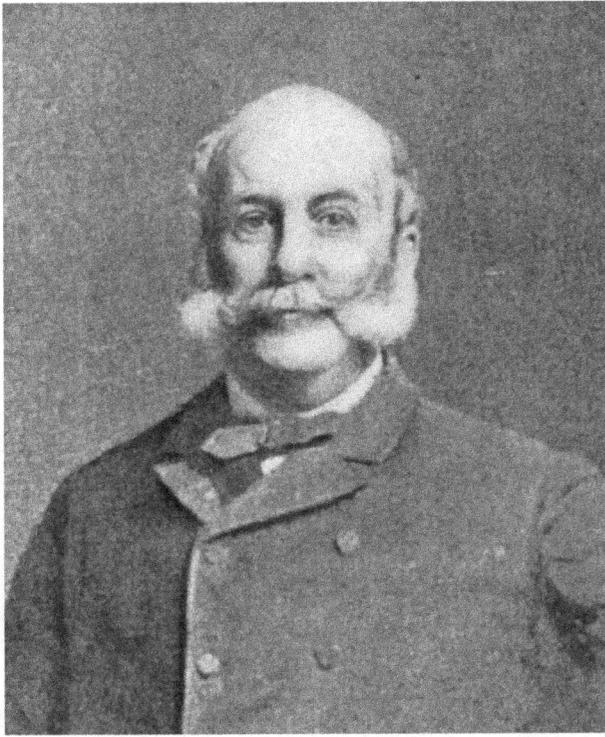

Eustace C. Fitz was mayor of Chelsea for three terms, from 1864 to 1866. He also served in the legislature and was on the board of directors of a number of institutions, including one railroad, two banks, and three colleges. His generous donation to the city of a permanent place for a public library was made shortly before his death in 1885. His own home still stands on Parker Street, an imposing Italianate mansion.

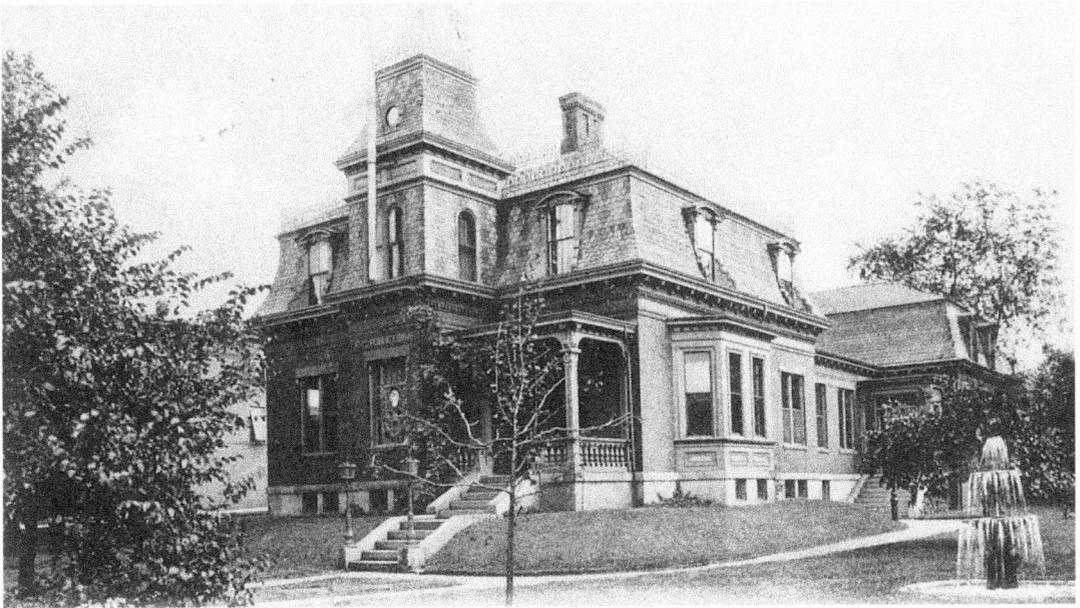

The city's first library was set up in Green's Block in Chelsea Square in 1870. In 1884, the elaborate Second Empire home of George Gerrish was purchased by Mr. Fitz for $12,500, and offered to the city for use as a public library. Former Mayors Francis and Frank Fay donated books from their collection. Poet James Russell Lowell gave the dedication address just before Christmas in 1885. It was in the same location as the current library.

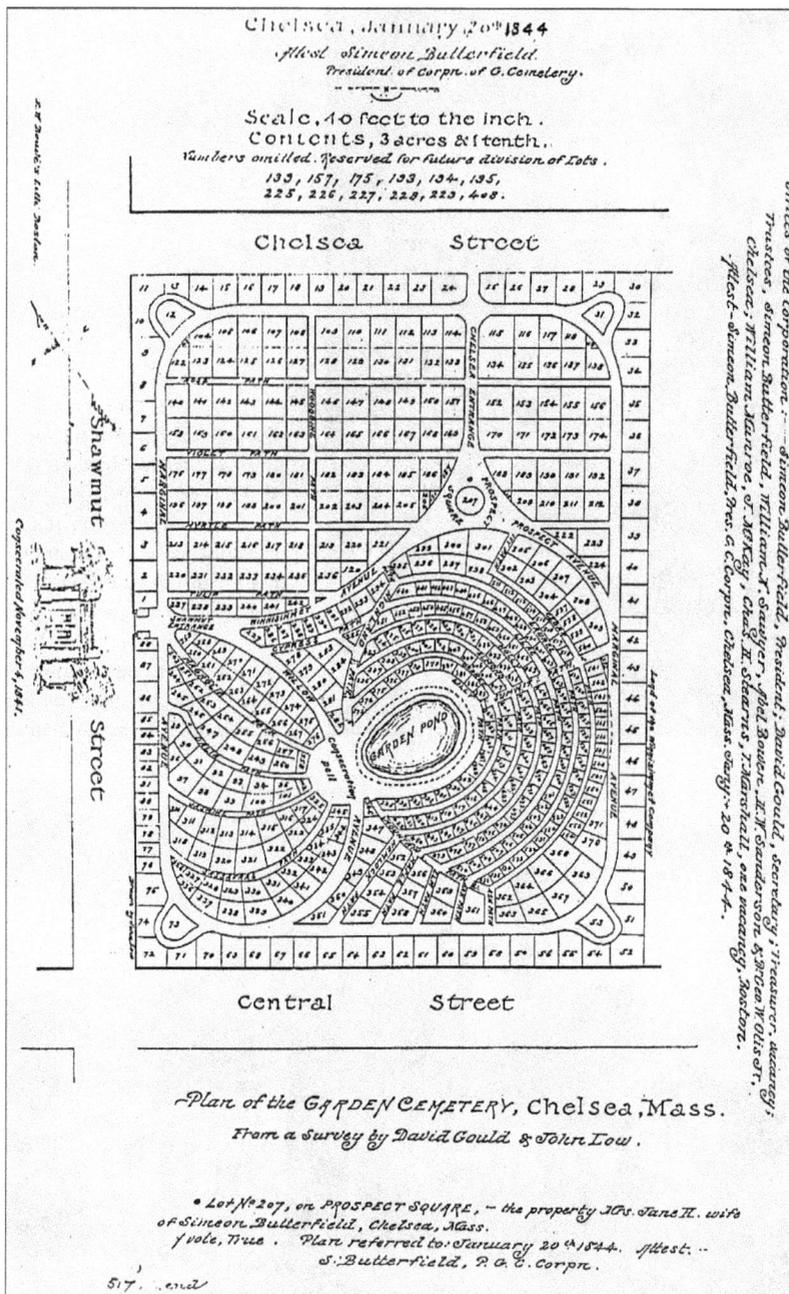

The advent of the garden cemetery movement began with Mount Auburn Cemetery in Cambridge in 1831, and was followed 13 years later with the Garden Cemetery in Chelsea. This 1844 plan shows the original layout, which is virtually intact. In contrast with earlier burial places, garden cemetery grounds were adorned with flowers, shrubs, and trees and became places for people to stroll and enjoy the plantings; even picnicking was welcomed. They were used like public parks. It made visiting the departed a more pleasant experience and, when contemplating one's own mortality, it was perhaps more agreeable to imagine oneself in eternal rest under a shady tree. (Courtesy of the CPL.)

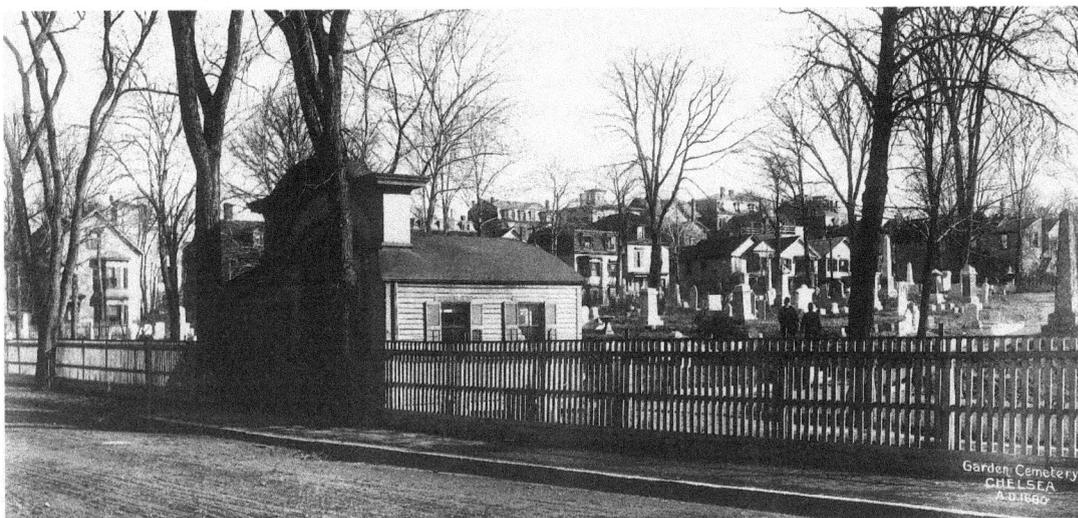

Simeon Butterfield was a leader in the movement to establish a cemetery closer to the village than the one that existed in Revere. Land on Shurtleff Street appeared to be a good choice, other areas under consideration being too small or marshy. The price of lots was set at $25 and $50. The Garden Cemetery is all that remains of the mid-19th-century pastoral Shurtleff/Bellingham neighborhood. A verse of the hymn sung at the dedication in 1844 went as follows: "Around their lowly bed shall flowers their fragrance shed, and birds shall sing; on every verdant mound Love's offering shall be found, and sighing trees around their shadows fling." (Courtesy of SPNEA.)

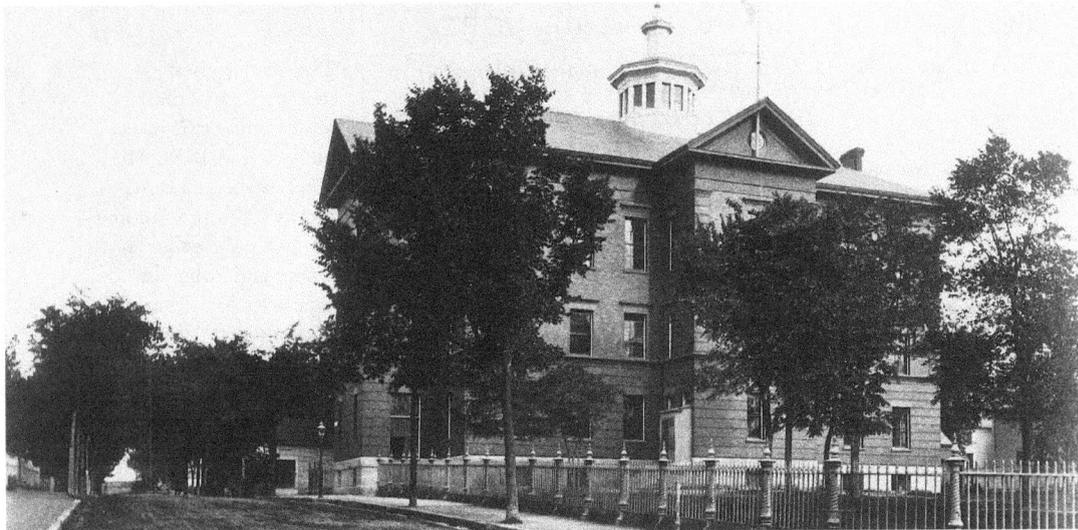

After considerable discussion at town meetings, the idea was approved to build a town hall. This handsome brick building was erected at the corner of Central Avenue and Shurtleff Streets in 1853. The octagonal cupola made it a landmark from various parts of the city. As there were schoolrooms in the building, it was also referred to as the Shurtleff School. This view is from the corner of Hawthorn Street, looking up Central Avenue. The land on which the town hall stood was formerly part of the Shurtleff Farm. Before being purchased by the Ferry Company for development in 1835, the land was dotted with apple trees and farm buildings. The main farmhouse was on a hill facing the river, its lawn lined with trees leading to the water's edge at Marginal Street. (Courtesy of SPNEA.)

109

The city's earliest newspaper was the Winnisimmet Chronicle, published in 1838. The Chelsea Record came out in 1843, proclaiming "to make the paper an ardent and influential supporter of society and good morals." It was not published regularly but reappeared successfully in 1890. Many other papers came and went between 1850 and 1900, one of the longest running being the Chelsea Telegraph and Pioneer, which was published for over 40 years at 132 Winnisimmet Street. The Chelsea Gazette began in 1886; the special features that it published have become important historical documents.

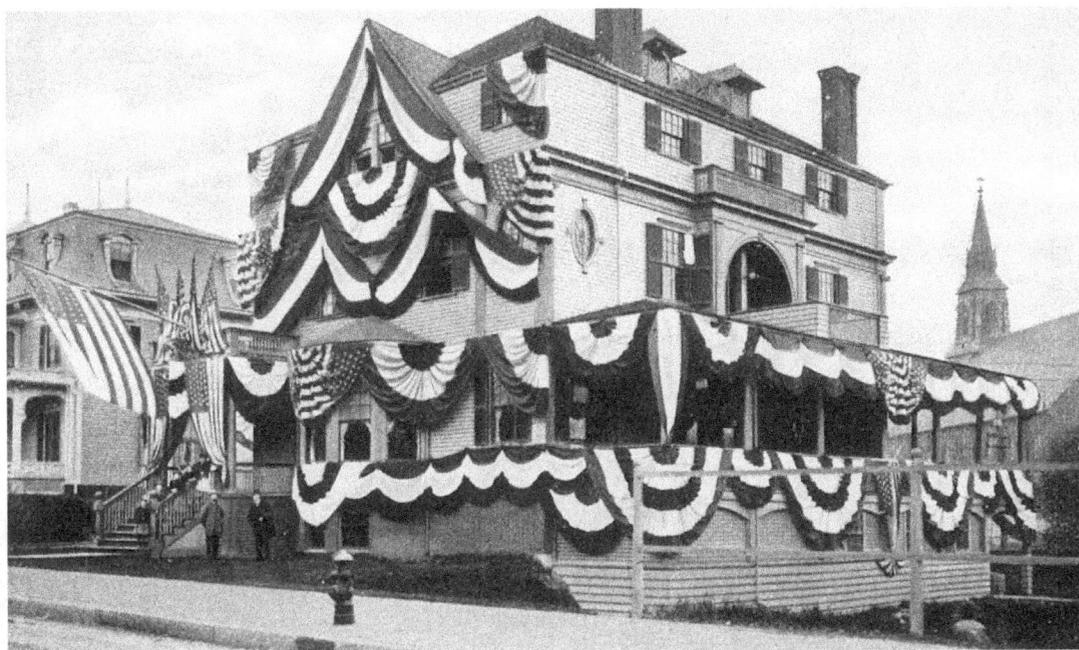

The Review Club, decked out in patriotic bunting, was built c. 1885 at 23 Crescent Avenue. Organized in 1869, it was one of the most prestigious of the literary, social, and political clubs that were popular in Chelsea in the 19th century. The steeple of St. Rose Church on Broadway is across the railroad tracks at the right.

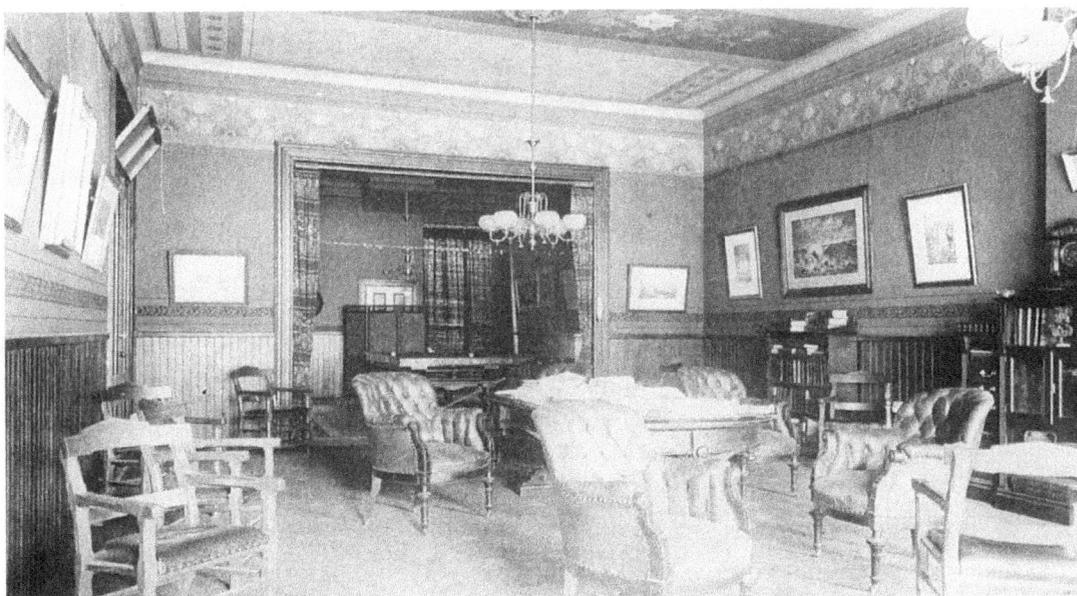

One of the comfortable reading rooms of the Review Club is pictured here, with its interesting wallpaper border and decorative ceiling. Typical of the high-fashion artistic wallpapers of the 1880s, the frieze has a Japanese influence that was "the latest craze among wealthy people of aesthetic taste." Low Art Tiles were the perfect complement to this style. (Courtesy of the CPL.)

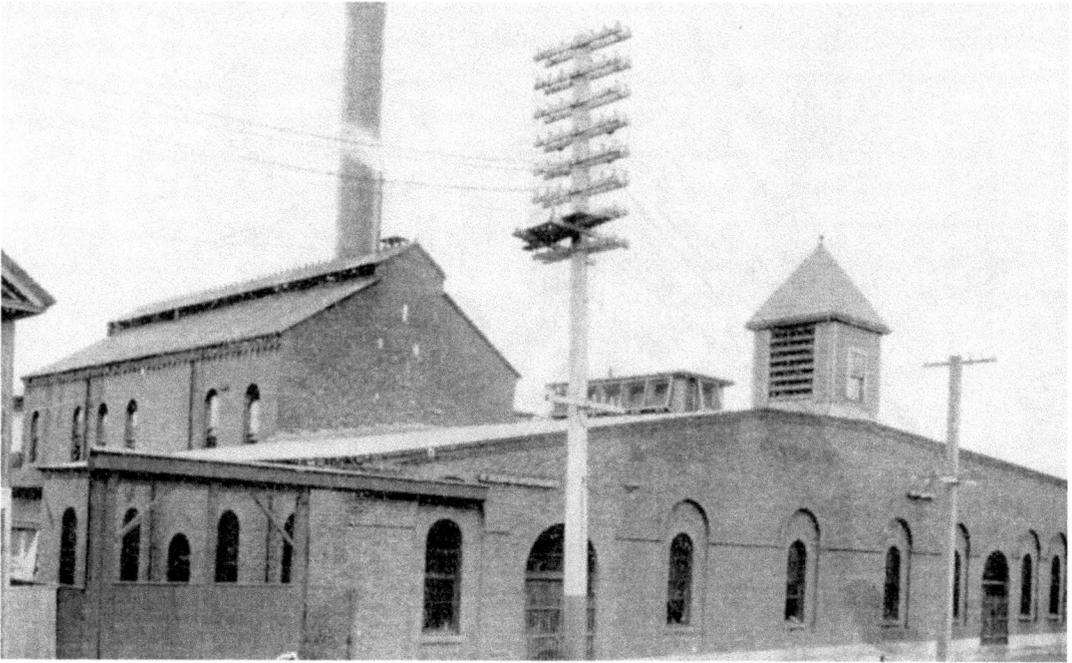

The Chelsea Gaslight Company and Electric Lighting Station, c. 1898, occupied nearly the entire block of Williams, Auburn, Spruce, and Cypress Streets. The gas works came into the city in 1852, followed by electricity in 1889. Unsure which would be most reliable, many people had both forms of power in their homes.

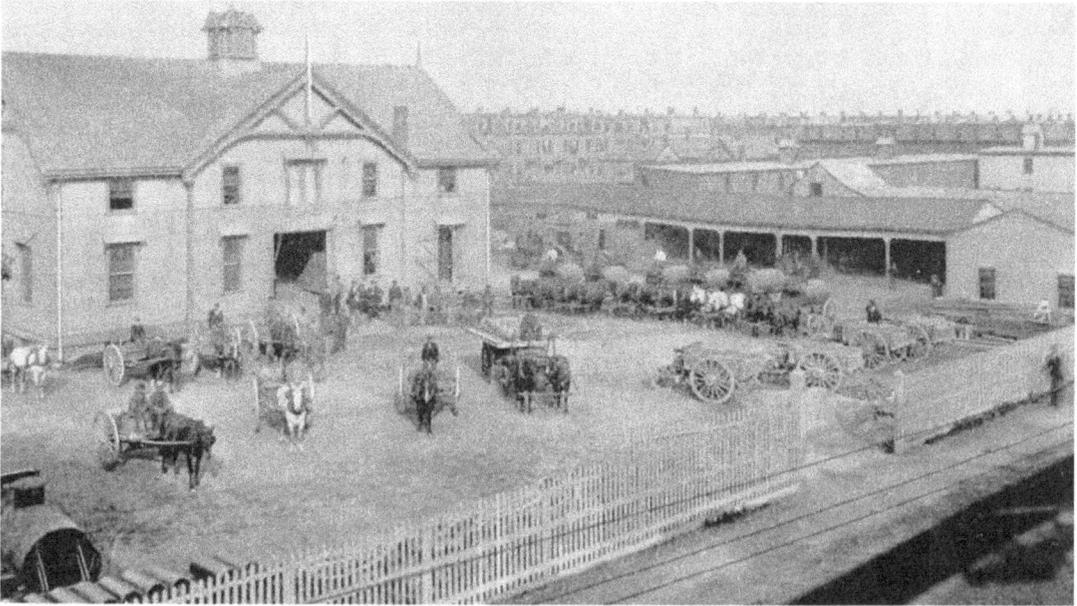

The complex of buildings that made up the City Stables in the 1890s occupied a large area on Fifth Street. The city kept the stables full of animals and equipment for the use of road crews, fire engines, etc. Great changes were made with the invention of the automobile, not many years after this photograph was taken.

In 1898, the water commissioners posed in the carpeted office of the new water department building. They appear justly proud of the many services provided the citizens of Chelsea; as early as 1846 sewer pipes had been laid, and water was piped in from Charlestown in 1867.

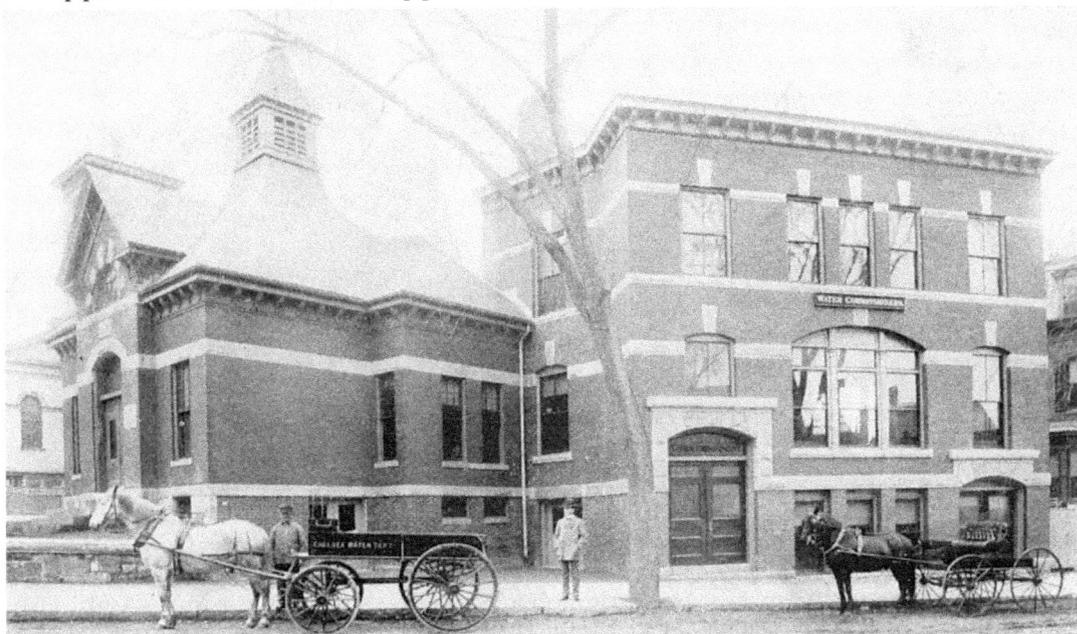

Note the sparkling windows at the water department, located at the junction of Hawthorn and Park Streets. St. Luke's Church on Hawthorn Street is just visible to the left of the building. Currently on the site is a real estate office and apartment house.

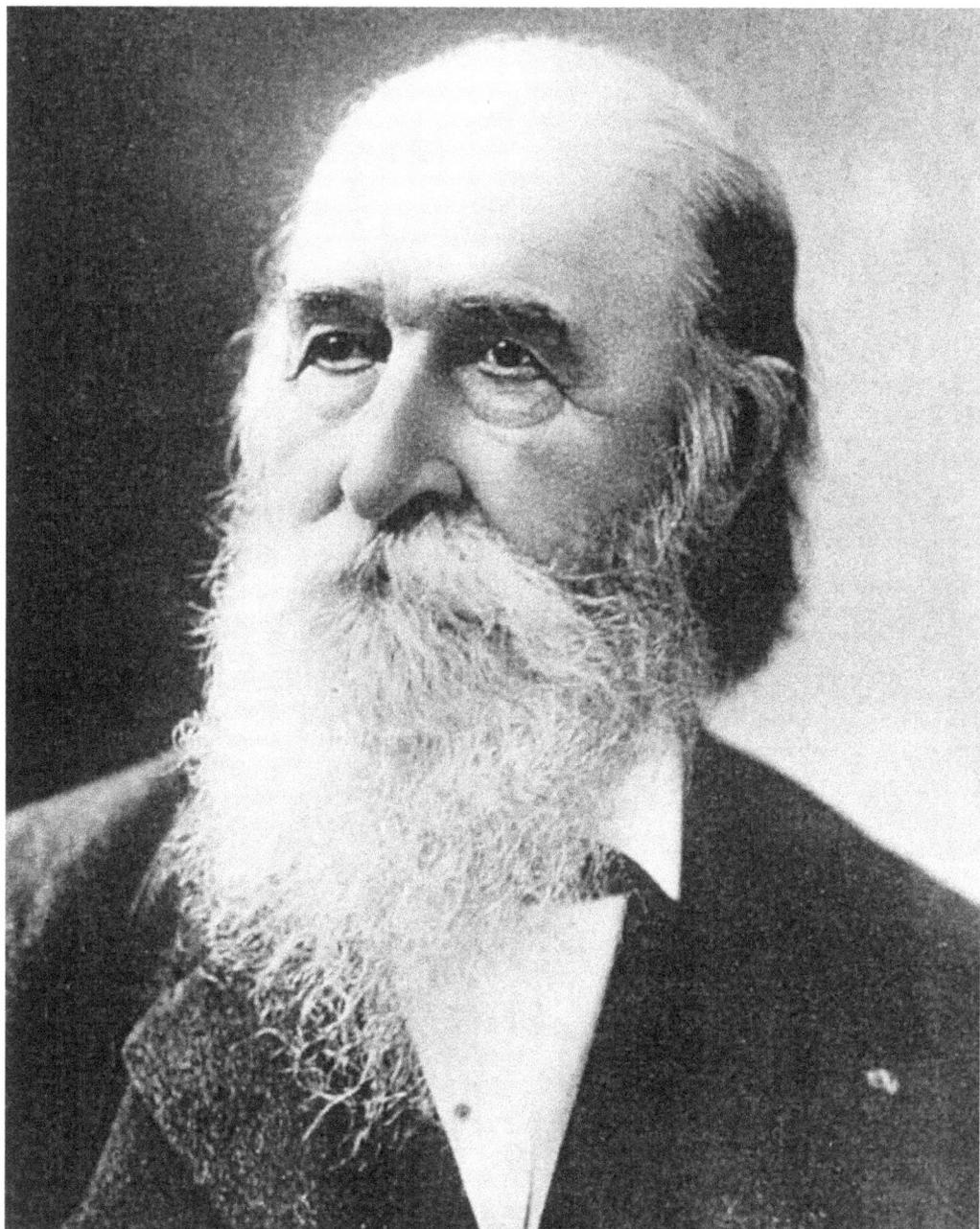

Frank B. Fay held the office of mayor during the Civil War, from 1861 to 1863. He was also very active in the United States Sanitary Commission, the forerunner of the American Red Cross. This organization of volunteers was of crucial aid to the troops during the war. Mayor Fay's service began in May of 1861, when he escorted the Chelsea Light Infantry to the State House to be sworn in as Company H of the First Massachusetts Regiment. After the Battle of Bull Run in July, Mayor Fay escorted Chelsea's six fatalities home for burial. He declined a fourth term in office in order to continue his work with the troops. Commenting on the unlikeliness of his years at the front, he wrote, "I was a man of peace. I never believed in war."

Helen Gilson, governess to the Fay family, also worked tirelessly in the war effort. She organized the local Soldiers' Aid Society, which sent clothing and supplies to the troops. In 1862, she was called upon to nurse the wounded, and spent the rest of the war working with the evacuation teams that transported soldiers from the battlefields to hospital boats. A Boston minister remarked, "Never have I forgotten . . . the light in her eyes and her smile. She was always calm, cheerful, and brave." In 1866, she was married to E.H. Osgood; she died in childbirth just two years later. The monument at her grave in Woodlawn Cemetery was made by possible by donations from grateful veterans. (Courtesy of Helen Hannon and the Somerville Public Library.)

H.A. Spencer was made chief engineer of the Chelsea Fire Department in 1889, after serving 20 years in the department. A veteran of the Civil War, he was active in numerous local organizations. He was at the helm when the great fire struck the city on April 12, 1908.

At its original location on Broadway, near Webster Avenue, is Engine 3, built in 1887. Its systems have been modernized over the years, and it is the last 19th-century fire station in the city to remain in operation. Always prepared, Chelsea bought its first engine in 1835 and housed it in Chelsea Square.

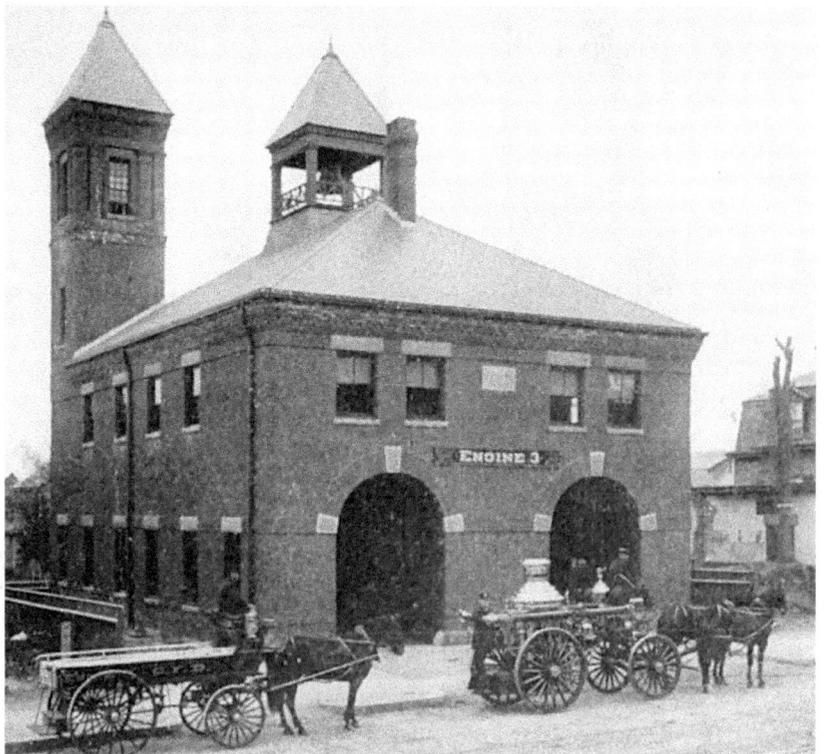

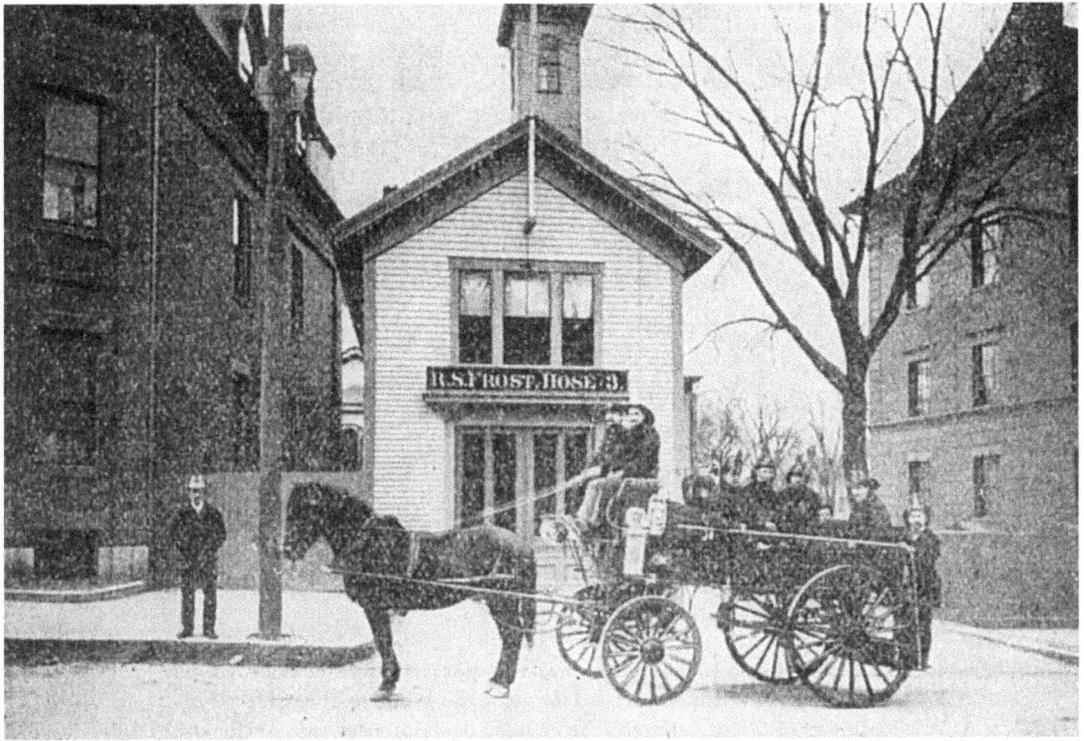

The quaint Rufus S. Frost Hose 1 was on Shurtleff Street across from Maverick Street. Fire was a serious concern in this area because of the industries along the nearby waterfront, including lumber yards and oil and varnish works. The old city hall is just to the right.

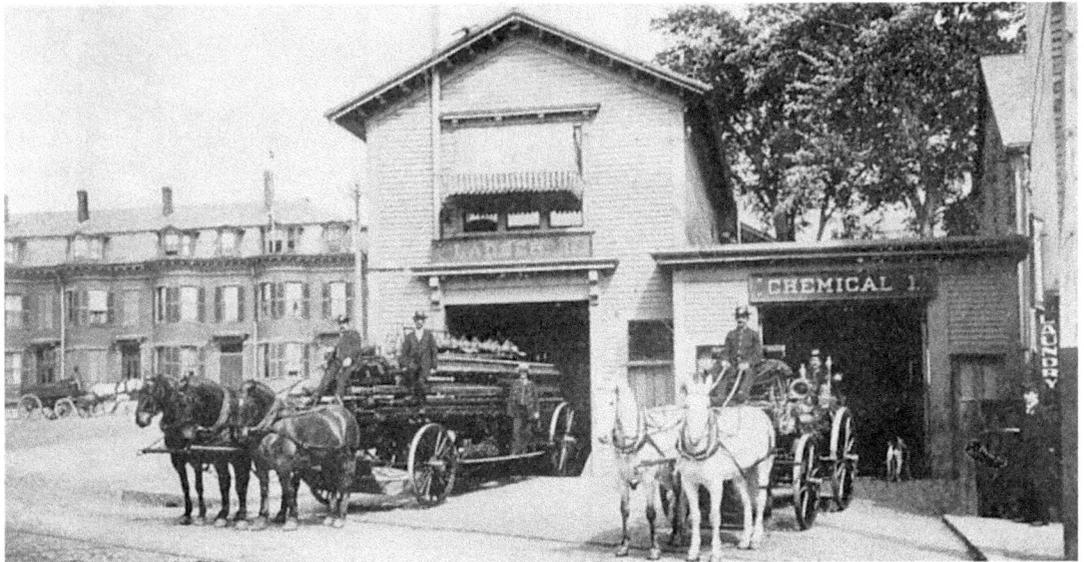

Chemical 1 and Hook and Ladder 1 were at 481 Broadway, across from today's city hall. As small as Chelsea was in 1908 it had seven firehouses, as each city was responsible for fighting its own fires. The only mutual aid agreement was with the city of Boston.

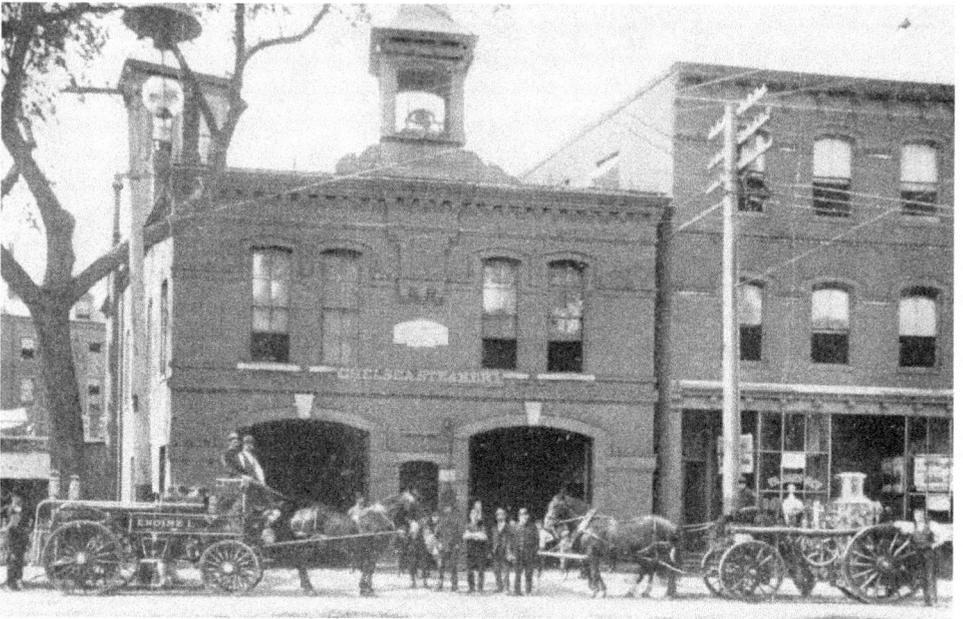

The house for Chelsea Engine 1, or "Chelsea Steamer" as it reads over the door, was built in 1871 in Park Square. After doing valiant service and surviving the 1908 fire, it remains on its original site. An important part of the city's history, the building has been nicely adapted for reuse by two commercial establishments.

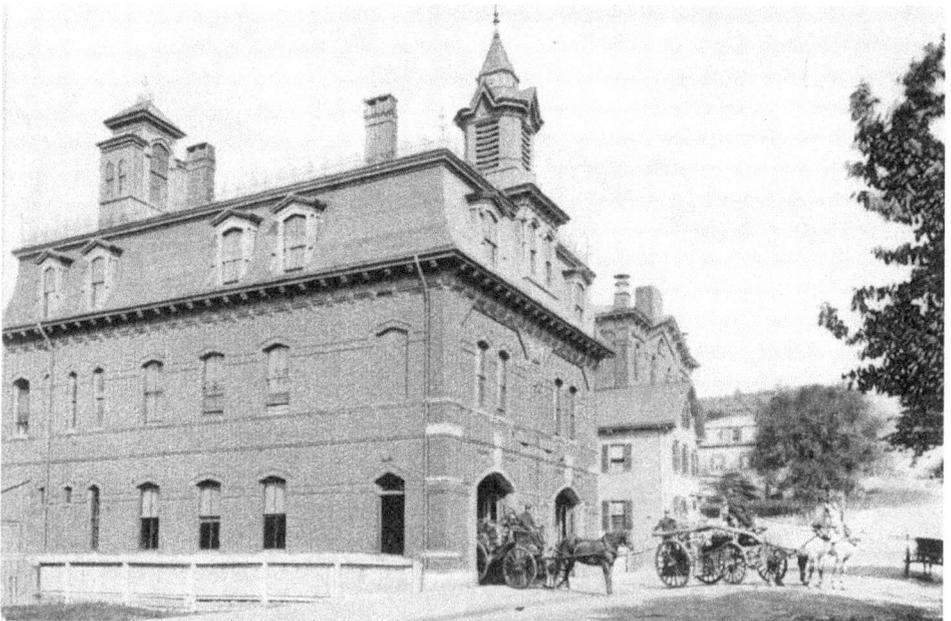

Dominating Forsyth Street in Cary Square was Chelsea Engine 2, built c. 1870. This was a costly and impressive improvement over the early days; in 1838 the fire department expenses for the year totaled $535, which included $170 for a second-hand engine. The Carter School is just up the street.

eight

Marine Hospital, Naval Hospital, and Soldiers' Home

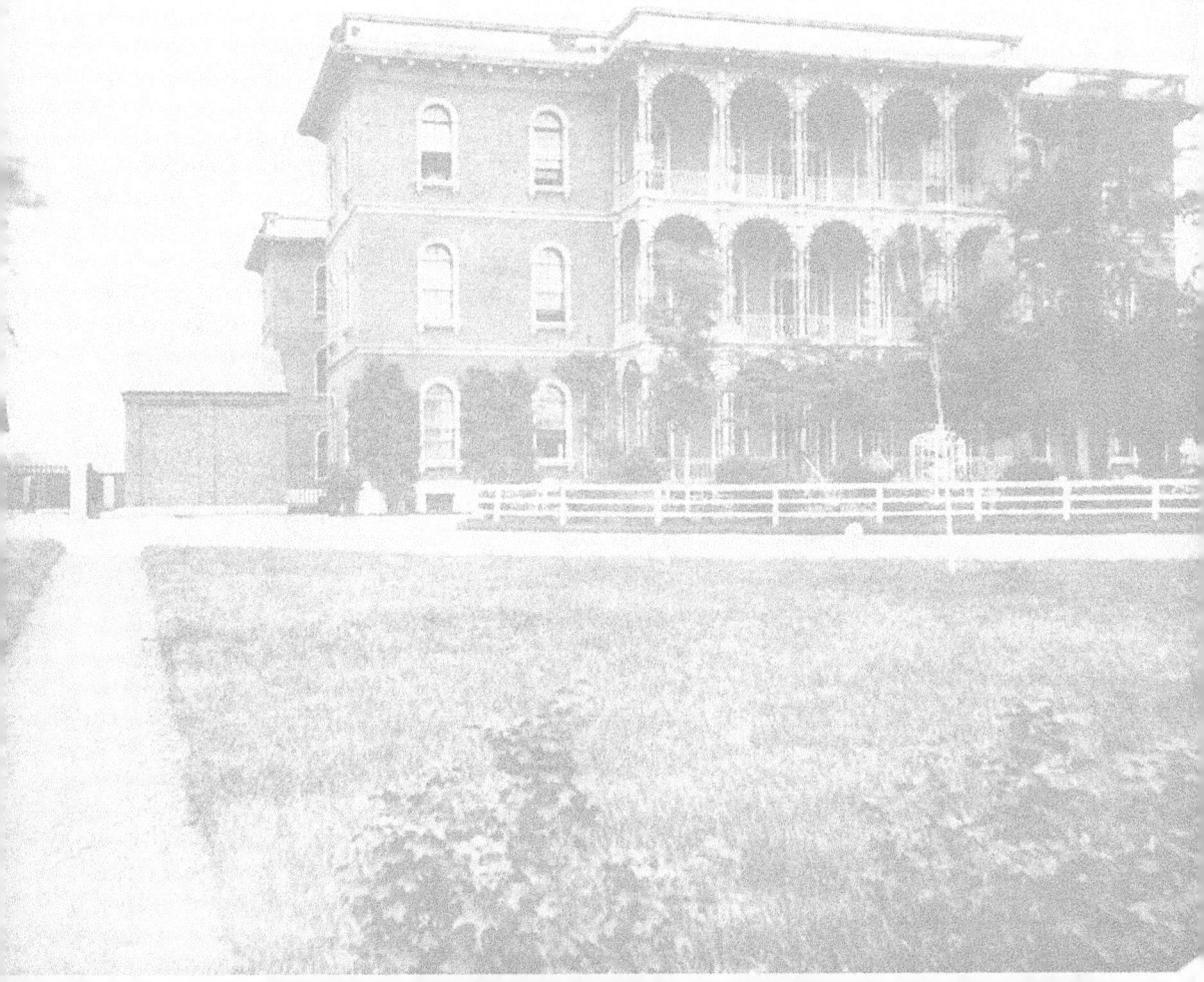

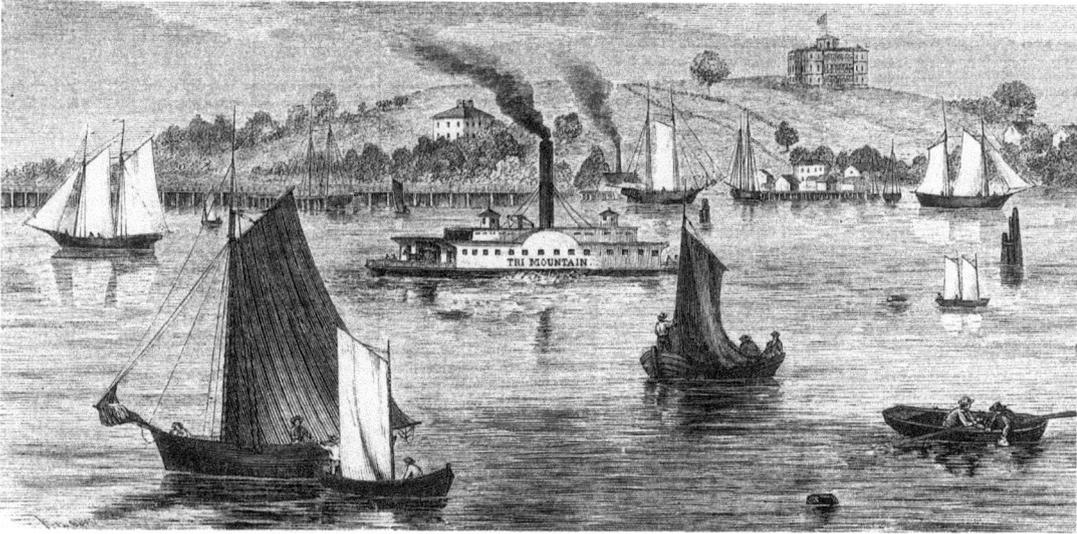

The federal government purchased land along the waterfront on both sides of Broadway in the early 1800s. In this lithograph of 1860 are two important military hospitals built on that property that served their original use for over a century. Amid a cluster of trees, in the background of the steam ferry Tri-Mountain, is the granite Naval Hospital building, erected in 1827. On the hill stands the brick Marine Hospital (later part of the Naval Hospital) completed about 1860. It is a remarkably idyllic scene of the harbor before heavy industry filled the waterfront resort with oil tanks and factories.(Courtesy of the BPL.)

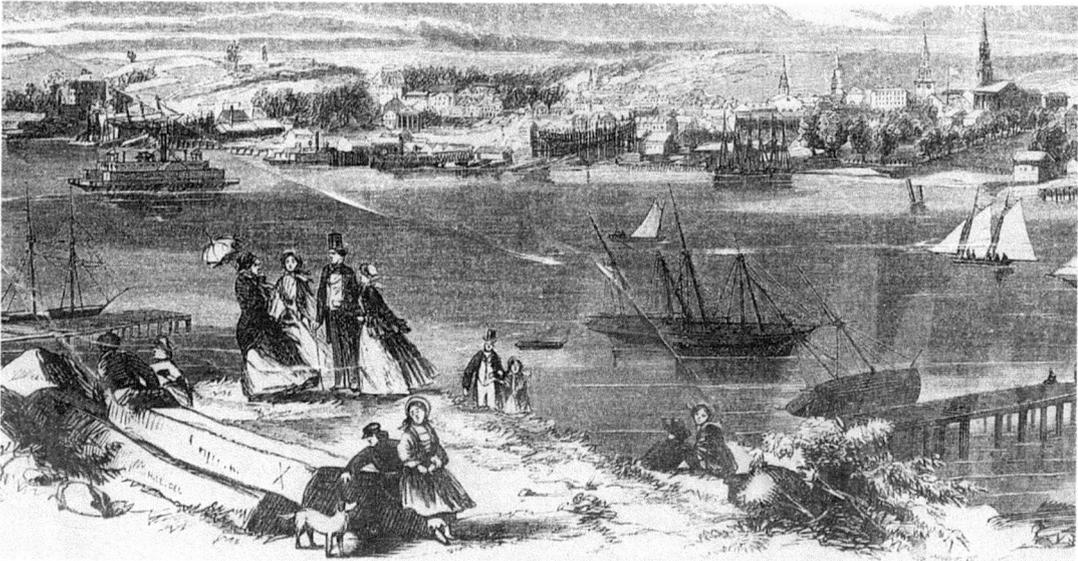

This wider view of the Chelsea waterfront from East Boston, dated 1855, includes the more populated part of the town east of Broadway. At the far right is the area of the old Shurtleff Farm; the city hall can just be seen on Central Avenue, its octagonal cupola rising up above the original Marine Hospital on Essex Street. The drydock for one of the shipbuilding companies is in the center, next to the ferry landing on Winnisimmet Street. At the far left is the 1803 bridge to Charlestown and the Naval Hospital. The brick Marine Hospital on the hill had not yet been built, nor was there anything of note on Powderhorn Hill. (Courtesy of the CPL.)

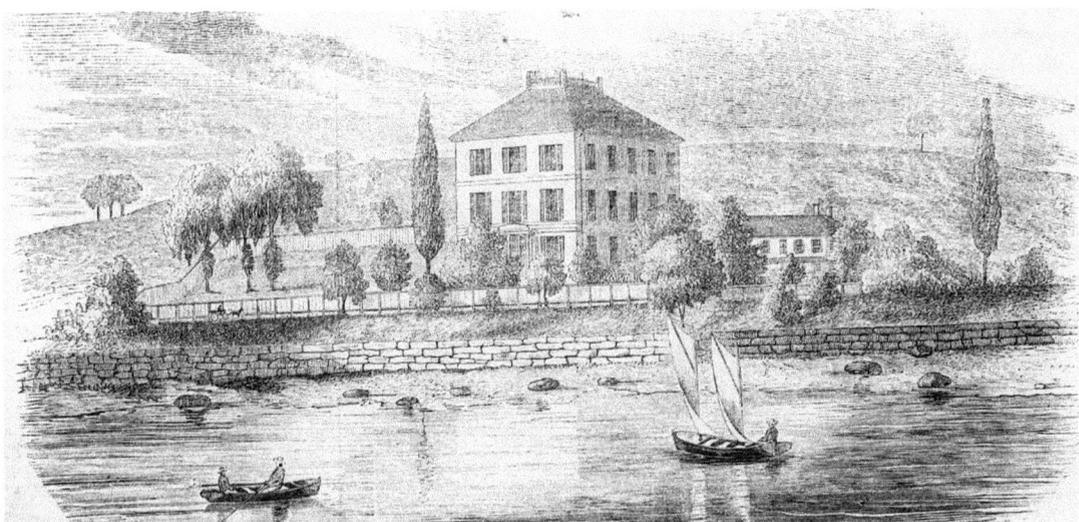

In 1831, architect Alexander Parris was again commissioned to design a military hospital in Chelsea. The original Vermont granite building of the United States Naval Hospital is still extant, having been enlarged in 1865. The joining of the two buildings is imperceptible. The 1831 and 1865 interior stairways remain intact and the original central doorway and pediment are still visible on the facade.(Courtesy of the BA.)

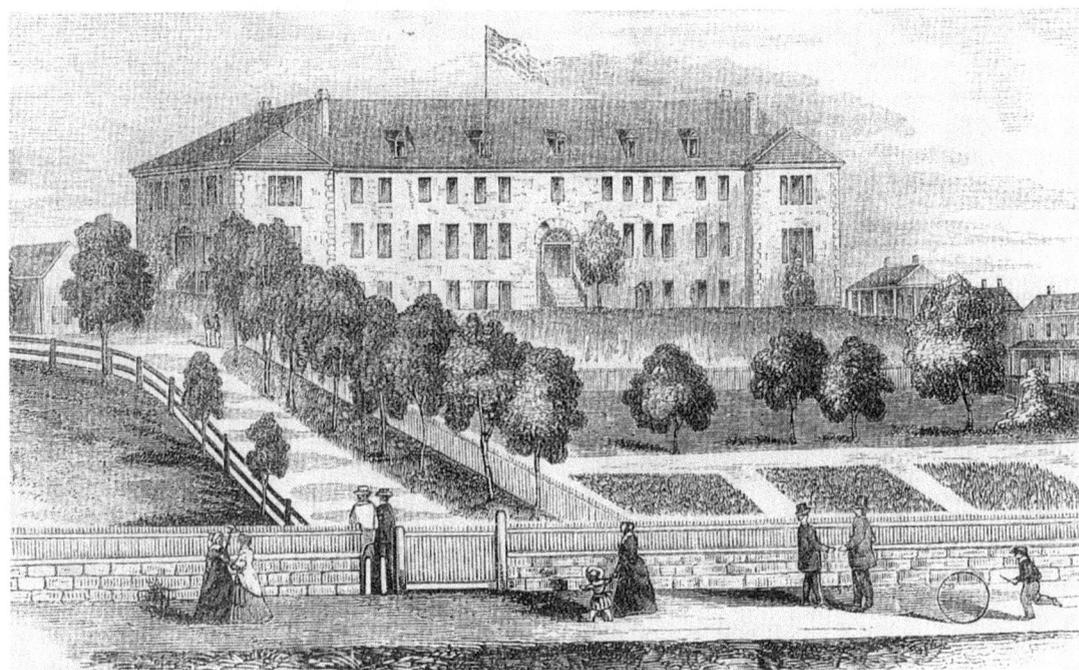

The United States Marine Hospital on Essex Street was designed by well-known architect Alexander Parris in 1827. Parris had previously supervised the construction of the Massachusetts General Hospital and designed the Quincy Market Buildings in Boston. This building was sold to the City of Chelsea in 1872, remodeled, and named the Shurtleff School. It was destroyed in the 1908 fire. (Courtesy of the CPL.)

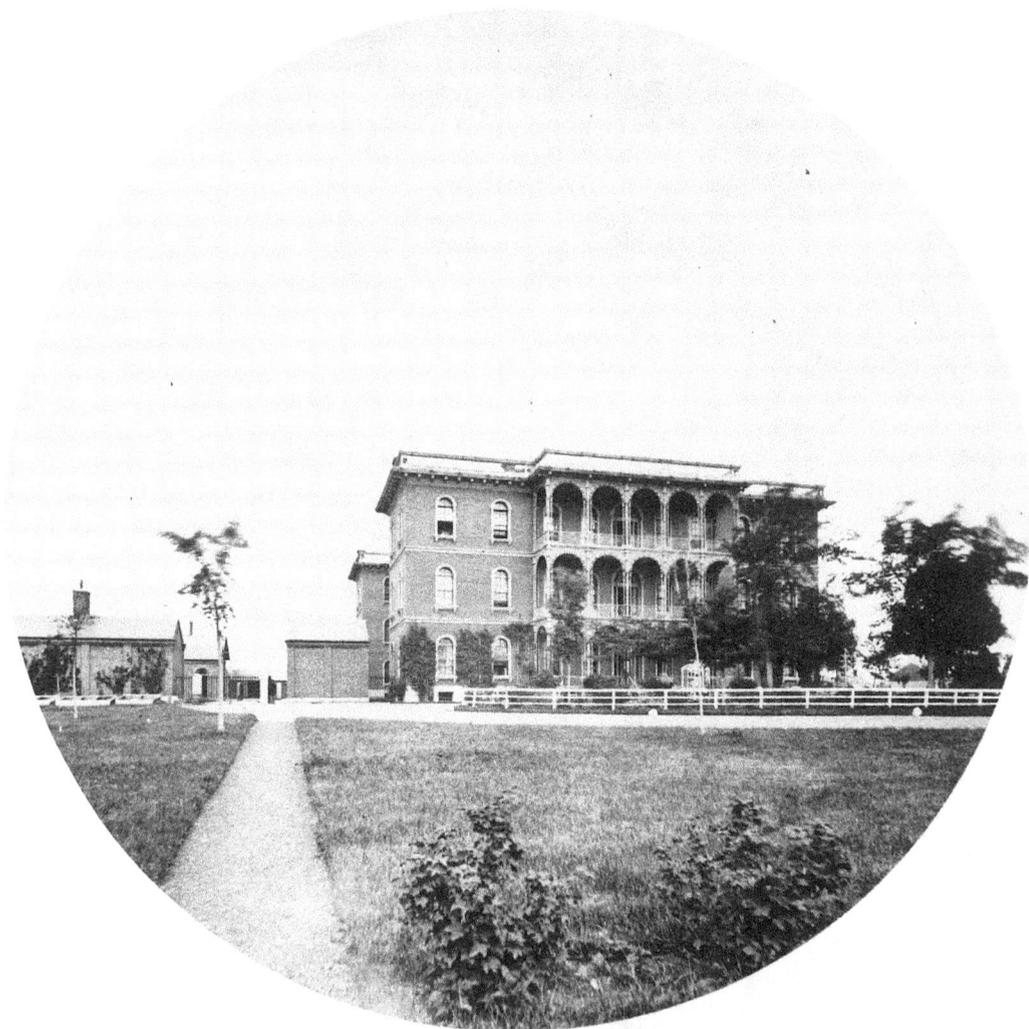

After the federal government sold the first Marine Hospital on Essex Street to the city in the mid-1850s, a new brick building was erected on the hill above the Naval Hospital. This rare early photograph by Josiah Hawes of Boston shows the Marine Hospital before the Mansard roof was added in 1866. The original roof balustrade was purely decorative and soon discarded in favor of adding another story of usable space. The hospital was completed in time to take care of casualties of the Civil War. Early records of the institution indicate that a seaman's life averaged only 32.5 years.(Courtesy of the BA.)

This view is from the Marine Hospital entrance on High Street, c. 1868, looking into the early heart of the city. Some houses in the foreground on High, Beacon, and Chestnut Streets still survive, but much of the area was burned in the 1908 fire. In the distance is Bellingham Hill and East Boston. (Courtesy of SPNEA.)

A composite of two c. 1868 stereopticon photographs shows the view from the hill of the Marine Hospital looking toward Boston Harbor. The Marginal Street industries are in the distance at the left; the bridge to Charlestown crosses the Mystic River at the foot of Broadway. The naval commandant's house at the base of the winding road is now an architectural firm. (Courtesy of SPNEA.)

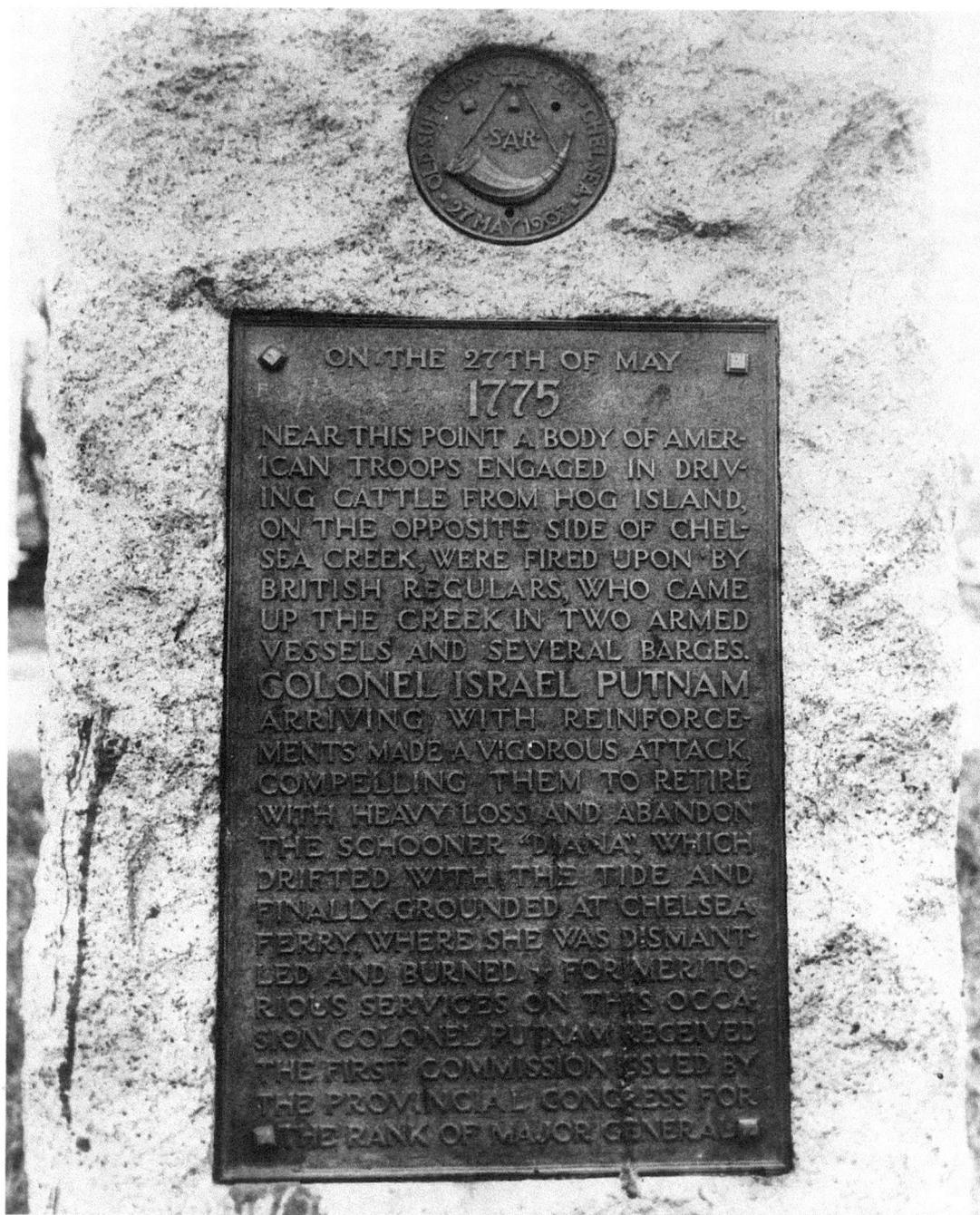

ON THE 27TH OF MAY
1775
NEAR THIS POINT A BODY OF AMER-
ICAN TROOPS ENGAGED IN DRIV-
ING CATTLE FROM HOG ISLAND,
ON THE OPPOSITE SIDE OF CHEL-
SEA CREEK, WERE FIRED UPON BY
BRITISH REGULARS, WHO CAME
UP THE CREEK IN TWO ARMED
VESSELS AND SEVERAL BARGES.
COLONEL ISRAEL PUTNAM,
ARRIVING WITH REINFORCE-
MENTS MADE A VIGOROUS ATTACK,
COMPELLING THEM TO RETIRE
WITH HEAVY LOSS AND ABANDON
THE SCHOONER "DIANA", WHICH
DRIFTED WITH THE TIDE AND
FINALLY GROUNDED AT CHELSEA
FERRY, WHERE SHE WAS DISMANT-
LED AND BURNED ✦ FOR MERITO-
RIOUS SERVICES ON THIS OCCA-
SION COLONEL PUTNAM RECEIVED
THE FIRST COMMISSION ISSUED BY
THE PROVINCIAL CONGRESS FOR
THE RANK OF MAJOR GENERAL

This bronze tablet was installed at the entrance to the Naval Hospital by the Sons of the American Revolution in 1903. It commemorates the first naval battle in the war for independence, May 27, 1775, the Battle of Chelsea Creek. The British and rebels skirmished as the rebels removed supplies of grain and livestock from Noddle's and Hog Islands to keep them from British troops. The British ultimately abandoned the fight and the schooner Diana drifted ashore and was burned by the rebels. The whereabouts of the tablet is unknown. (Courtesy of SPNEA.)

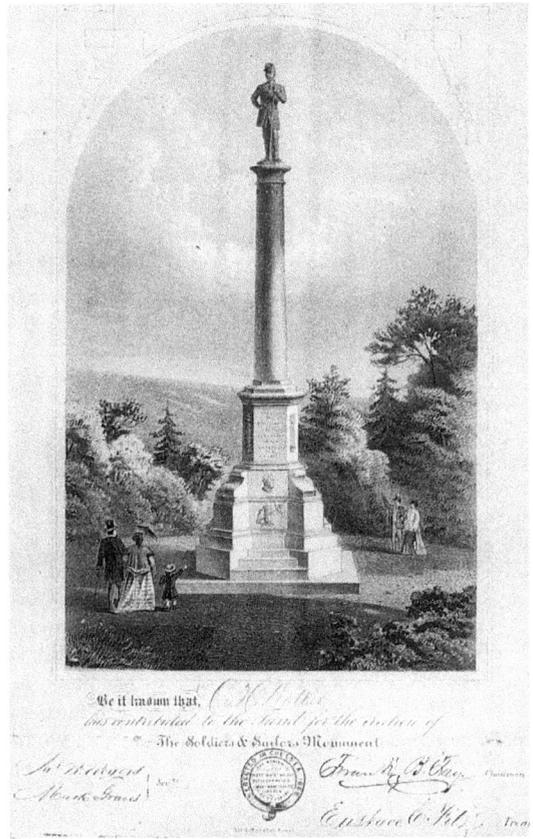

Right: The Soldiers' Monument, originally located in the center of Union Park, was funded by contributions from local citizens, who received this handsome scroll, signed by Frank Fay and Eustace Fitz, in appreciation. The monument was later moved to Broadway, across from the Chelsea City Hall. (Courtesy of the CPL.)

Below: Union Park occupied an entire block between Fifth and Sixth Streets and Arlington and Walnut Streets. It was a memorial to the men from Chelsea who had fought in the Civil War. Many of the trees within the park were dedicated to the memory of local citizens who had been of service to the community. (Courtesy of the BPL.)

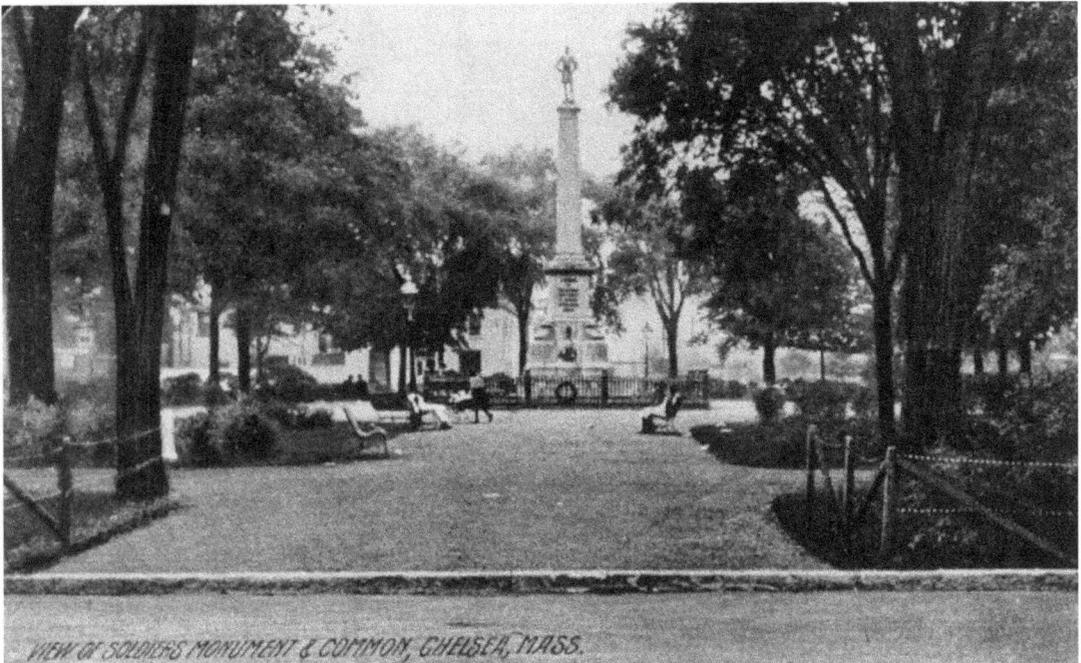

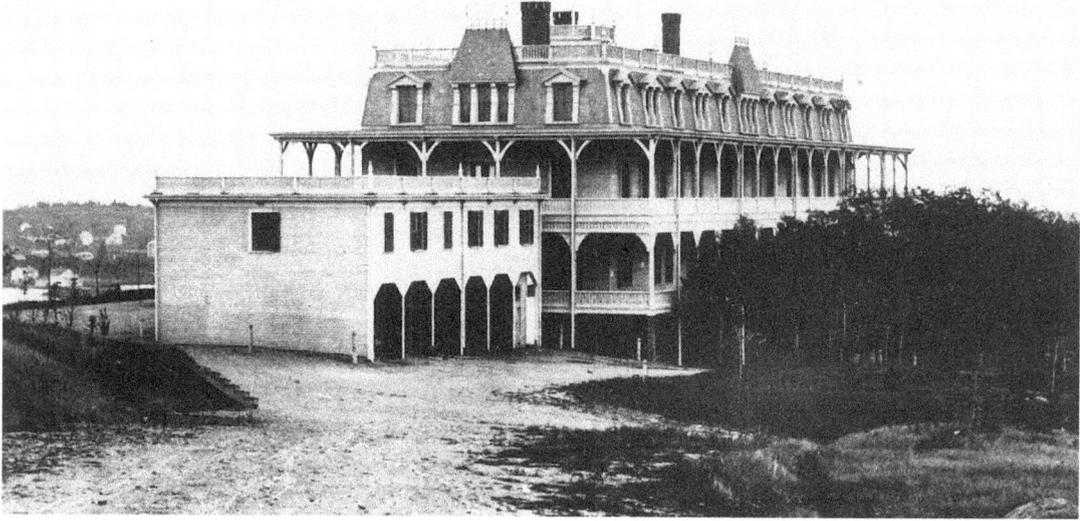

The Highland House Hotel, atop Powderhorn Hill, was a popular summer resort in the 1870s. Cool breezes and the spectacular view of Crescent Beach in Revere were a welcome respite from the city's noise and heat. As the summer people moved further up the North Shore, the hotel was sold and renovated for use as a Soldiers' Home—for just $20,000, including 4 acres of land. (Courtesy of SPNEA.)

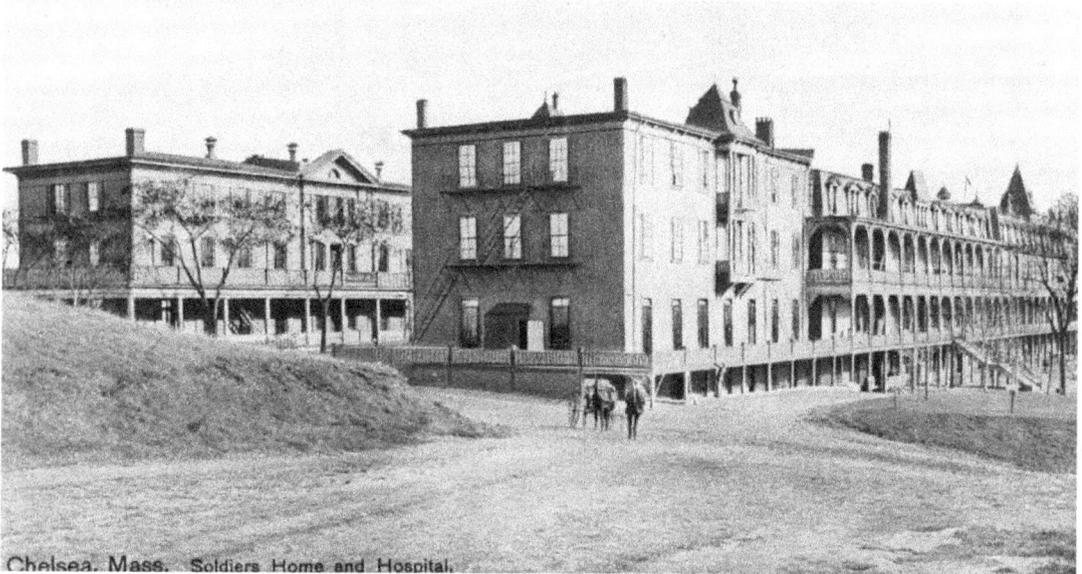

Chelsea, Mass. Soldiers Home and Hospital.

Care and housing of veterans from the Civil War became an important issue in the 1870s. Much of the money needed to purchase the old hotel and convert it into a proper home was raised at bazaars and balls organized by hundreds of women. The Home was dedicated in 1881, and by 1883 had 154 residents. The old hotel is at the right, with later additions to its left and across Crest Avenue. (Courtesy of the BPL.)

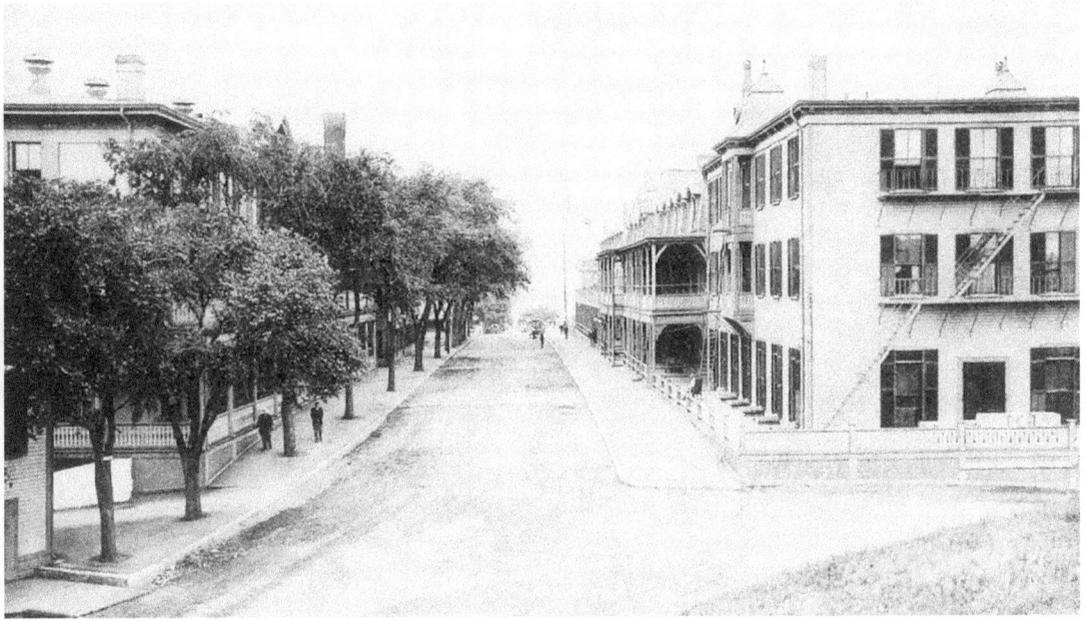

A veteran wrote to a friend, "I am a man now and not ashamed to look in the faces of my fellow man. I am in the Soldiers' Home." The oldest structure on the site is the building at the left, Sargent Hall. As demands for housing and hospitalization rose, larger brick buildings eventually replaced all the early wooden ones.

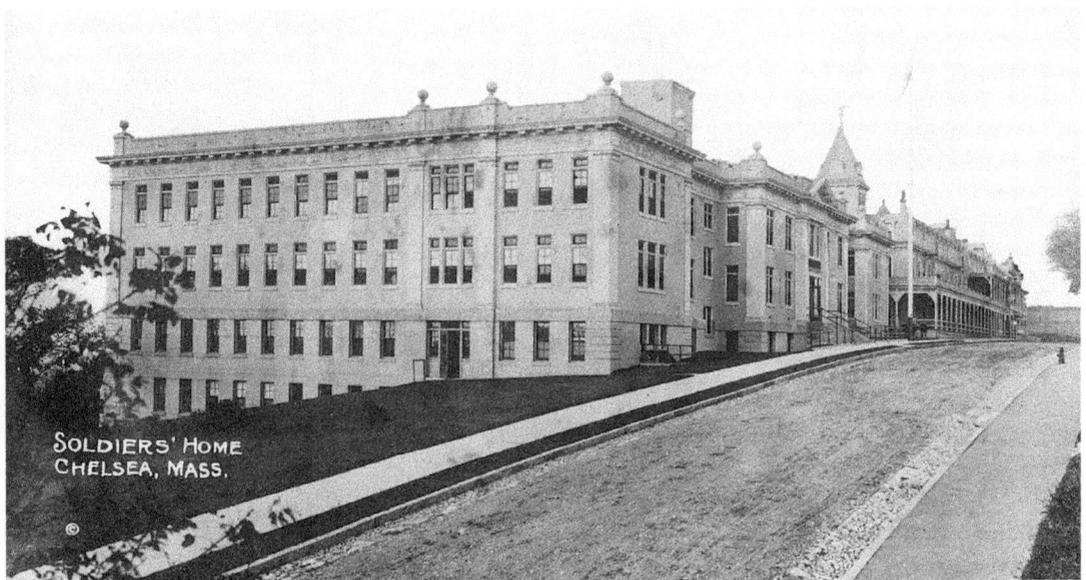

The 1909 Adams House was used as a hospital, added to the left of the original Highland House Hotel. In 1940, there still remained one veteran of the Civil War, a 98-year-old gentleman named Henry Bird. The home had fulfilled its original mission, to house veterans of the Civil War, which had ended in 1865.

Acknowledgments

I appreciate the encouragement and good wishes of those who showed interest and shared my enthusiasm as I worked on this book. For information and photographs, I would like to thank the following people and institutions: Martin Blatt and Joyce Connolly of the National Park Service; Angela Charlton; Bob Collins and Dennis Cooper of the Chelsea Public Library; Lorna Condon of the Society for the Preservation of New England Antiquities; Andy Demeter of the Chelsea Clock Company; Katherine Dibble, Sinclair Hitchings, and Aaron Schmidt of the Boston Public Library; Pamela Greiff and Sally Pierce of The Boston Athenaeum; Helen Hannon; Ned Keefe of the Chelsea City Hall; Herb Kupersmith; Jeff Lincoln of the Christian Science Church; Jim McCluskey; Joseph McMahon of the Citizens Bank, Chelsea; Anthony Sammarco; the Somerville Public Library; Douglas Southard of The Bostonian Society; the State Library; Donna Sullivan of The Architectural Team, Chelsea; Lois Svirsky; and Dennis Williams.

The signature of Samuel Maverick, Chelsea's first white settler

Visit us at
arcadiapublishing.com